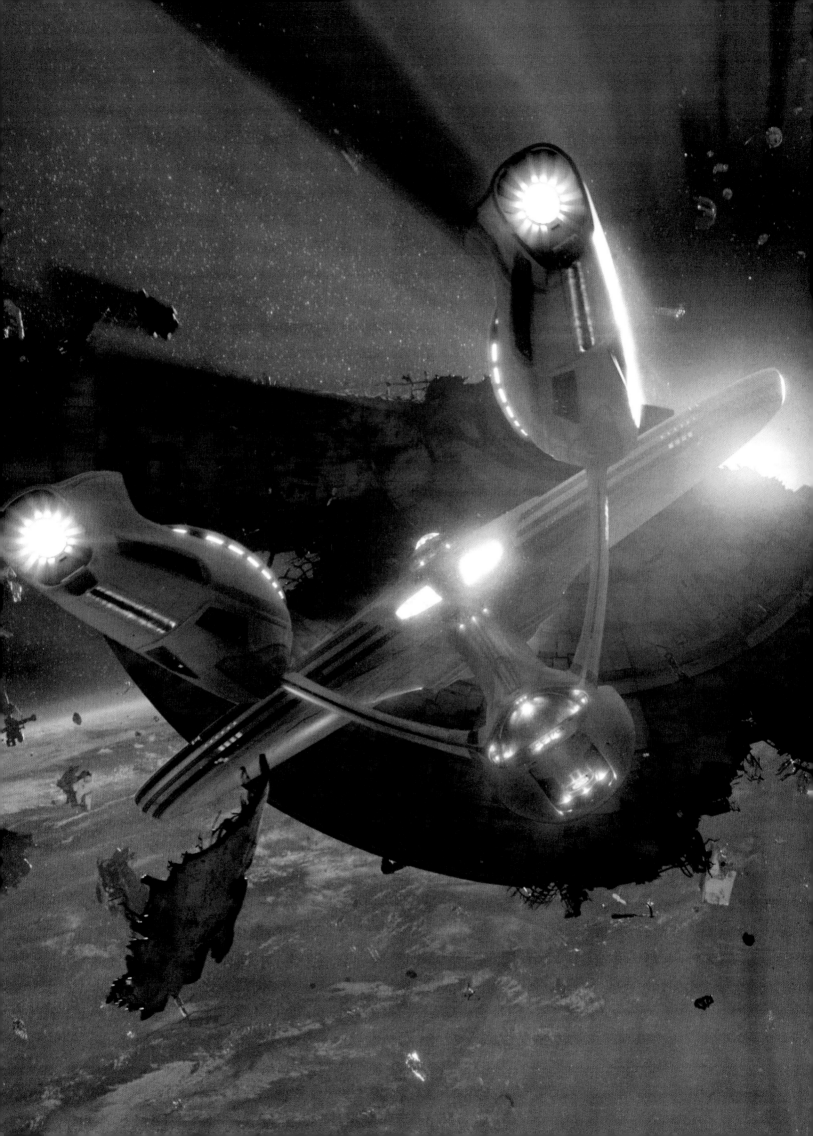

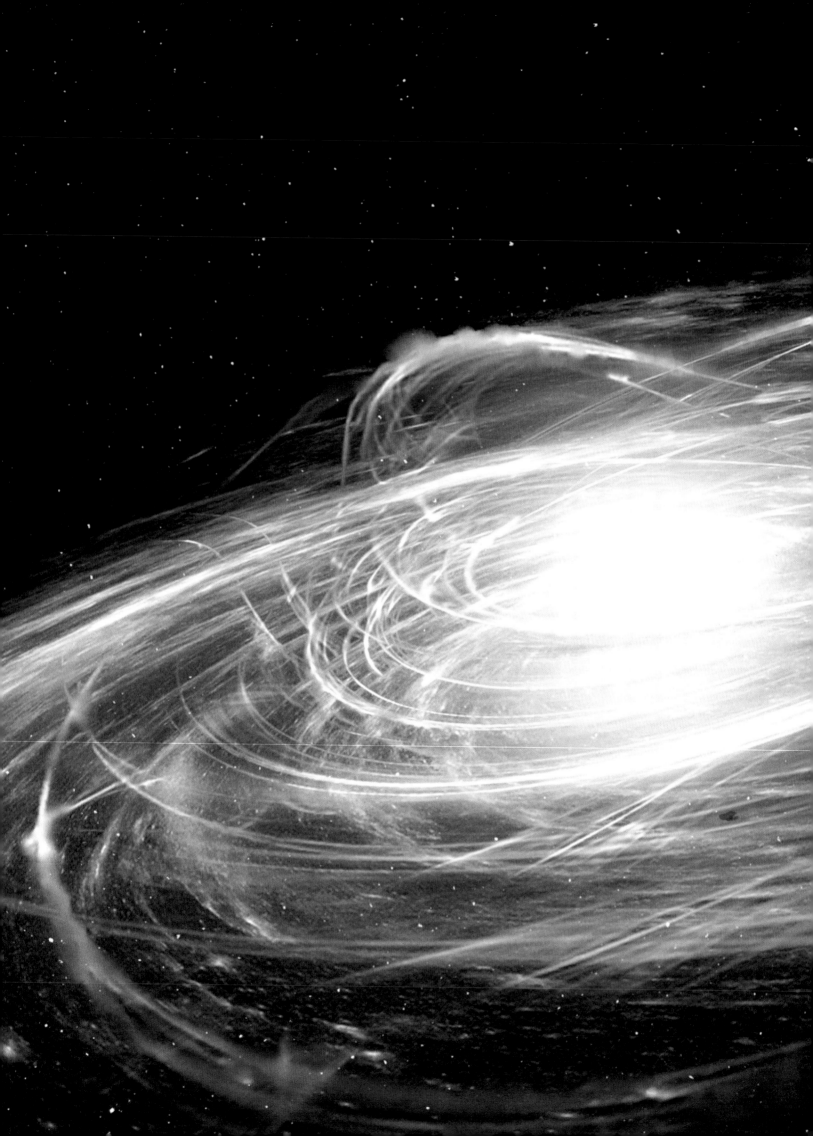

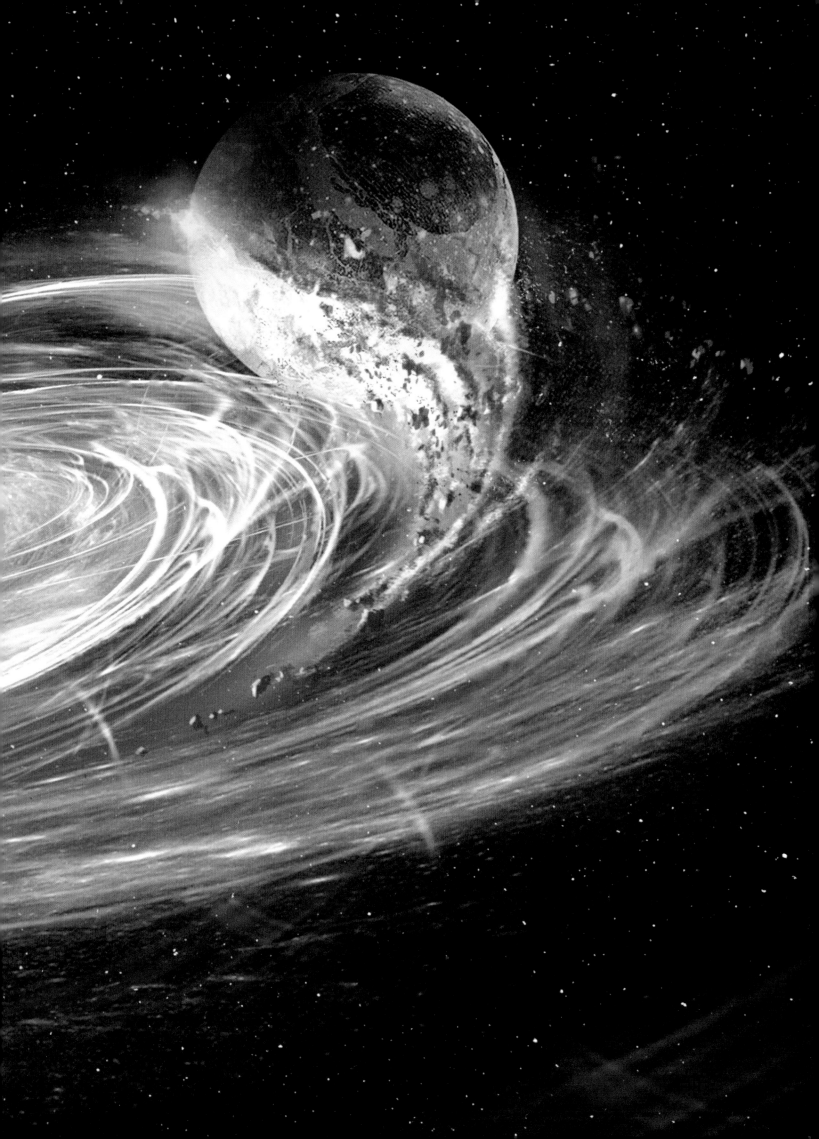

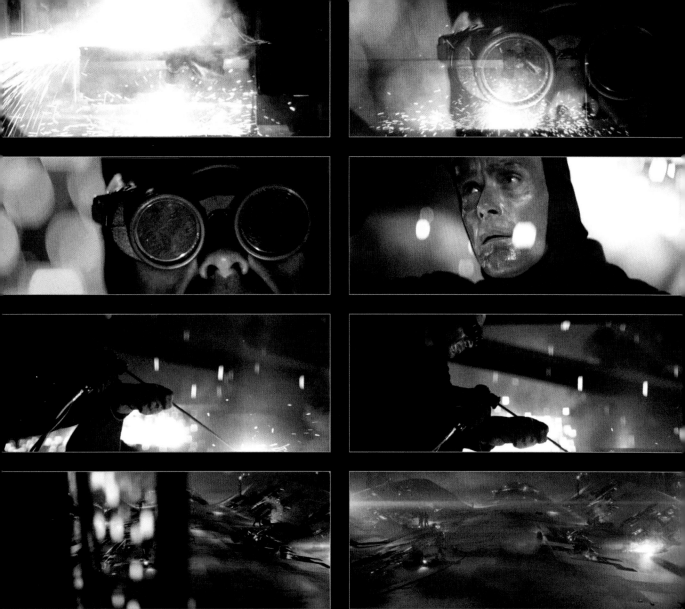

PREFACE

The acetylene torch flares and muscular workers in goggles sweat it out as they weld in the molten glow. A movie camera follows their work upon a gleaming surface as a voice from the Space Age begins a 30-second launch countdown. President John F. Kennedy declares, "The eyes of the world now look into space." Other voices follow: "Godspeed, John Glenn"..."The *Eagle* has landed"..."That's one small step for man, one giant leap for mankind." There is a final voice, deep and gravelly and familiar: "Space, the final frontier...." It is Leonard Nimoy, who embodied the Vulcan Spock, uttering the phrase that opened the original *Star Trek* TV show. And then the first trailer for *Star Trek*, the new movie, ends with a majestic reveal of the fabled starship *U.S.S. Enterprise* being built on land, and a notice on the movie's own progress: "Under Construction: Summer 2009."

Star Trek was as much a resurrection as a construction project. A few years into the new millennium, after ten feature films and five spin-off television series, the franchise had stalled. "After almost four decades of boldly going, *Star Trek* is drifting into the final frontier...can sci-fi's grandest franchise be rescued?" summed up a summer 2003 *Entertainment Weekly* article.[1] Paramount Pictures thought so and would approach director/producer J.J. Abrams and his Bad Robot production company to do the rescuing. "Early on, J.J. decided he wanted to embrace the original TV series and build around that and make it fresh and new," recalled producer Bryan Burk.

The decision was completely logical, as Spock would say. Although the seminal five-year mission "to boldly go where no man has gone before

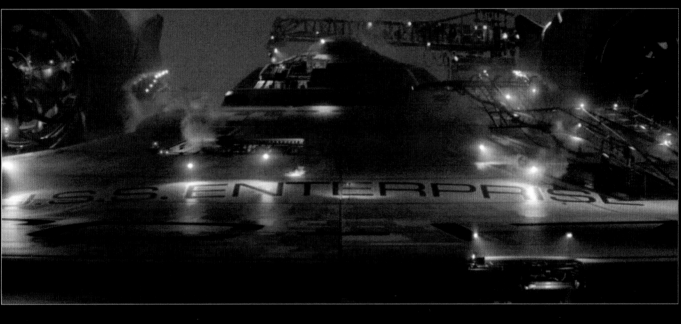

lasted only three seasons, its voyages into the unknown mirrored the true-life adventures of the *Gemini* and *Apollo* space programs. The last *Trek* episode aired June 3, 1969, but a few weeks later, on July 20th, television sets around the planet were tuned to the epochal telecast of *Apollo 11* astronauts walking on the moon. *Star Trek* would live on in syndication and in the movies and spin-offs to come, while science fiction and fact got ever closer – in 1976 the U.S. space shuttle *Constitution* was renamed *Enterprise*. "The moon landing created a sense of the possibility of space travel," Leonard Nimoy noted. "The context for *Star Trek* changed as a result."

"Part of the fun of *Star Trek* is that beyond being a pop culture staple, it is an optimistic view of our future," reflected Abrams, who directed, as well as produced. "In our teaser trailer there was the idea of creating a continuum of our history from 40 years ago and the beginning of space travel and *Star Trek* and the *Enterprise*, with its five year mission. That connection of what we know, and who we are, brought it back home."

That teaser trailer, in addition to recalling Space Age roots, stepped out of *Trek* canon by having the *Enterprise* built entirely on Earth (later revealed as the sunburnt fields of Iowa), and a fresh start was declared with the notice: "The Future Begins." But Abrams and his longtime collaborators and creative brain trust – producers Bryan Burk and Damon Lindelof, the screenwriting team of Alex Kurtzman and Roberto Orci – had a vision for how to take the old, make it new, and still keep the *Trek* universe in equilibrium. The idea required the participation of a venerable link to the storied past – Leonard Nimoy would be asked to "put on the ears" of the inscrutable Vulcan. The entire enterprise hinged upon his answer. ▲

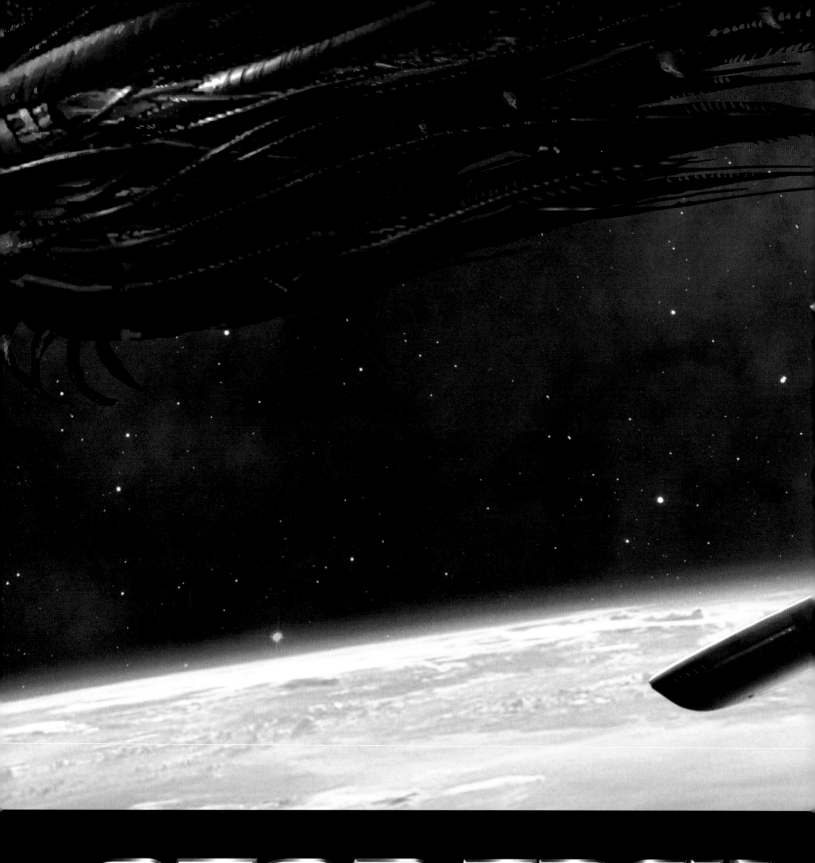

STAR TREK

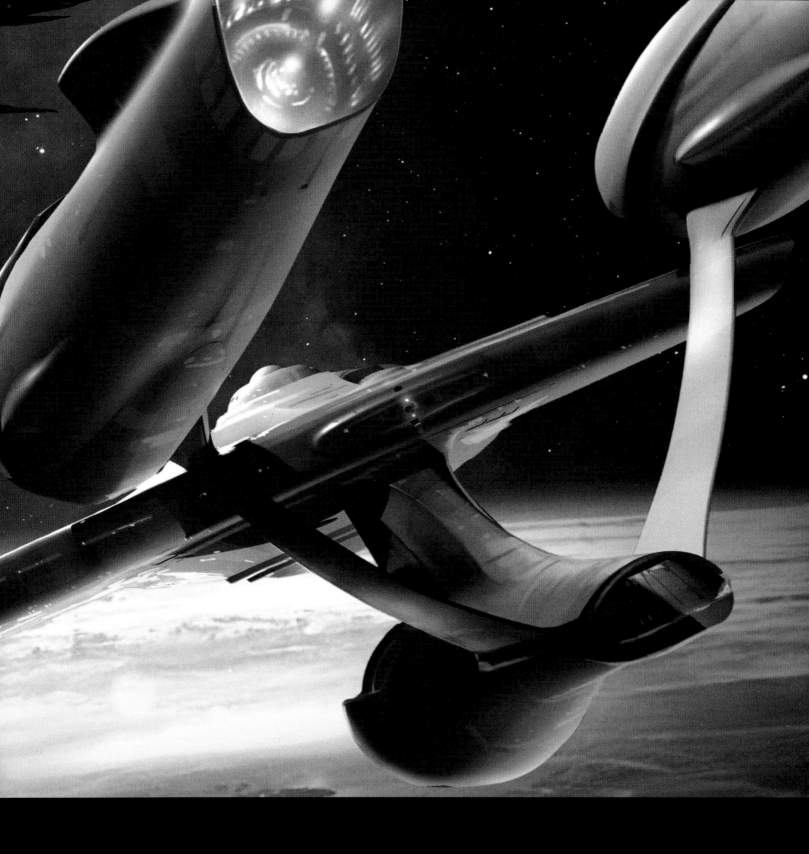

THE ART OF THE FILM

MARK COTTA VAZ
FOREWORD BY J.J.ABRAMS

To Gene Roddenberry, the trailblazer,

To William Shatner and Leonard Nimoy, whose characters set a course for the stars,

To J.J. Abrams and the producers, cast, and crew who brought *Star Trek* back for new adventures,

And to Dr. Edgar Mitchell, space voyager.

— Mark Cotta Vaz

CONTENTS

FOREWORD BY J.J. ABRAMS

"**O**h my God, Robau is bald, too."

The realization hit me in a crashing, sudden and terrible way; the wonderful actor playing the role of Captain of the *U.S.S. Kelvin* had no hair. Of course he didn't. I knew that. Neither, obviously, did the troupe of actors playing our evil, pointy-eared, tattoo-faced Romulans.

But somehow, in the endless process of prep – the non-stop decision-making, design and redesign meetings, the storyboarding, previz and rehearsal sessions – somehow, it never actually occurred to me that absolutely everyone in this scene was 100% bald.

And I started to sweat. Like really, truly freak-out sweat and a profound, powerful question began broadcasting inside my head: HOW CAN I MAKE THIS SCENE NOT SUCK?

We had just moved production from the set of the *Enterprise* bridge to an adjacent soundstage at Paramount Pictures. Movies like *Sunset Boulevard* and *Rear Window* had been shot there and that morning I'd felt inspired. But now...now I was surrounded by, I think, fifteen bald dudes and one bald woman, and I was closer to a panic than I had been in my entire *Trek* experience thus far.

Then something else occurred to me – a question I'd been asked countless times since I agreed to direct the film: "Aren't you terrified to do *Star Trek*?" What I could tell people sometimes meant was, "Aren't you terrified of pissing off those crazy Trekkies?" But more often than not, the implication was, "How can you even touch something so iconic? So beloved?"

Maybe it was because I was never an ardent *Trek* fan (unlike many of my friends) that I felt more comfortable directing this picture. Certainly it was Mr. Roddenberry's brilliant, brave, optimistic and all-inclusive vision of the future that so deeply appealed to me when I first became involved in the picture – but I never felt that it was sacred text, I was never afraid of *Star Trek*.

Until this moment.

I don't know why the baldness did it. Maybe it just made me realize how much I might have – and probably already had – screwed it all up. But those shiny heads, all sixteen of them, triggered the inevitable: I finally felt the stakes of making this movie. I was suddenly, horrifically aware of the risks, and instantly stunned that the studio had ever put such precious cargo into the hands of a guy who, when first approached about helping bring a new version of *Trek* to the screen, hadn't seen half the episodes of the original series.

I accidentally made everyone bald and this movie would blow, and the sweating wasn't letting up.

And then...and then, thank God, I looked around. And I saw the crew. The spectacular crew. The artists and designers of this movie. The grips and technicians. I don't think any of them realized I was freaking out about inadvertently destroying a cherished sci-fi staple. No, they were too busy doing their jobs; I remember Michael Kaplan making some adjustments to his sublime costumes. Russell Bobbitt was unwrapping Nero's wicked-cool scepter. The flawless and tireless makeup department touched up the (hairless) actors. And there was Scott Chambliss, moving around his truly genius set – gorgeous and chilling at the same time (the set, not Scott); it was a massive modular design that would allow one room, one single stage, to serve as every location on what was meant to be a miles-long spaceship.

Watching the crew was a comfort I can't describe. It wasn't just a reminder that I was not alone. It was a reminder that I was surrounded by the most remarkable and inspiring group of filmmakers you could ever wish to work with. And I knew in that moment that the real reason I'd never been afraid on this film was entirely because of them. Because I was lucky enough to work with the absolute best in the business. To have producers like Damon Lindelof and Bryan Burk. A screenplay as lovingly written by Roberto Orci and Alex Kurtzman. I began to calm down on that wonderful set, lit by the incomparable director of photography Dan Mindel and overseen by the definition of perfection, first assistant director Tommy Gormley.

There are hundreds of other people, many of whom you'll meet in this book, who are responsible for *Star Trek*. I am so deeply grateful to them (and to Mark Cotta Vaz for doing such a splendid job celebrating them!), not only for doing their job so well, but for being there at all.

Especially on the day I realized that Robau, too, was bald. **ʌ**

J.J. Abrams
Los Angeles, 2009

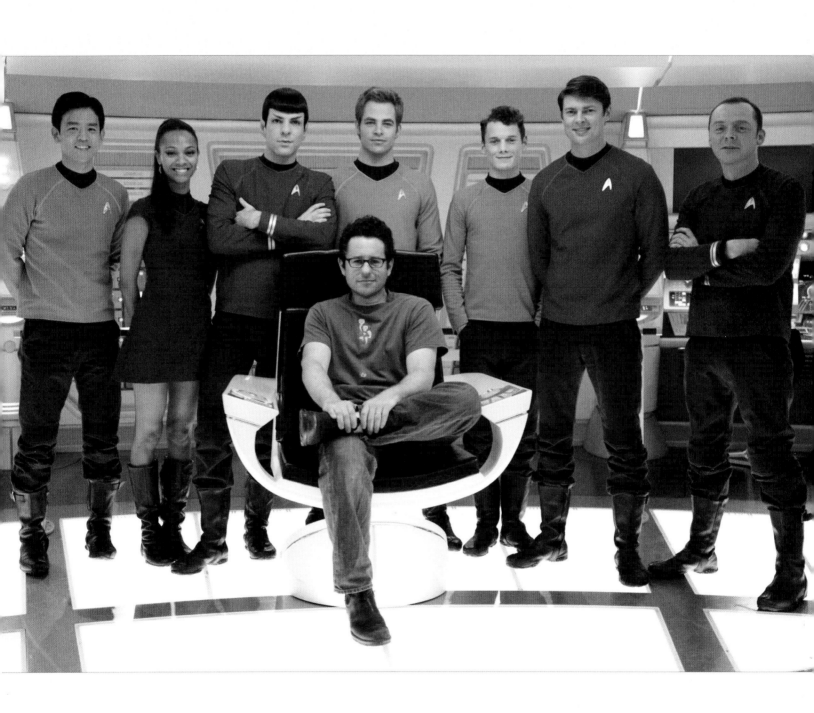

THE FUTURE BEGINS

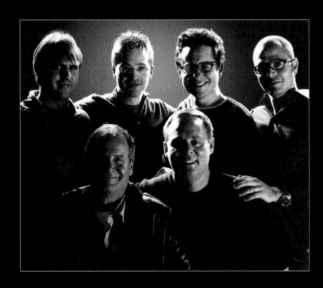

The new crew. Clockwise from top left:
writers/executive producers Roberto Orci and
Alex Kurtzman, director/producer J.J. Abrams,
producer Damon Lindelof, executive producers
Bryan Burk and Jeffrey Chernov.

Nothing much was happening in the *Star Trek* universe in 2005, but one stirring moment was the Special Recognition Award honoring the franchise at the 31st annual Saturn Awards held at the Universal City Hilton. "There was this palpable excitement in the audience," Bryan Burk recalled of the *Trek* portion of the May 3 event. "I had a passing conversation with J.J. that we should look at getting involved in *Star Trek*."

The initial reaction of Burk's colleague, Damon Lindelof, was that it was a terrible idea. "It just sounded like hubris," Lindelof said. "I held the franchise in high esteem and felt it should lay dormant for a while." But Abrams later asked Lindelof if there was a *Star Trek* story worth telling. "I said I wanted to see an origin story of how Kirk and Spock meet. J.J. was very receptive, and seemed to be thinking along those same lines. A couple months later, he called me and said, 'I think we're going to do this – do you want in? Do you want to produce *Star Trek* with me?' I couldn't say no to that!"

The first story meetings, which Lindelof pinpoints as early 2007, debated how to attract new fans who, after decades of *Trek* lore, had no "natural entry point into the franchise," Roberto Orci noted. The filmmakers also wanted to imagine the original characters as cadets at Starfleet Academy, create a new look for the starship *Enterprise*, and generally update the iconic trappings of the original show's 23rd-century world. "The fandom has been such a pivotal part of *Star Trek* staying alive, how do you do that sacrilege of re-casting these characters, what do you do with canon?" noted Orci, a life-long *Trek* fan.

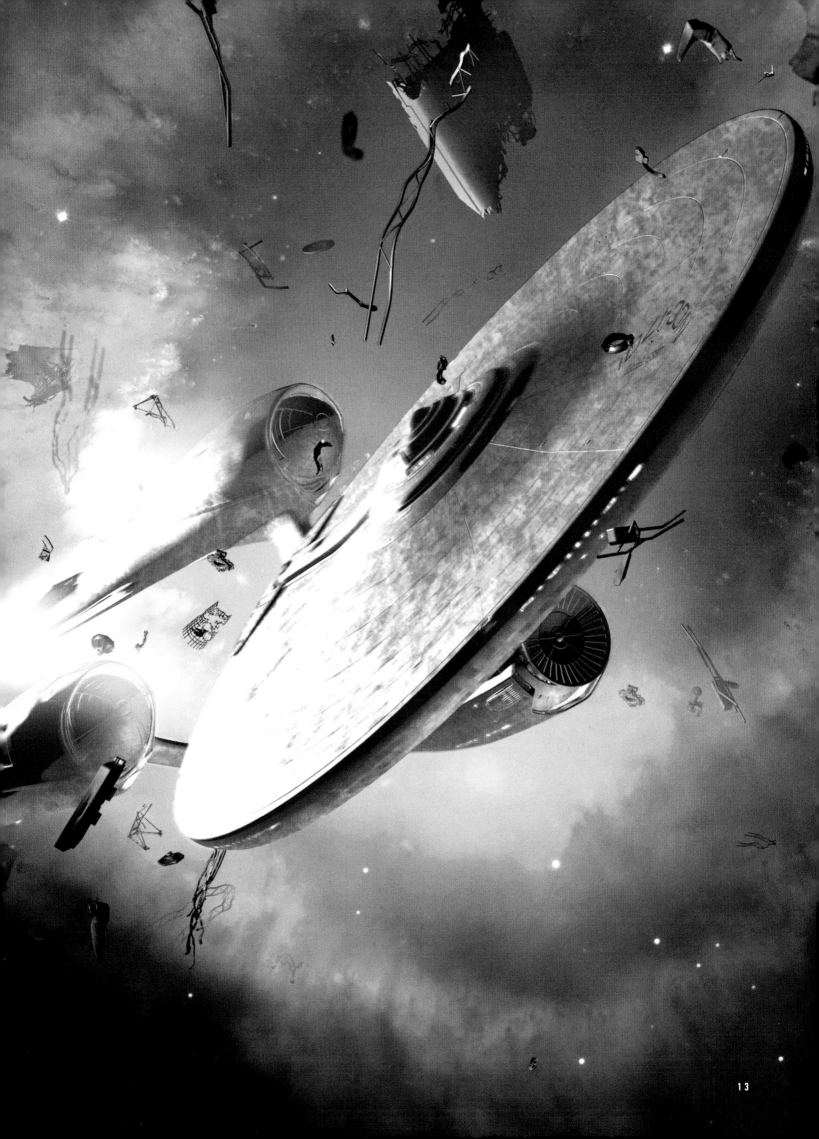

"It was a thrill to play an iconic character like Captain Kirk. Even better was the way J.J. and the writers went back to the beginning to tell the story of how Kirk met Spock. I think we also touched upon the Space Age roots of *Star Trek*, a time when nothing seemed impossible. That sense of optimism and exploration really seeped into the classic TV show and, I think, J.J.'s thinking for the 'reboot.' It's the spirit of adventure, and that's a timeless theme."

— CHRIS PINE

The answer was time travel, with Leonard Nimoy's Spock "the catalyst for change, the in-canon solution," Orci explained. The audacious plot set the original TV show continuity in the future, with an older Spock and an antagonist transported through a black hole into the past, causing a parallel reality that included planet Vulcan's destruction and the death of Spock's mother. "All these things are explained by the fact that Leonard Nimoy's original Spock character has slightly altered the universe," Orci observed. "Some of the best *Star Trek* episodes and movies have used the time travel device – but they've always re-set in the end. We chose not to do that, to buy ourselves freedom to continue on and explore strange new worlds."

Nimoy, however, hadn't played Spock in years and wasn't a sure thing. "He would be a huge 'get,'" Lindelof noted, "because *Trek* fans would know he wouldn't do it if the new production wasn't worthy of him. It was also a litmus test – if Leonard didn't want to do it, maybe it wasn't worth doing. If he said 'No,' we'd be screwed. It was like in a Western, where you ask the retired gunslinger to strap on the gun belt to save the town. We were going to ask him to put on the ears one last time for the sake of returning *Star Trek* to its former glory."

Nimoy agreed to a "pitch" meeting, and met with Abrams, Burk, Lindelof, Orci, and Kurtzman. "It was incredibly surreal and frightening," Lindelof recalled. "We were essentially pitching a Spock story to Spock!"

The screenwriters detailed story points, and Orci recalls an "amazing" moment when he mentioned Vulcan's destruction and Nimoy, Vulcan-like, raised an eyebrow. "Alex and I are telling him we're going to kill Spock's mother, for God's sake," Orci recalled. "We told him we were going back to the beginning, it's how Kirk and Spock meet, but the reason it's all happening a little differently is because your character – you, Leonard Nimoy – has come from the future, and we can't do [the movie] without that, otherwise it's sacrilege."

"He listened to the whole pitch, I had no sense how he was reacting," Lindelof noted. "I think he thought we were meeting with him as a courtesy, or about a cameo – not that the entire movie hinged on his participation! He got very emotional. I'd never been in a meeting like that, especially in a business where people play things emotionally close to the vest. He was basically saying, 'I hope you understand what you're asking of me.' He was about to explain when there was a knock at the door – it

"The notion of intergalactic exploration is exhilarating and unfathomable by many standards. But being part of such an exhilarating and optimistic franchise, that deals with that very notion, reaffirms a faith in humanity and allows one's imagination to color in all kinds of exciting possibilities. I think the diversity of the *Enterprise* crew, and the way they execute their missions, is full of plausible and viable ideas. I hope our species will be able to see the bigger picture and rise above our self-generated obstacles, that we transcend our own limitations."

— ZACHARY QUINTO

was J.J.'s assistant with lunch or something. The moment was forever lost! It was a very necessary icebreaker, but I'll always wonder what he would have said, had there not been that knock at the door."

Nimoy did ask to see a script. Kurtzman and Orci spent the next six months writing, and the screenplay was sent to Nimoy. Abrams recalls driving to pick up his kids when he decided to call Nimoy to ask if he liked it. "Oh my God," Nimoy began. It was, Abrams recalled, a *good* "Oh my God!"

"*Star Trek* took life the second Leonard said he was in," Burk noted.

Spock's younger self would be played by Zachary Quinto, with Chris Pine coming aboard as James T. Kirk. But as important as the many faces in front of camera would be the talent behind it. Most production principals were longtime collaborators with Abrams, notably production designer Scott Chambliss, whose work included the *Alias* TV series and *Mission: Impossible III*, Abrams' feature film directorial debut. Other *M:I:III* veterans who signed up for *Trek* included director of photography (DP) Dan Mindel and Industrial Light + Magic (ILM) visual effects supervisor Roger Guyett, who was also second unit director.

One key department head who had never worked with Abrams was costume designer Michael Kaplan, whose work included *Blade Runner*, *Flashdance*, and *Fight Club*. He had some "trepidation" about doing the film, but had agreed to meet the director at a coffee shop in Maine, where Abrams was vacationing. "I told J.J. I had only seen the TV series as a child and wasn't familiar with the movies. I knew how fervent the fans were, that it was a huge responsibility, and felt I would do them a disservice. He said, 'Perfect! That's what I'm looking for!' He wanted a fresh viewpoint. At the end of the meeting I had to say, 'Yes.'"

Abrams was fond of saying one couldn't just go film a *Star Trek* scene – *everything* had to be built. But, first, it all had to be designed. Chambliss began with a two-month research period, and charged concept artists Ryan Church and James Clyne with tracking the major design challenges. Both worked on the *U.S.S. Kelvin*, precursor to the *Enterprise*, but Chambliss generally cast Church and Clyne to their specialty. Church took charge of the *Enterprise*, while Clyne designed the *Narada*, the time-traveling Romulan ship which destroys the *Kelvin* (along with James Kirk's father, who briefly assumes command of the starship during the battle) and also featured a

"The very core strength of *Star Trek* was that it was about characters: about their differences and how when confronted with a common issue or problem, they can work together and solve it to the benefit of everybody involved, to the best of their ability. The longevity and success of the franchise is really a testament to the strength of those friendships."

— KARL URBAN

laser drill to implant "red matter," the stuff that sucks planets into oblivion. "I got the good guys, James did the bad guy stuff," Church summed up.

"We started turning out concept image after concept image to get the dialogue rolling with J.J., and I started bringing in art directors and set designers to begin working together," Chambliss explained. "Set designers who were drawing [architectural plans] digitally, fed those files to the eight or nine illustrators I had working who used them in their drawings, and vice versa. It was a process of discovery. What are the structural elements, color palette, mood? There was also the idea this was a positive future and, hopefully, believable enough that we could go in this direction as our own future. That was enough of a framework to start my journey."

For the conceptual leads, the beginning was all "blue sky." "There's no real boundary, you're doing rough sketches," Clyne explained. "I try to stay within that world as long as possible."

"We had discussions about how people today have more high-tech stuff in their cars than anything in the TV show or the later movies," Church laughed. "So, we had to push things *way* out there."

Also involved from the blue sky period was David Dozoretz, the "previz" lead who came aboard in May of 2007. Traditionally, hand drawn storyboards explore shot dynamics and composition, but previsualization takes shots into motion with computer graphics (CG) characters, environments, and virtual camera moves. "Previz is never meant to replace storyboards, it augments them," noted Dozoretz. "The tools have come a long way, but it's basically a fancy pencil. The litmus test is whether the story of the shot is being told. I worked closely with Scott, Ryan, James, and all the guys I've worked with over the years. They'd feed us great drawings and concepts and we'd build digital models to see them in depth, scale, and movement."

The first goal for the conceptual leads was to create "form language," the rough shape or silhouette that cracks a concept. The *Narada* only needed a few iterations before it won Abrams' approval. Clyne happily went to his "dark side" and created his own back-story. "My idea was it started as a typical Romulan ship, but during time travel became host for a virus that, in a symbiotic relationship, formed and created this spiky object, almost like an organism, that is splitting the old ship apart. I created

"My personal reflection on space exploration is that we need to continue feeding our precious evolution. The same way we evolved from primitive life forms, we should evolve in our exploration of Earth and space."
— ZOË SALDANA

a lot of bracing and bracketing, as though they're trying to hold this thing together. We wanted to stay away from it being too organic, but the flow and shape of it resembled a sea creature, an eerie crustacean."

In contrast, the *Enterprise* would be a sparkling new starship taking its maiden voyage. Church's initial concepts ranged from a simple updating of the iconic silhouette of saucer and nacelles, to pushing an entirely new design. Although Church favored pushing it, he describes the final look as a "minor re-skin of the original starship."

Church concurrently designed a new *Enterprise* bridge, which Chambliss recalls as the toughest design of the production. An early version had the traditional layout, including central captain's chair and view screen, but looked too sleek. Other designs strayed too far from the TV show. Chambliss decided to do a little time traveling himself, taking elements from the "sleek" pass and combining them with inspirations from influential designers of the 1960s and '70s, including architect Eero Saarinen, whose work includes the swooping, sculptural form of JFK Airport's TWA terminal. Tapping into period designers, part of the cultural milieu in which *Star Trek* originally existed, helped "approach the whole visual world of *Star Trek* seriously," Chambliss concluded.

The design watchword became "retro," an evocation of a 1960s version of the 23rd century, but using new millennium technology. "Makeup techniques and products have advanced since the original series, so we needed to move the look forward using current innovations, techniques, and products," makeup department head Mindy Hall noted. "My goal was to bring the look back to the original TV series, but with fresh eyes." It was also at this point that Chambliss's longtime key collaborator set decorator Karen Manthey joined on as a major contributor, diving into the virtually unlimited possibilities of what materials, details and processes the future might embrace.

A driving force throughout was the director's "marching orders," Dozoretz recalled: "I want it to look and feel real." An example was the "space jump," a thrill-ride sequence where a trio led by Kirk dive from a shuttlecraft and parachute onto the laser drill platform the *Narada* has dropped into Vulcan in the first stage of its destructive mission. Dozoretz prevized the sequence, which was overseen by

"Space remains the great mystery. As the Earth grows smaller in terms of travel and communications, the curiosities of the cosmos grow ever more intense. One thing we humans dislike is not knowing. Ironic, then, that we're surrounded by a colossal unknown. Our desire to 'boldly go' is entirely logical, as Spock would say. We have a long way to go before we are as integrated a species as our *Trek* descendants, but the fact that so many people have passionately responded to *Star Trek* over the years demonstrates a belief in the idea and desire to see it come true."

— SIMON PEGG

producer Lindelof. "The idea was how would you really film someone skydiving from space?" Dozoretz noted. "Well, you'd have another skydiver with a camera, probably mounted to his helmet. An exciting notion for us was imagining starting in the calmness of space and then, when you hit the atmosphere, you get sound, wind resistance, the camera starts shaking."

Neville Page, a creature designer who conjured the rampaging monster of *Cloverfield*, a 2008 Abrams production, also had real world concerns for the creatures that bedevil young Kirk when he's stranded on the lonely, dangerous world of Delta Vega. Page's mantra: "Form follows function." "In a film, a mythical creature with a lion's head and scorpion tail would look nutty," he explained. "Designing creatures is not rocket science! You can't fool people about textures, fur, movement. It's just built into us to accept something that is plausible. You have to approach a creature design as if it were a real thing, it has to be biologically sound."

Once designs went into production, there was also the concern for seamlessly blending what would be physically produced and what would become synthetic ILM creations. Spaceship interiors, for example, would become physical sets for live-action filming, while views of the ships from space would be realized as three-dimensional CG models. Ultimately, the budget could not accommodate physically building all that was envisioned. "The foundation rule is to adhere to the design concepts and, with a guy like Scott, we had so much visual information," DP Mindel said. "The question became what to translate."

"It quickly became apparent the scale of the movie would take up two entire lots of stages, as opposed to the five stages we had at Paramount," Chambliss noted. "At that point we started going for locations."

Location work included building part of the *Narada* drill platform in the Dodger Stadium parking lot for the fight scene portion of the space jump sequence, with ILM completing the rest digitally. The rugged and rocky location of Vasquez Rocks served as Vulcan, with ILM adding fantastical touches. Some locations were dressed for make-believe — a Budweiser beer plant became the inner workings of the *Enterprise*, while a 1930s power plant became the *Kelvin* engine room.

The main *Kelvin* soundstage set, Dan Mindel notes, was the first ship he filmed in. "The *Kelvin* was a try-out for us. It had less sleek fixtures, different kinds of

"As an Asian-American, Sulu was a pioneering image for me. There were very few roles then for Asians that weren't martial arts or stunts, and he had this very exemplary role on an outstanding show as a really fascinating person who had so many interests and skills. For me, there was a real headiness in becoming part of this new adventure."
— JOHN CHO

lighting. In contrast, I wanted the *Enterprise* to feel like a brand new car, everything shiny and new, using lens and lights to give it a twinkling, almost glittering effect."

James Clyne's art became part of the live-action *Narada* set, his renderings of the interior blown up into huge backings to provide scale and depth beyond the foreground set pieces. The commander of the *Narada*, Captain Nero himself, heartily approved the vessel. "It's a badass ship," said actor Eric Bana, who played Nero. "When I walked on the set, I couldn't believe it. I love mechanical things, and with all its exposed wiring and everything you could see how the whole structure was put together. It was an amazing design."[2]

But with so much that still had to be created by ILM in post production, the look of entire sequences, with the exception of previz imagery, were a mystery during principle photography. "Scott Chambliss and Michael Kaplan had a tremendous amount to do with the look of everything," explained ILM's Roger Guyett. "But a big challenge was creating the huge space visuals, those moments in-between [live-action]. You'd shoot on a set and cut to something intangible, which might be described in the script as 'space battle.' Every shot is important in telling the story, and you literally had these big holes in the movie."

"The challenge is what you don't see," Dan Mindel agreed. "It takes a lot of conversation in order to make a seamless balance between what is real and not real, that it all blends and feels completely natural. Obviously, things happen on the fly, but usually Roger and I would take the conceptual drawings and decide, in advance, how we were going to do something, or I'd give Roger enough latitude to do what he's going to do in the CG world. Roger might say, 'Dan, think about what is out the *Enterprise* window at this point.' So, on set, we'd shoot it to feel interactive, adding flashes of color changes as if something is going on outside the window, so when Roger filled in those blanks it felt like something was really happening."

That kind of collaboration extended throughout the production. Michael Kaplan, for example, did not design costumes in a vacuum — an actor's final wardrobe had to work with hair and makeup. The latter department included the off-set work of the Proteus Make-up FX team, Neville Page's Romulan tattoo design work, and Joel Harlow and Mindy Hall handling everything on set, with Hall "master and

"Walter Koenig told me that in order to make a character great, you have to make him your own. That's the whole approach that J.J. took as well, and it influenced everything on this movie, from the wardrobe to our performances. J.J. took all the strongest elements from the past and mixed them up with his own epic vision."

— ANTON YELCHIN

commander," as Page playfully dubbed her. "We were asked to work as one department, blended and borderless," Hall recalled. "I was responsible to J.J. and the producers for this small village of artists, but we all had a voice. The closeness was essential for the team to R&D designs and arrive at a final look. I am very proud of how we all pulled together."

As ILM began building models and environments in the digital realm, their work became intrinsic to the overall design. "You might have an impressionistic stroke of what something looks like, but building it is the difference between a concept and an architectural plan," Guyett explained. "Designing a movie like this gets down to details like landing lights for the shuttle bay." Guyett hailed ILM art director Alex Jaeger as the one who took production designs and "turned them into something real."

"We always work with the production department as early as possible, and carry the 'book' for the look of the film into the visual effects," Jaeger explained. "Once that world, which has lived in concept art, has begun to live in sets, actors, and costumes, we try to bring everything up to that level of detail. But a lot of design changes can happen as we take an illustration into the real world."

When the *Narada* was under construction at ILM, James Clyne stayed with the ship, an example of how conceptual art, once restricted to pre-production, had become integral to the entire production process. "The *Narada* design was never really finished until ILM was well into it," Clyne noted. "The film industry is becoming more dependent on what conceptual artists do. Because of today's technology, whatever we dream up we can put on screen."

"It's beyond me...the integration of the sets with the extraordinary visual effects that are in this film," marveled Nimoy of technology far advanced from any of the previous *Trek* movies he starred in or directed.[3]

And every sequence was composed of a myriad of complex details. J.J. Abrams notes one — the eye blink of an alien *Kelvin* crew member. "That was a mask, ILM put in the blink [digitally], which gave the scene life. That's an example of the crazy layers of things you have to consider for a scene to work, because that location isn't real, can't be found, doesn't really exist."

"An example of Scott Chambliss' attention to detail was these [overhead] hand rails throughout the *Kelvin* bridge," Burk added. "No one touches them, you

'The positive vision of the future in *Star Trek* is a major factor in its continued acceptance, generation after generation. Remember, the *Enterprise* is manned by an interplanetary crew, which signals the possibility of a multi-cultural, multi-racial crew working in harmony as professionals to solve problems. 'A consummation devoutly to be wished.'"
— **LEONARD NIMOY**

wouldn't even notice them. But the idea was if there was turbulence you'd have something to grab onto. A friend of mine, a huge *Trek* fan, visited the set, saw the rails, and said, 'Oh, my God – this is going to work!' There was a rationale behind everything, a functionality. J.J. and Dan Mindel flared the lens, which ILM not only matched in the visual effects, they took the extra step of adding the little imperfections when light hits a lens."

Many ideas never advanced beyond concepts, including a Ryan Church sequence of Spock lost in a strange Vulcan forest, a Dozoretz previz for an early idea of opening the film with Earth's destruction, and a gladiatorial arena within the *Narada* where Nero and his sadistic court were to be entertained by alien prisoners in combat.

But everything evolved on the creative journey from idea to final image. Damon Lindelof had an early teaser trailer idea of two kids running to a hilltop to look down upon the construction of the *Enterprise*. That idea was ultimately realized as those muscular welders busy with the starship's construction, which was conceptualized by Dozoretz's previz team.

Then there was the notion of a "lightning storm in space," the phenomenon that precedes the cosmic singularity from which the *Narada* emerges. "J.J. kept saying 'What does that even look like?'" Lindelof recalled. "I said, 'I don't know what it looks like. Why don't you say "lightning storm in space" to someone you trust and see what they come back with?' And, lo and behold, that's what happened!"

The conceptual art became a vital resource for not only the various production departments, but the actors. "It is very important for me to look at conceptual production art when shooting a movie, especially for *Star Trek*," said Zoë Saldana, who played the classic character Uhura. "It gave me an idea of what to expect, it set the tone of how a scene should be carried."

"We weren't limited to the hard rules for what had been designed in the past," Clyne concluded. "J.J. really gave us the push to make this world sing."

The feeling, from the director's standpoint, was mutual: "In *Star Trek*, everything was up for grabs, whether it was production design, wardrobe, makeup, visual effects – there was so much to consider! All of the departments helped make

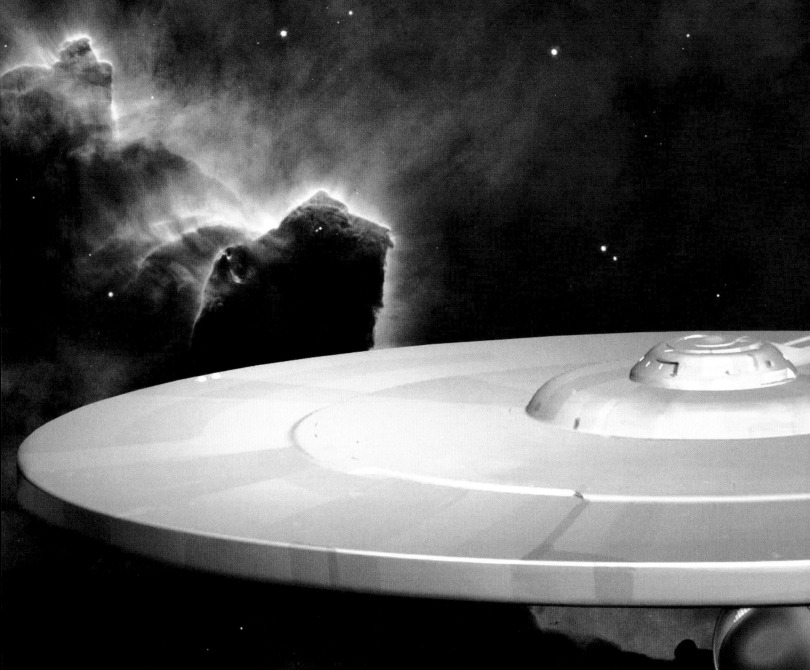

U.S.S. KELVIN

The *Kelvin*, precursor to the *Enterprise*, began with a "submarine-like, almost Soviet-era design," J.J. Abrams explained. "The *Kelvin* and *Enterprise* both have a retro feel," production designer Scott Chambliss added. "The *Kelvin* recalls sci-fi of the '30s through '50s, the *Enterprise* the sleek futurism of the 1960s and early '70s."

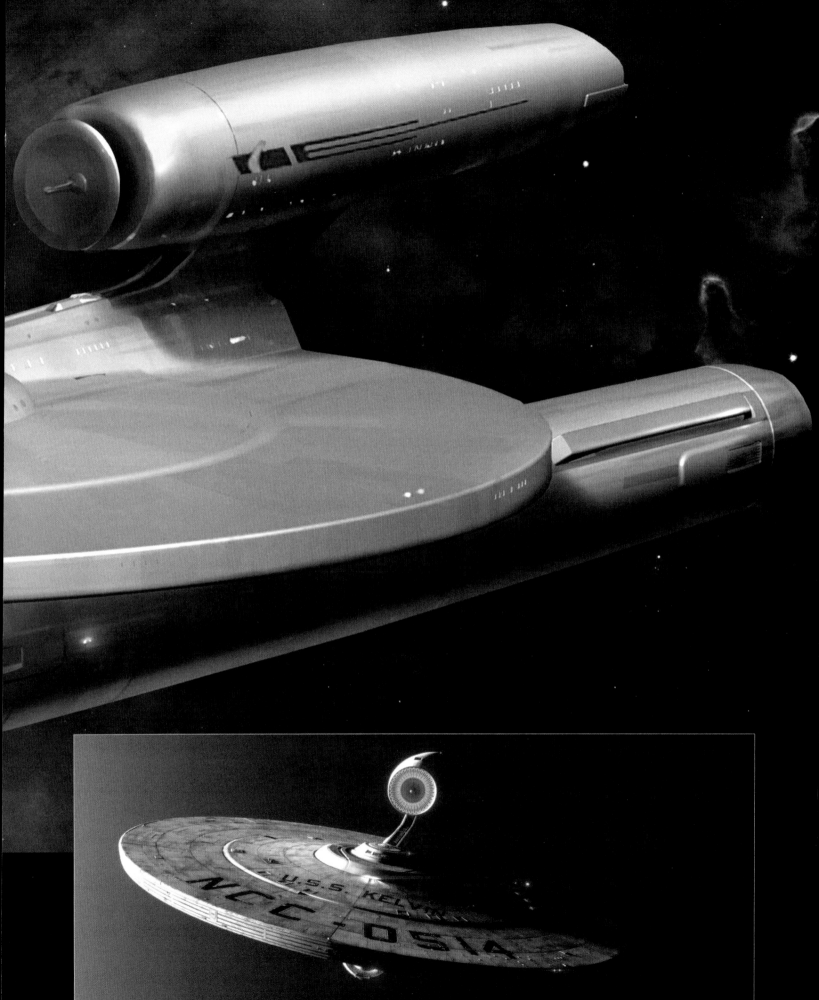

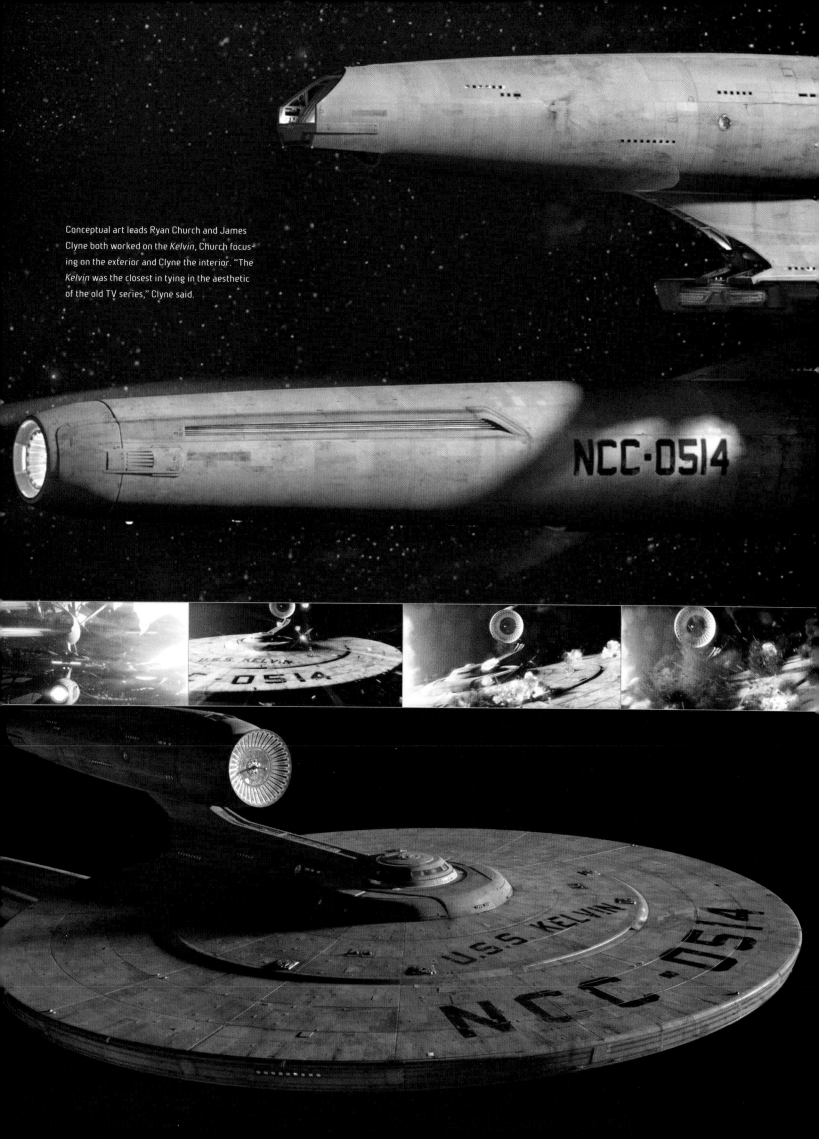

Conceptual art leads Ryan Church and James Clyne both worked on the *Kelvin*, Church focusing on the exterior and Clyne the interior. "The *Kelvin* was the closest in tying in the aesthetic of the old TV series," Clyne said.

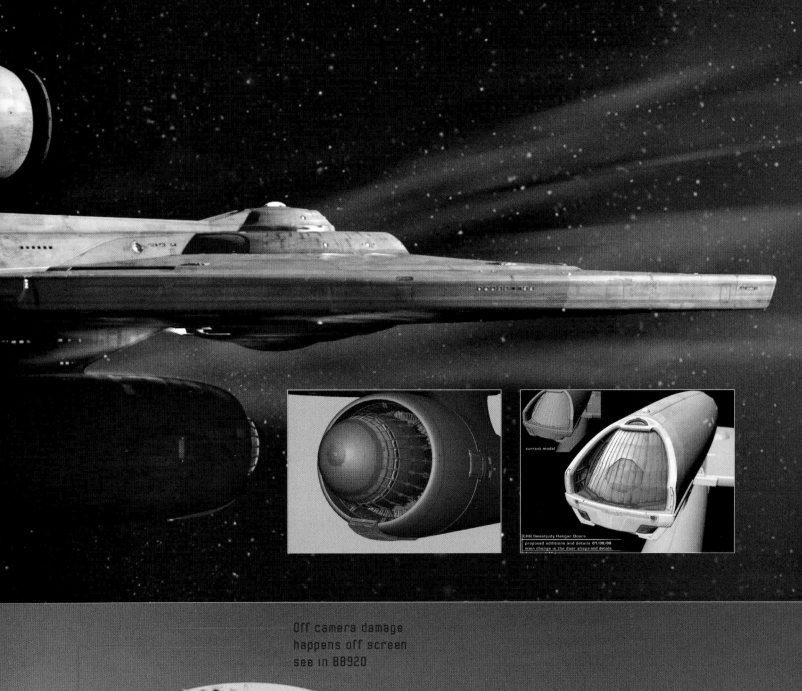

current model

CHQ Sweetjudy Hangar Doors
proposed additions and details 01/08/08
main change is the door shape and details

Off camera damage
happens off screen
see in BB920

First torpedo strike
happens in BB110

Second Torpedo strike
happens in BB170

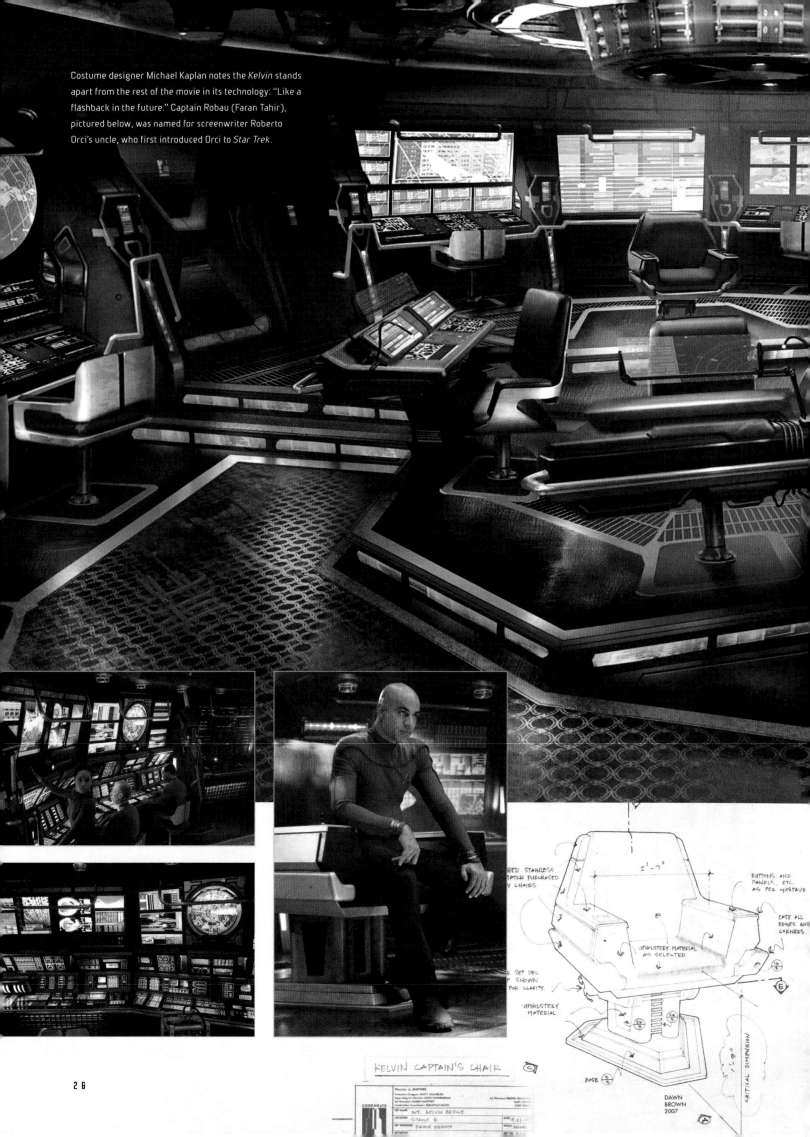

Costume designer Michael Kaplan notes the *Kelvin* stands apart from the rest of the movie in its technology: "Like a flashback in the future." Captain Robau (Faran Tahir), pictured below, was named for screenwriter Roberto Orci's uncle, who first introduced Orci to *Star Trek*.

KELVIN CAPTAIN'S CHAIR

DAWN BROWN 2007

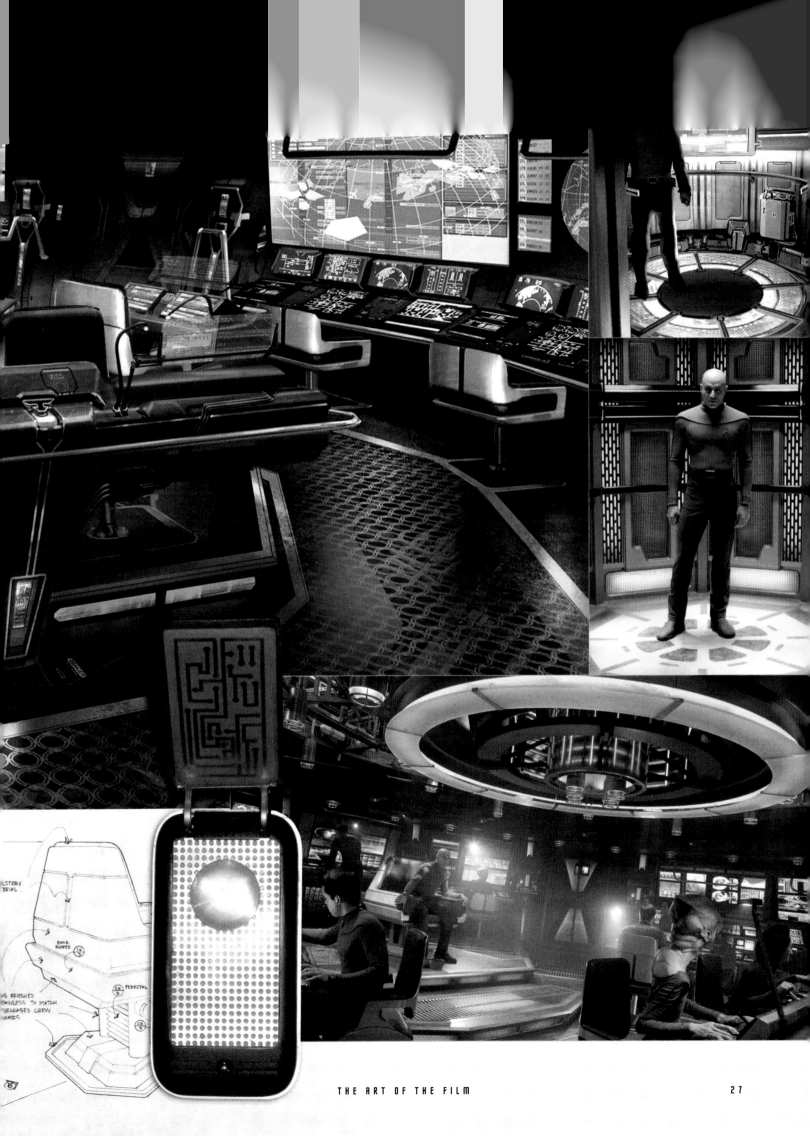

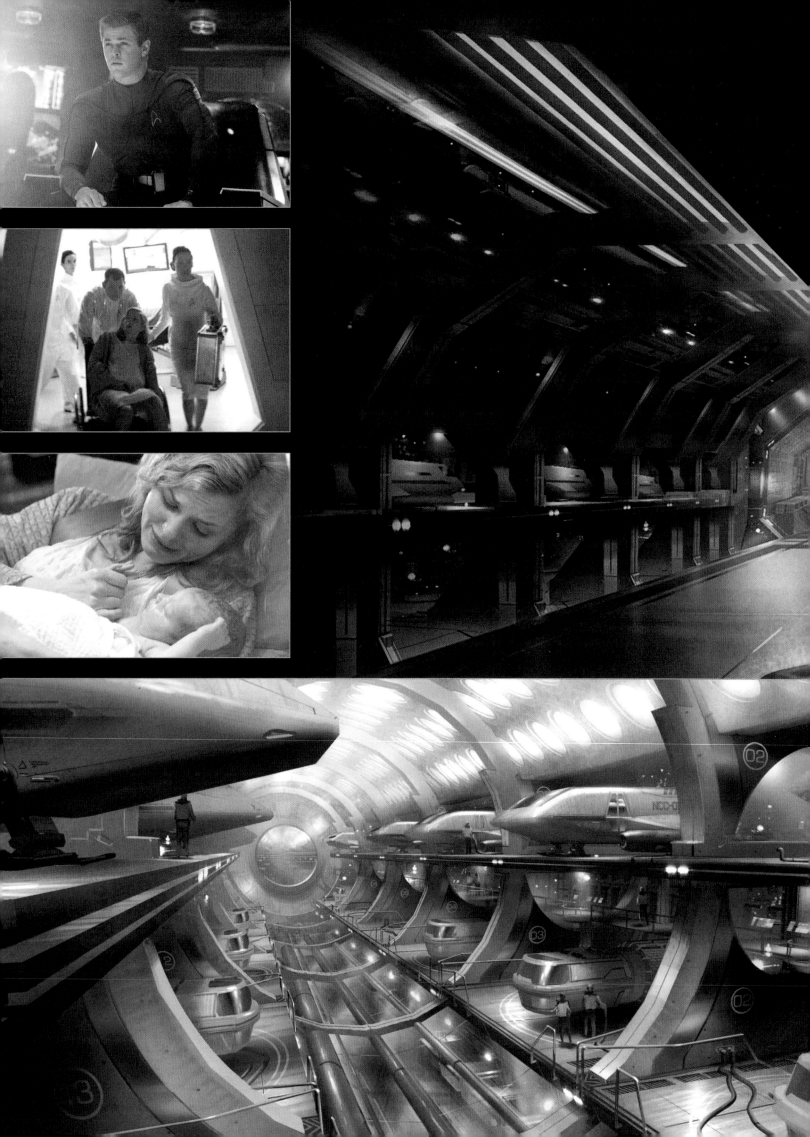

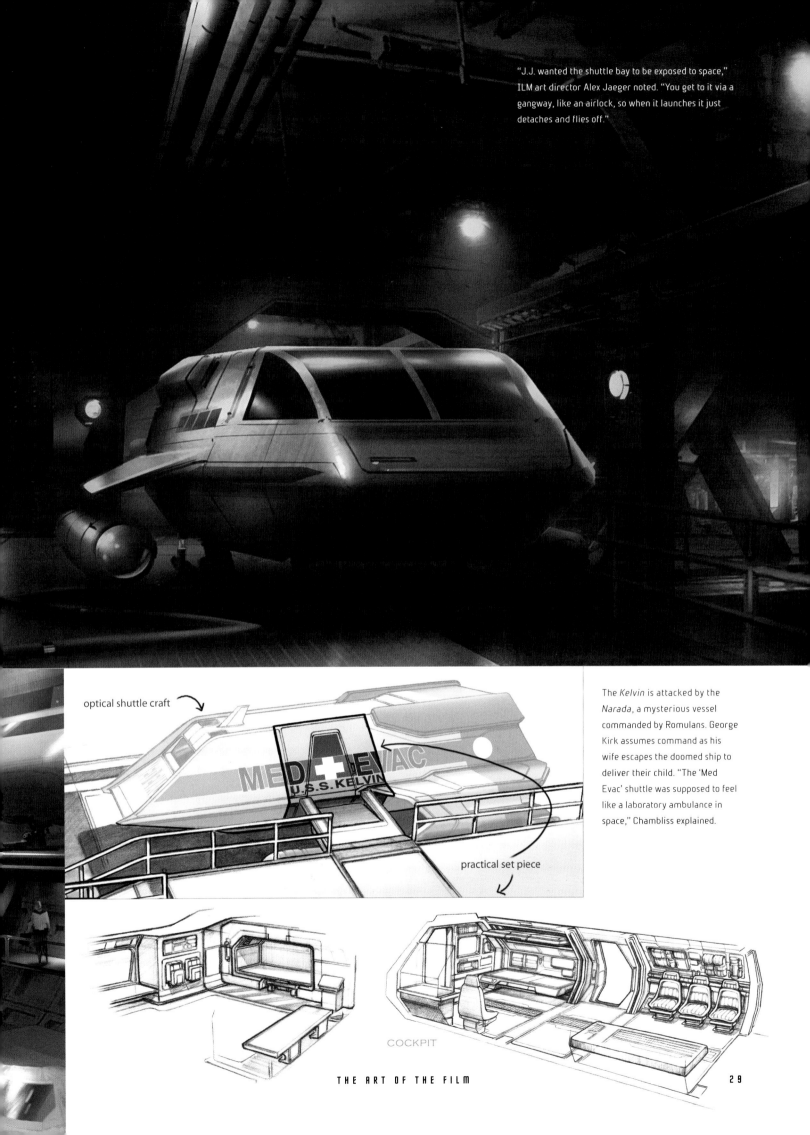

"J.J. wanted the shuttle bay to be exposed to space," ILM art director Alex Jaeger noted. "You get to it via a gangway, like an airlock, so when it launches it just detaches and flies off."

optical shuttle craft

MED EVAC
U.S.S. KELVIN

practical set piece

The *Kelvin* is attacked by the *Narada*, a mysterious vessel commanded by Romulans. George Kirk assumes command as his wife escapes the doomed ship to deliver their child. "The 'Med Evac' shuttle was supposed to feel like a laboratory ambulance in space," Chambliss explained.

COCKPIT

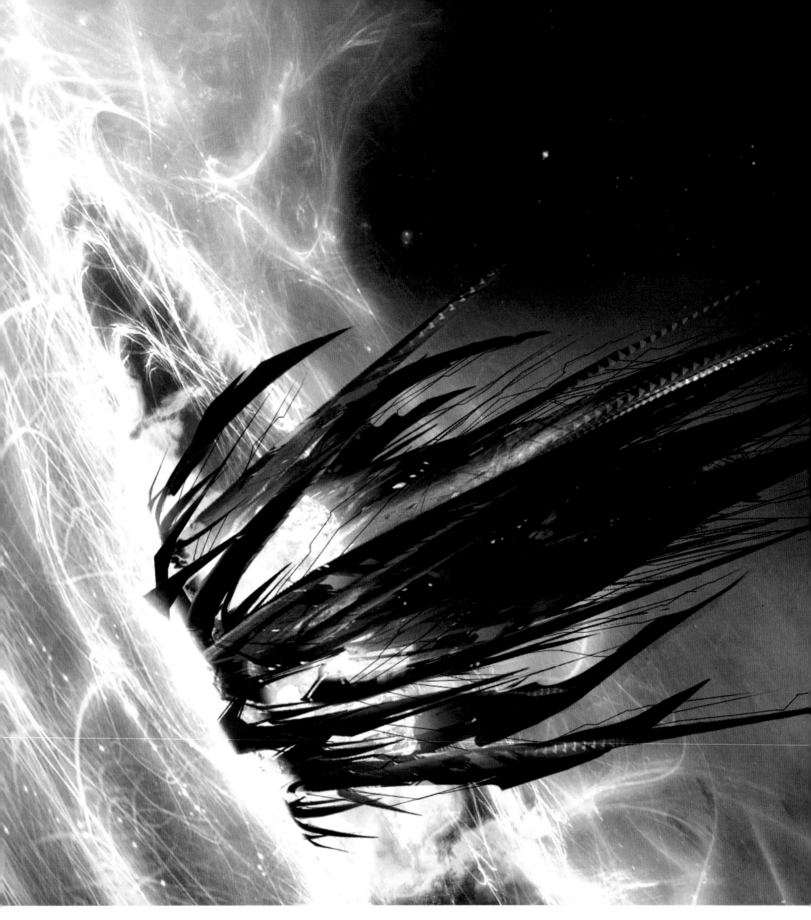

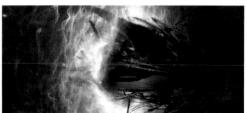

NARADA

The *Narada*, a former mining vessel commanded by Captain Nero and a rebel band of Romulans, comes from the future with "red matter" that can generate a black hole or, when bisecting an object, obliterate planets. "Scott wanted to make sure the *Narada* wasn't symmetrical, in contrast to the perfect symmetry of the *Enterprise*," said James Clyne, lead designer of the ship.

"J.J. has this interest in magic, and we played a visual trick with the black hole," ILM's Roger Guyett added. "During the previz we had the black hole as a 2-D image, so J.J. had an idea that when you travel from one side to the other, it's revealed as two-dimensional."

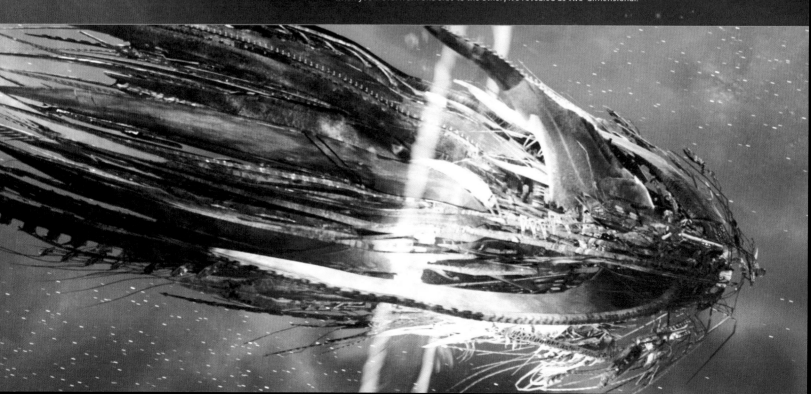

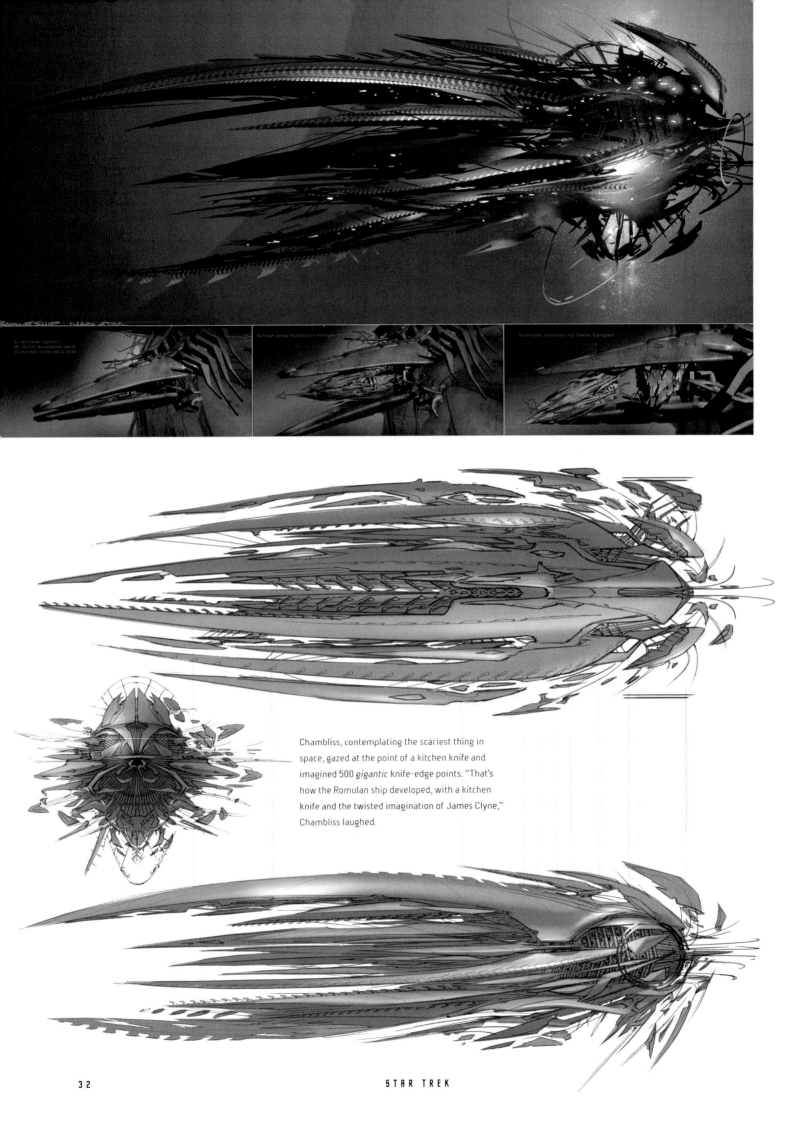

BATTLESHIP NAB ATA
1. doors open
2. Arm snakes out
3. head adjusts tilt

4. top and bottom hinge

5. Pods swivel to face target

Chambliss, contemplating the scariest thing in space, gazed at the point of a kitchen knife and imagined 500 *gigantic* knife-edge points. "That's how the Romulan ship developed, with a kitchen knife and the twisted imagination of James Clyne," Chambliss laughed.

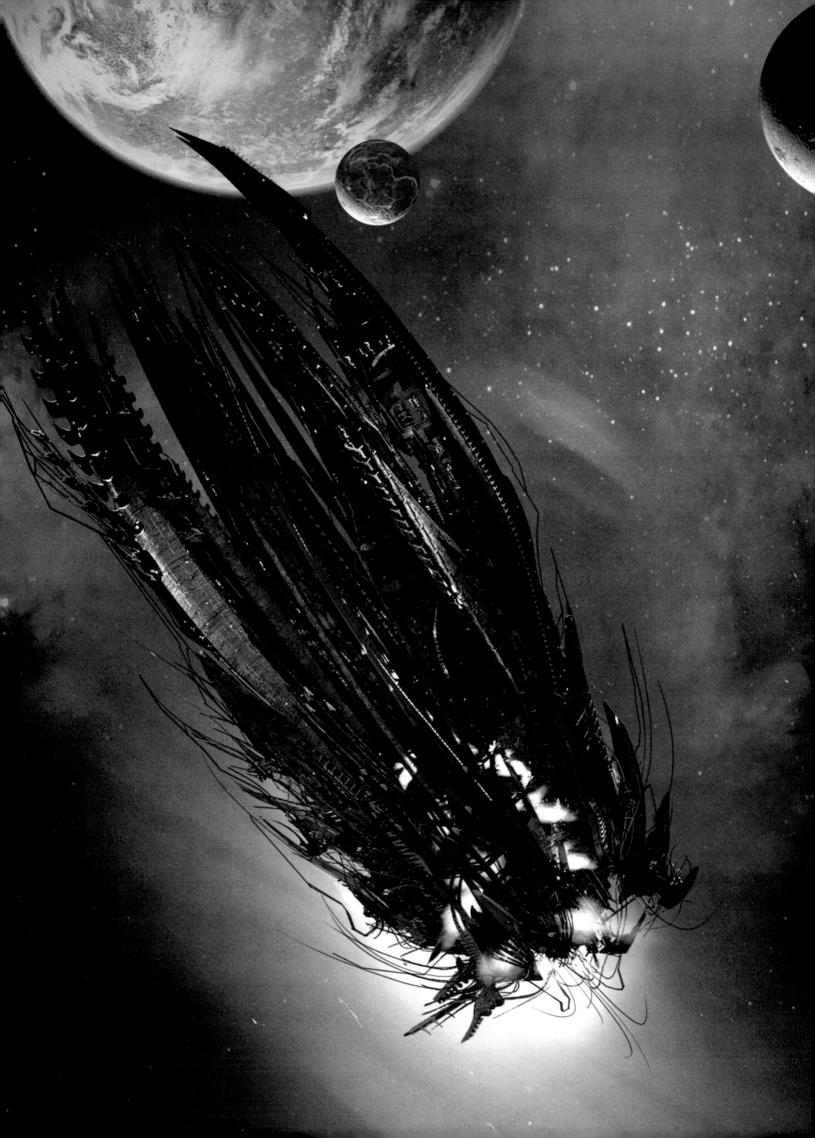

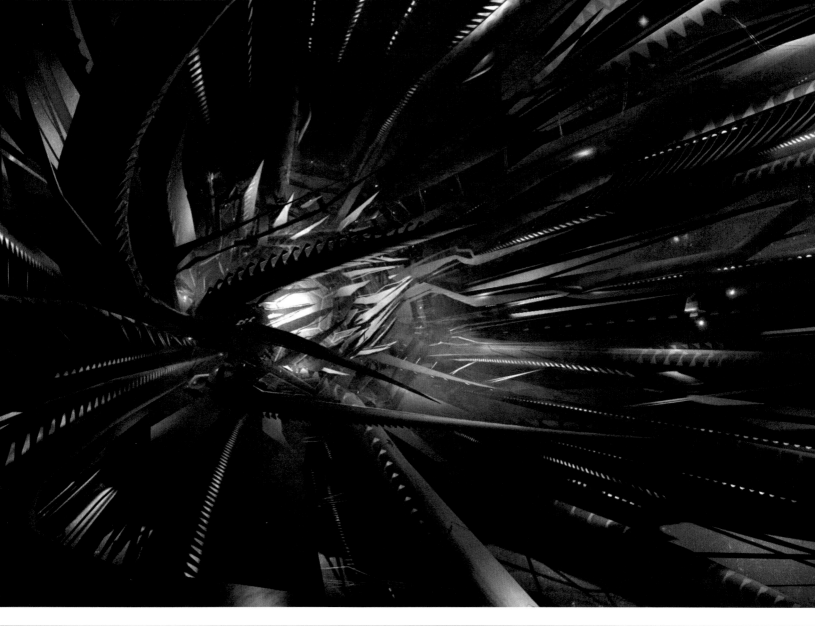

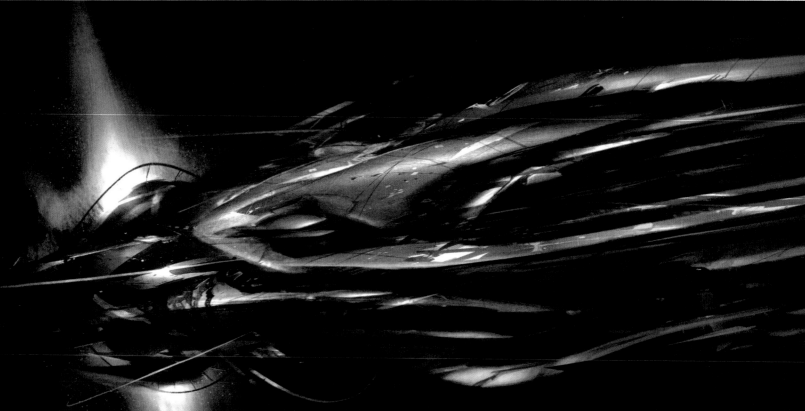

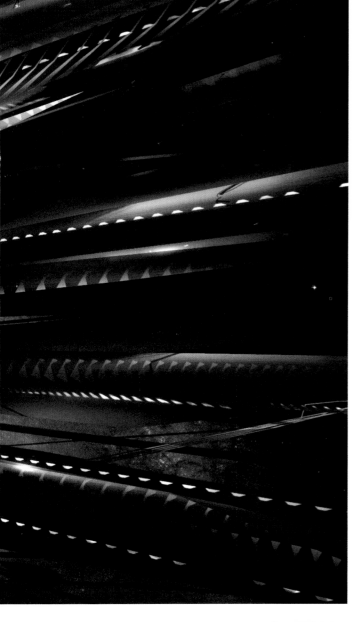

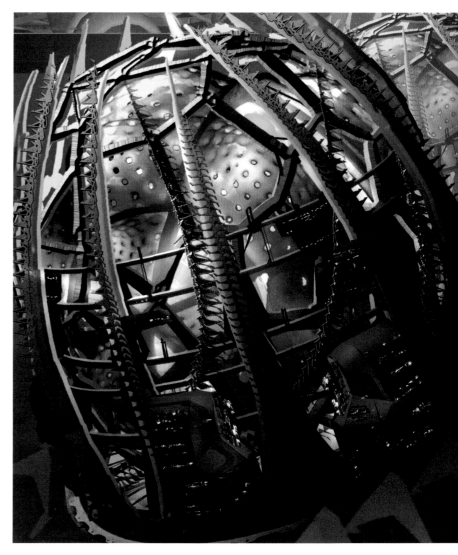

Clyne's *Narada* designs were taken into practical detail by ILM art director Alex Jaeger. Below: "CHQ" means "Corporate Headquarters," code name for the production, while "Hanson's Ranch" was code for *Narada*.

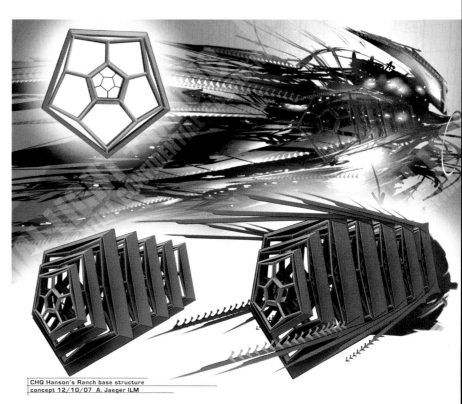

CHQ Hanson's Ranch base structure
concept 12/10/07 A. Jaeger ILM

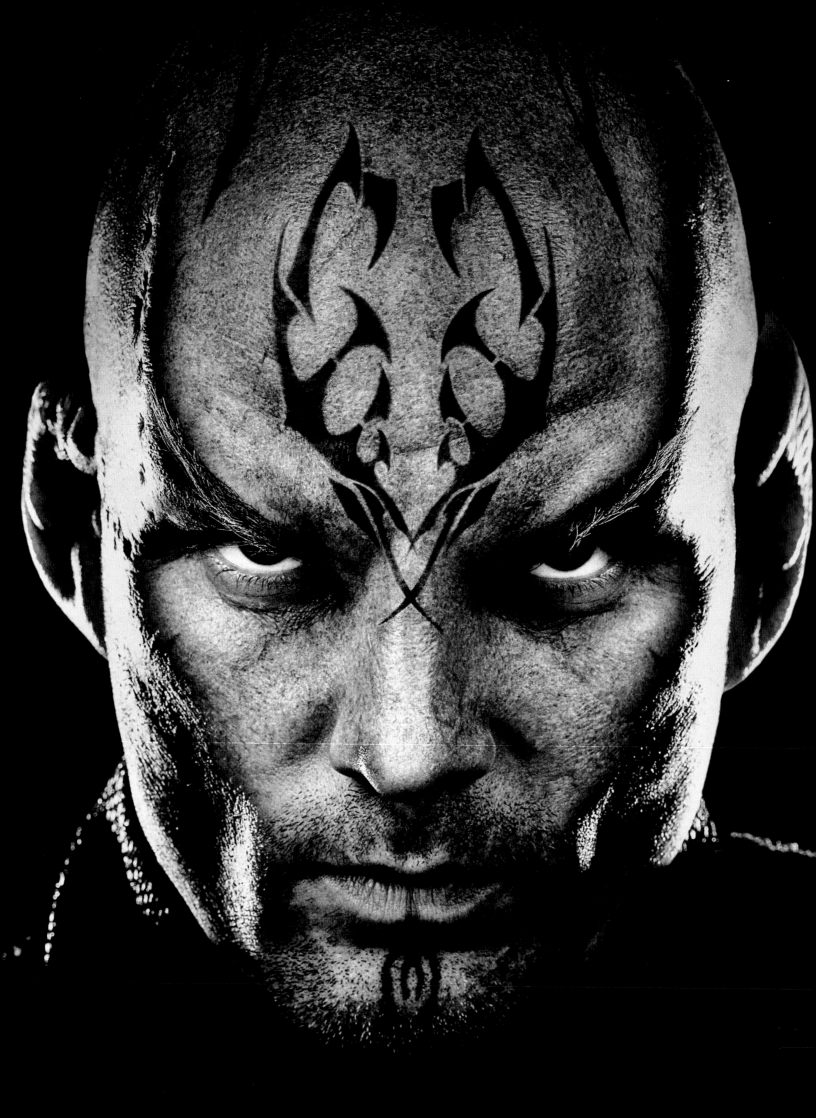

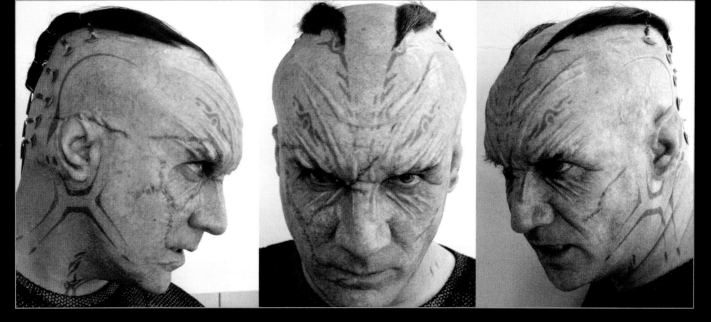

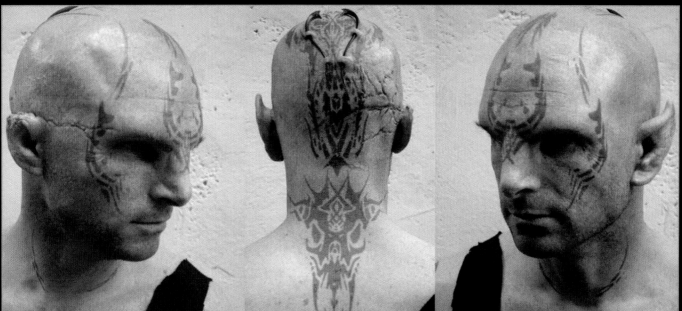

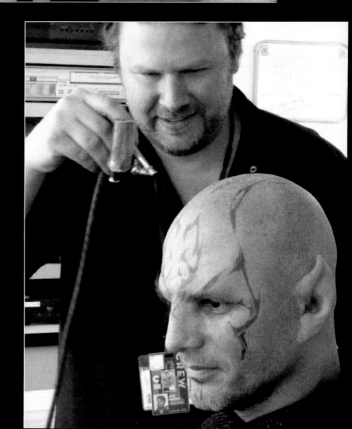

ROMULANS

Captain Nero, commander of the *Narada* (Eric Bana pictured opposite and right, with make-up co-supervisor Joel Harlow), was the "hero" design for the Rorschach test-like tribal tattoos which integrated with the ear and forehead prosthetics created by Joel Harlow Designs. Some forty main Romulan characters were created for camera, a process that began with lifecasts for each actor. Once the individual prosthetics were created and ready for filming, Harlow's team applied them, finishing by adding the tattoos, which were digitally designed by Neville Page.

"The tattoos were a transfer process, like you'd find at an amusement park, only much more expensive," Page said. "The results look tribal." Each had to perfectly conform to an actor's face, a laborious process of testing on the lifecasts and digitally adjusting each design. Page's final artwork was sent to Tinsley Transfers, which fabricated the sheets of paper for a couple of hundred tattoos, Page estimated.

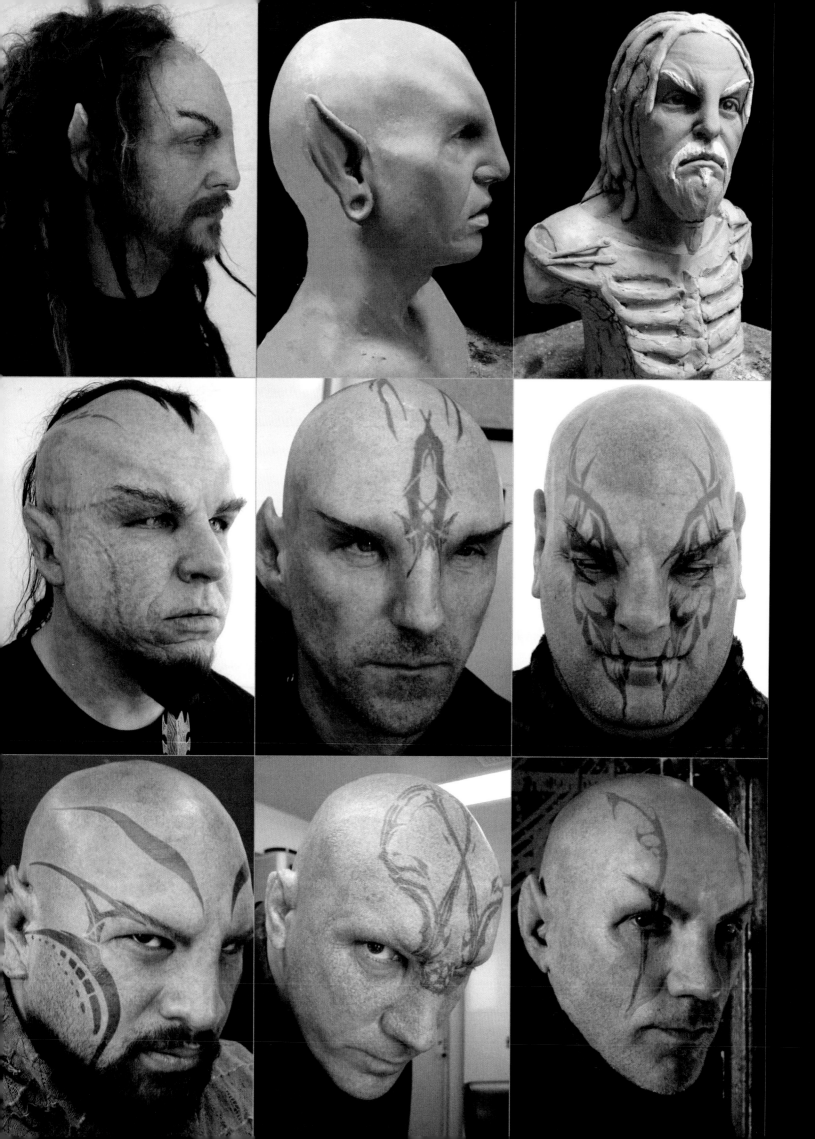

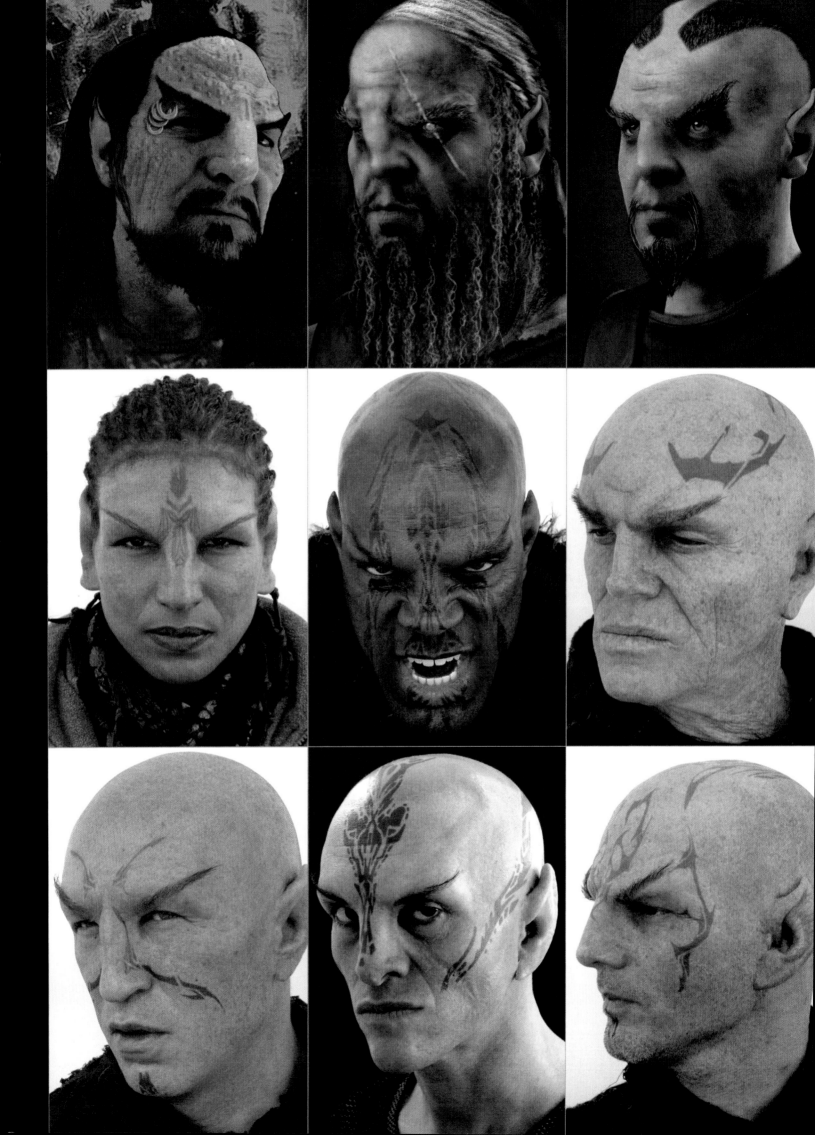

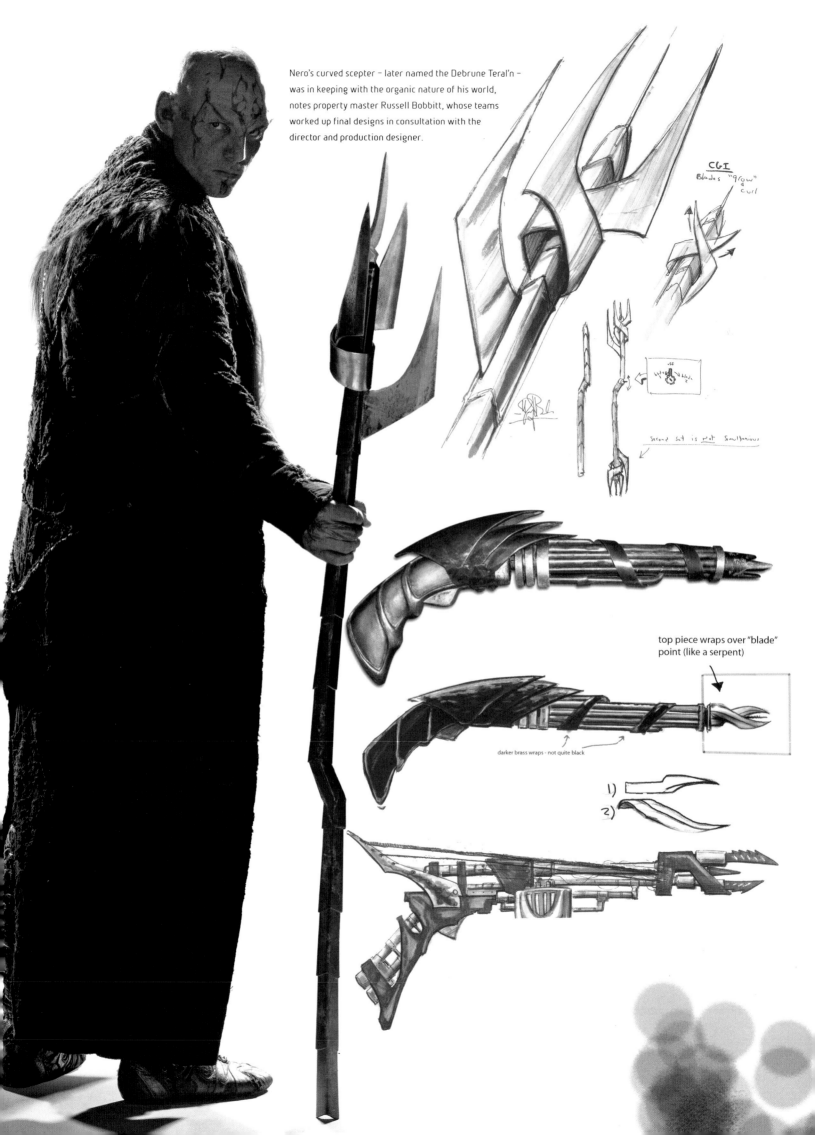

Nero's curved scepter – later named the Debrune Teral'n – was in keeping with the organic nature of his world, notes property master Russell Bobbitt, whose teams worked up final designs in consultation with the director and production designer.

CGI
Blades "grow" and curl

Second set is not simultaneous

top piece wraps over "blade" point (like a serpent)

darker brass wraps - not quite black

1)
2)

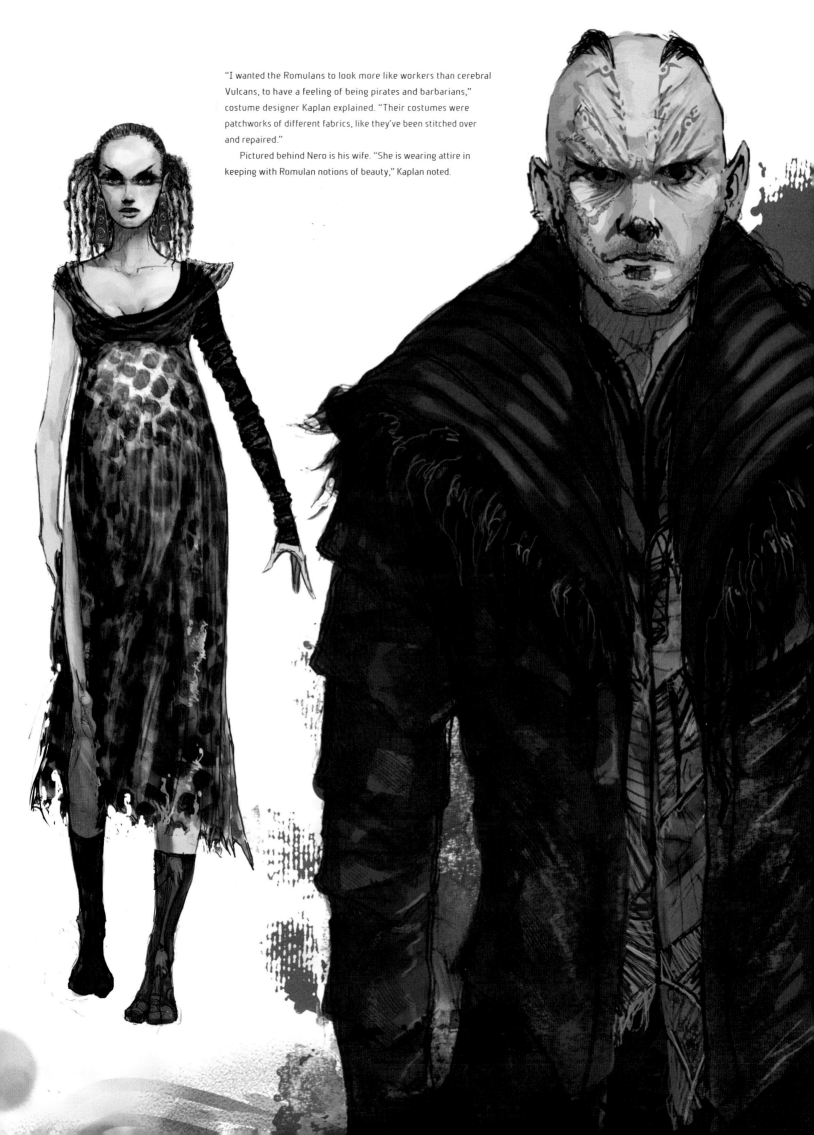

"I wanted the Romulans to look more like workers than cerebral Vulcans, to have a feeling of being pirates and barbarians," costume designer Kaplan explained. "Their costumes were patchworks of different fabrics, like they've been stitched over and repaired."

Pictured behind Nero is his wife. "She is wearing attire in keeping with Romulan notions of beauty," Kaplan noted.

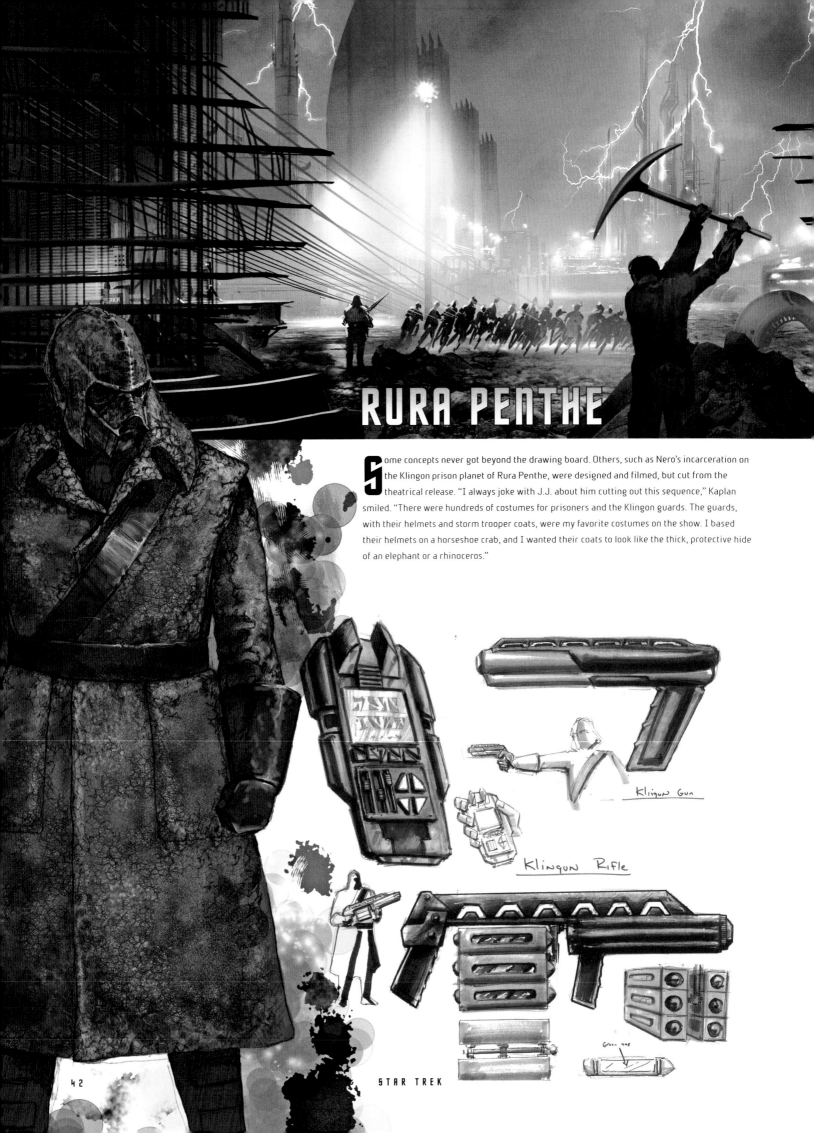

RURA PENTHE

Some concepts never got beyond the drawing board. Others, such as Nero's incarceration on the Klingon prison planet of Rura Penthe, were designed and filmed, but cut from the theatrical release. "I always joke with J.J. about him cutting out this sequence," Kaplan smiled. "There were hundreds of costumes for prisoners and the Klingon guards. The guards, with their helmets and storm trooper coats, were my favorite costumes on the show. I based their helmets on a horseshoe crab, and I wanted their coats to look like the thick, protective hide of an elephant or a rhinoceros."

Klingon Gun

Klingon Rifle

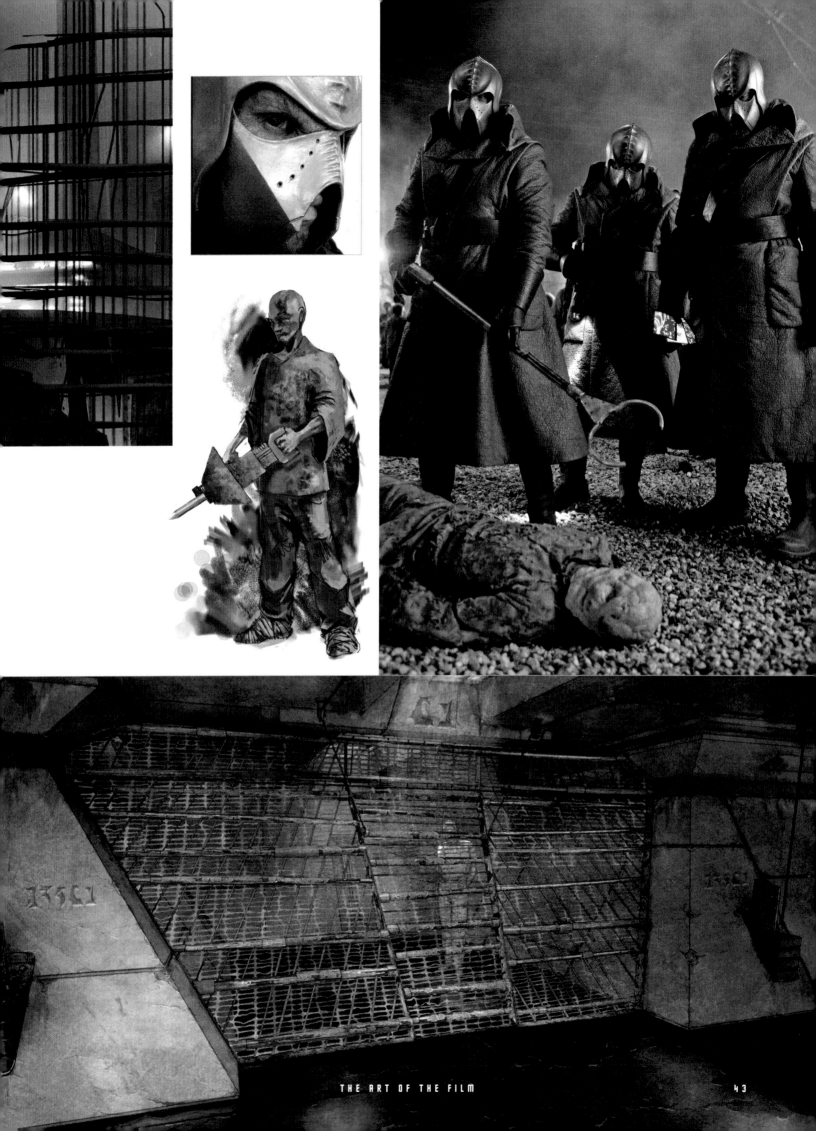

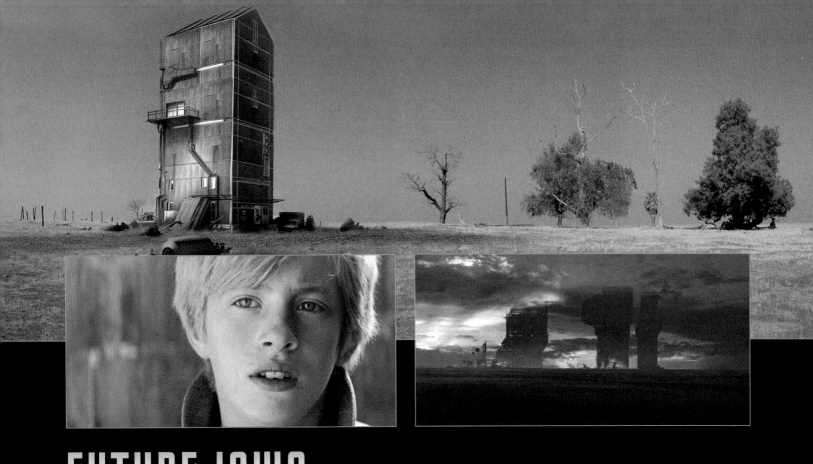

FUTURE IOWA

"I wanted 23rd-century Iowa to be familiar and feel like home, but also be the kind of arid place young James Kirk would want to get the hell out of," Chambliss chuckled.

Abrams wanted gigantic structures in the distance. "The idea is these might be mega-farm factories which have replaced traditional farms," Alex Jaeger noted.

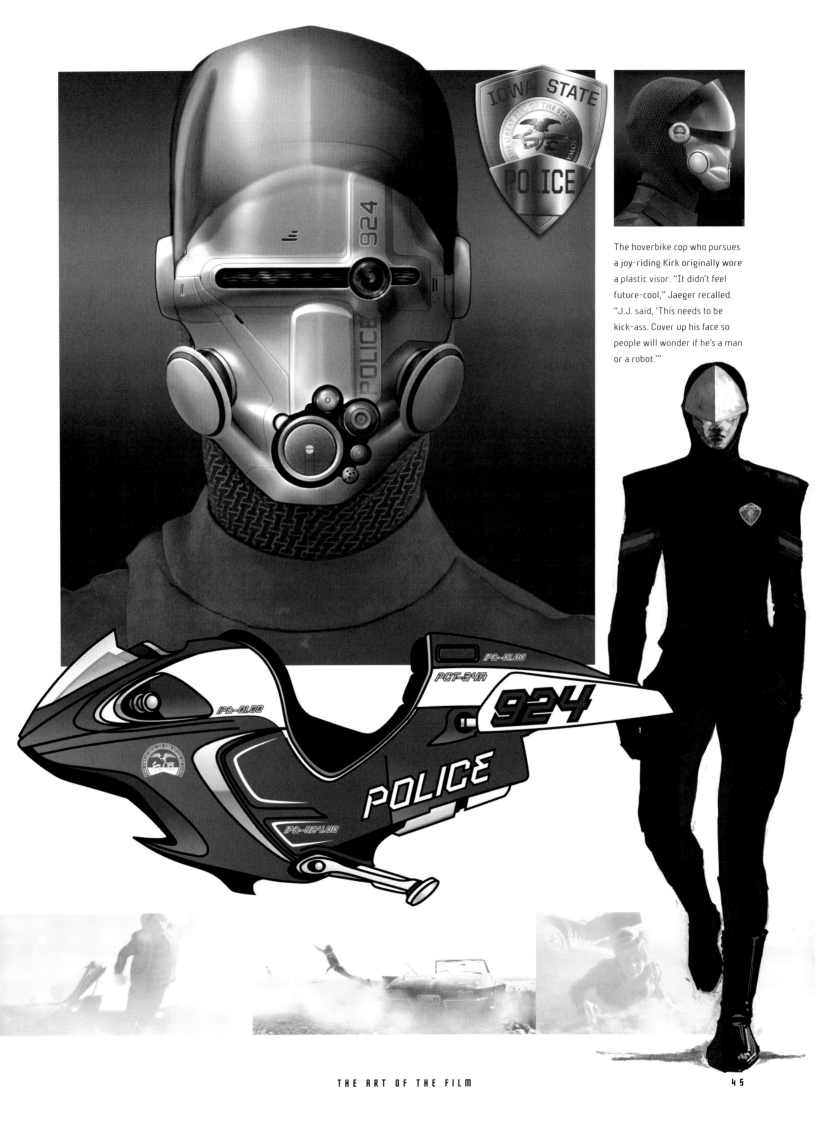

The hoverbike cop who pursues a joy-riding Kirk originally wore a plastic visor. "It didn't feel future-cool," Jaeger recalled. "J.J. said, 'This needs to be kick-ass. Cover up his face so people will wonder if he's a man or a robot.'"

James Kirk makes a rowdy appearance at an Iowa bar frequented by Starfleet cadets (below).

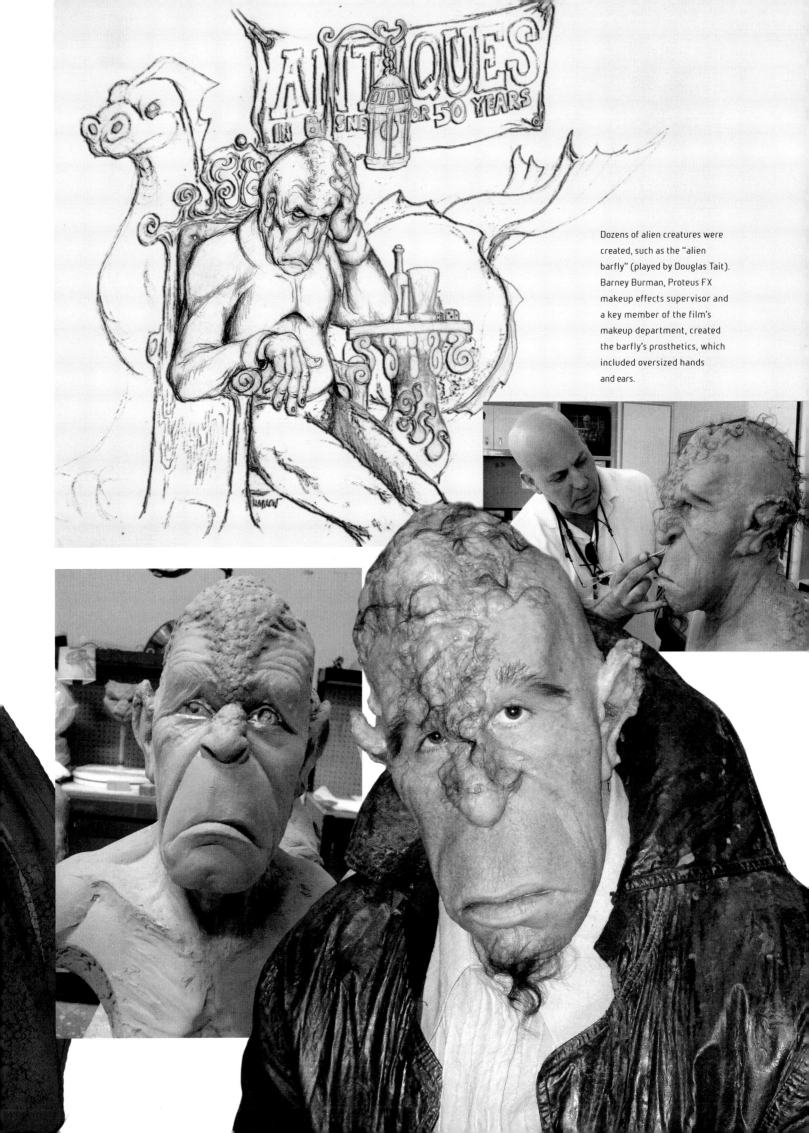

Dozens of alien creatures were created, such as the "alien barfly" (played by Douglas Tait). Barney Burman, Proteus FX makeup effects supervisor and a key member of the film's makeup department, created the barfly's prosthetics, which included oversized hands and ears.

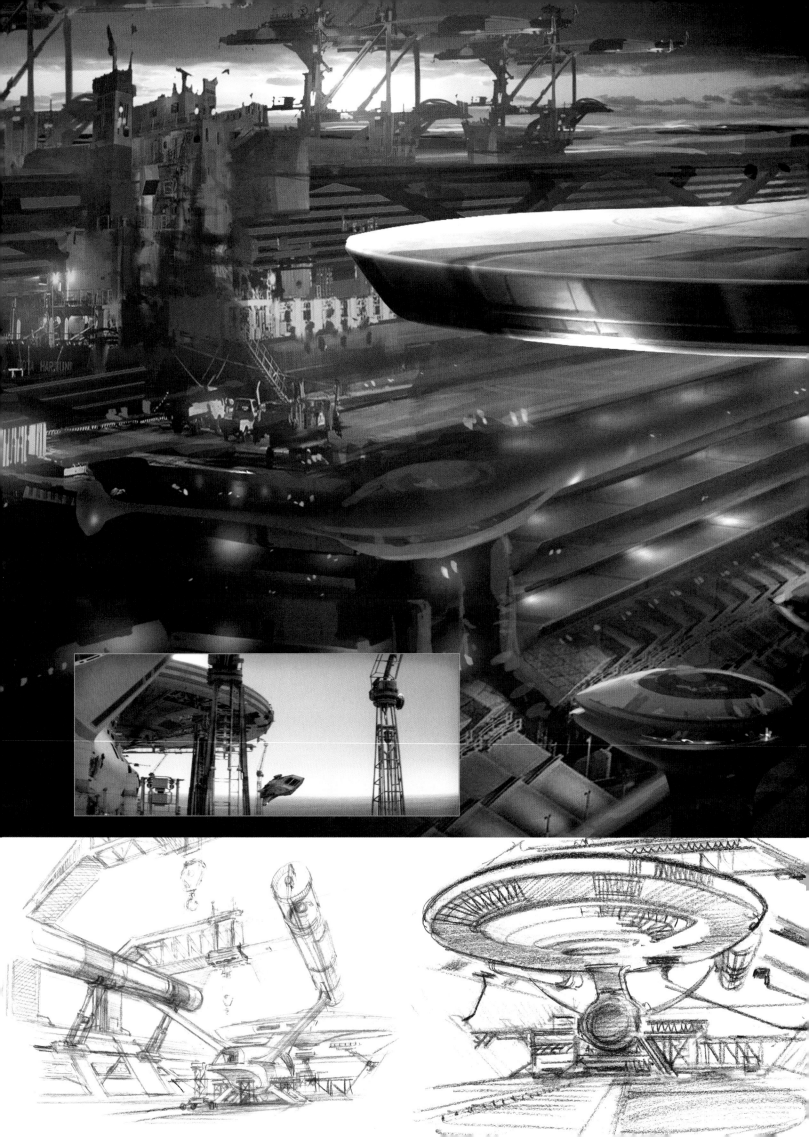

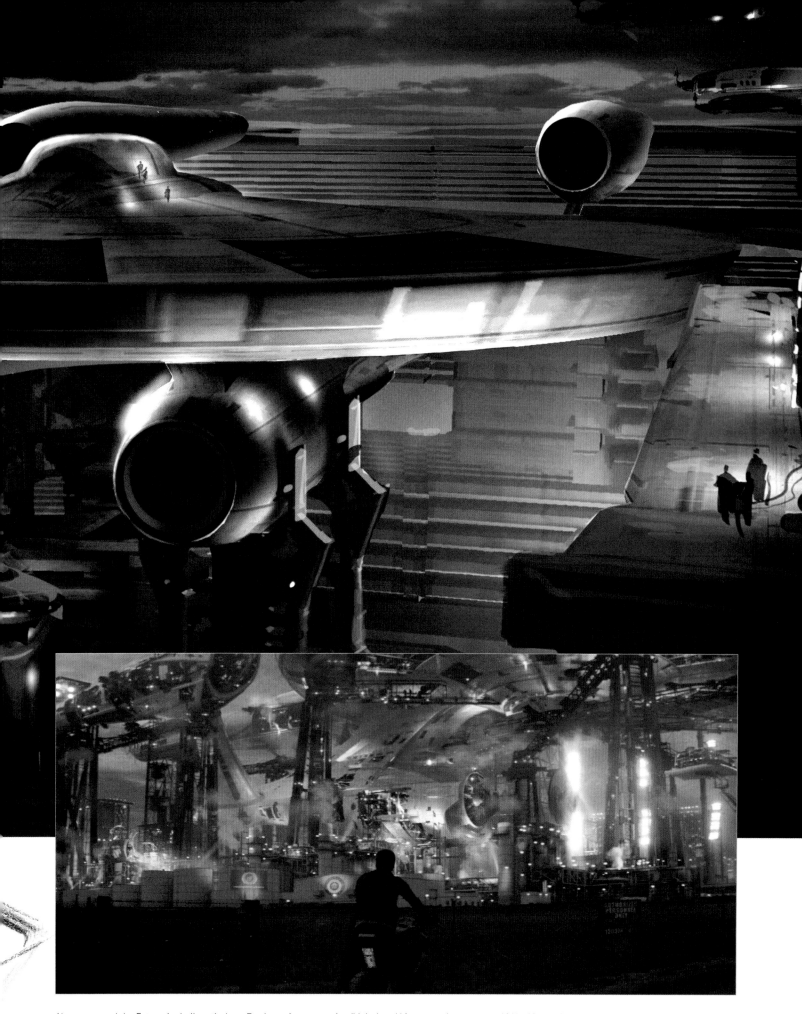

Abrams wanted the *Enterprise* built entirely on Earth, not in zero gravity. "J.J. closed his eyes and saw a young kid looking up from his bike at the *Enterprise*," Ryan Church said of James Kirk's first look at the starship under construction. "The design was about a storytelling moment, about J.J.'s vision and that one iconic shot."

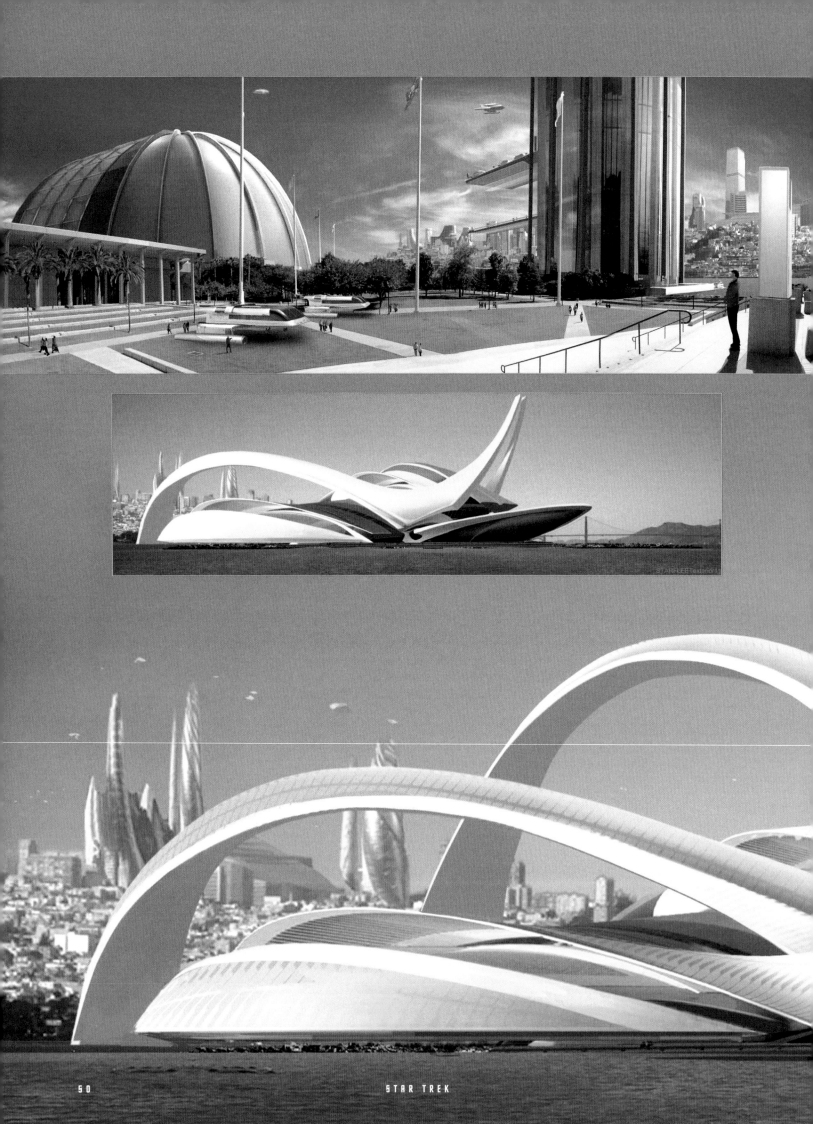

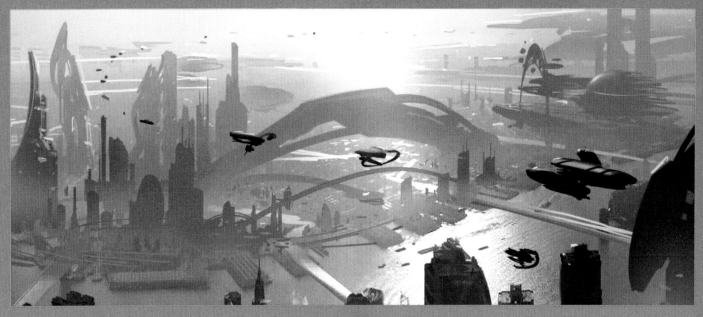

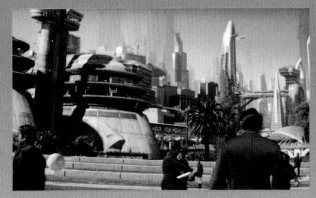

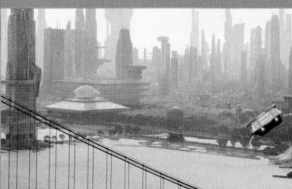

STARFLEET ACADEMY

Three or four different versions of 23rd-century San Francisco, Starfleet's home, were developed, Roger Guyett explained. "There would be no reason there still couldn't be current buildings around. I once lived in London, in a house a couple hundred years old. The Golden Gate Bridge still exists, but as a monument. People don't need bridges, they use hovercars."

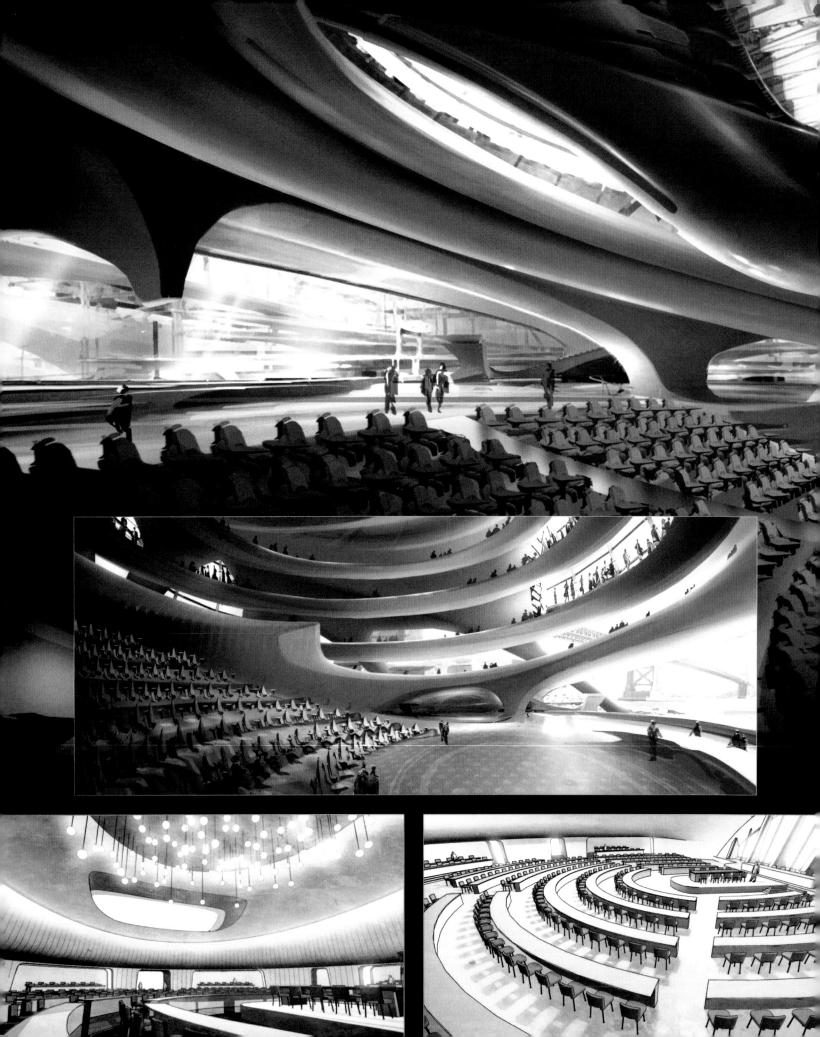

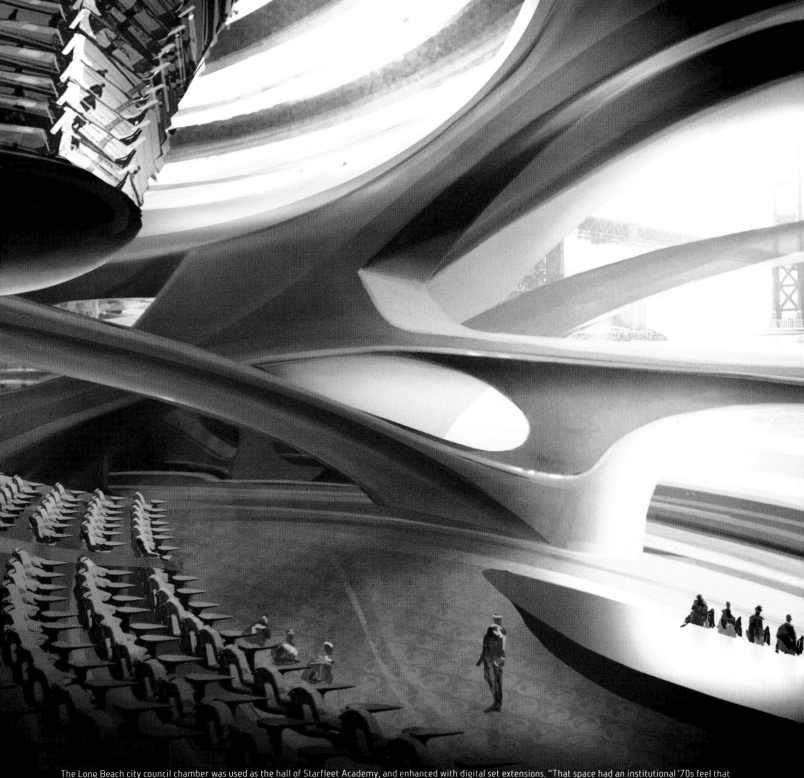

The Long Beach city council chamber was used as the hall of Starfleet Academy, and enhanced with digital set extensions. "That space had an institutional '70s feel that fit perfectly with the [period] aesthetics we were setting up," Chambliss noted.

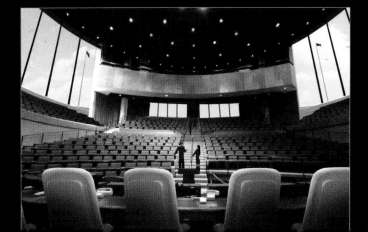

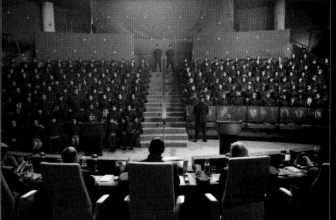

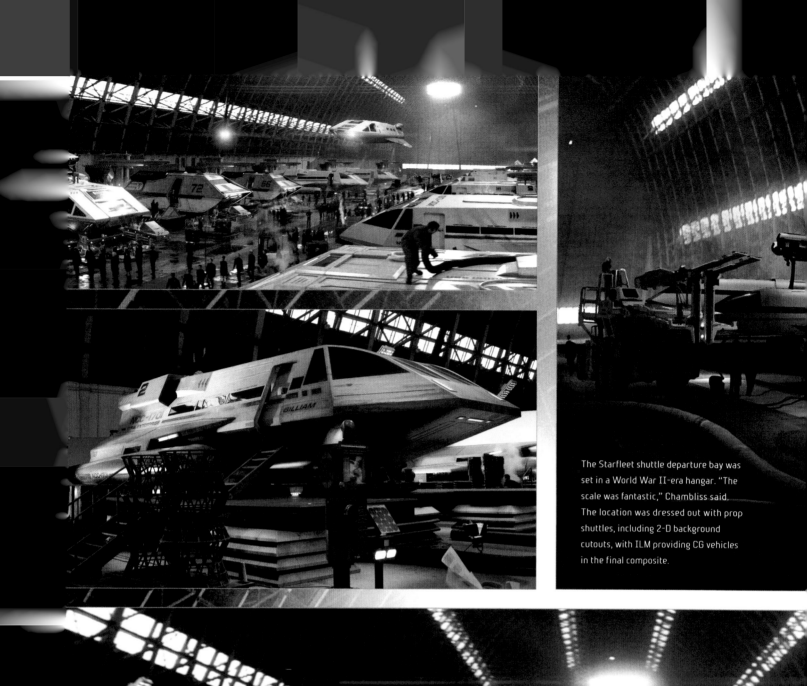

The Starfleet shuttle departure bay was set in a World War II-era hangar. "The scale was fantastic," Chambliss said. The location was dressed out with prop shuttles, including 2-D background cutouts, with ILM providing CG vehicles in the final composite.

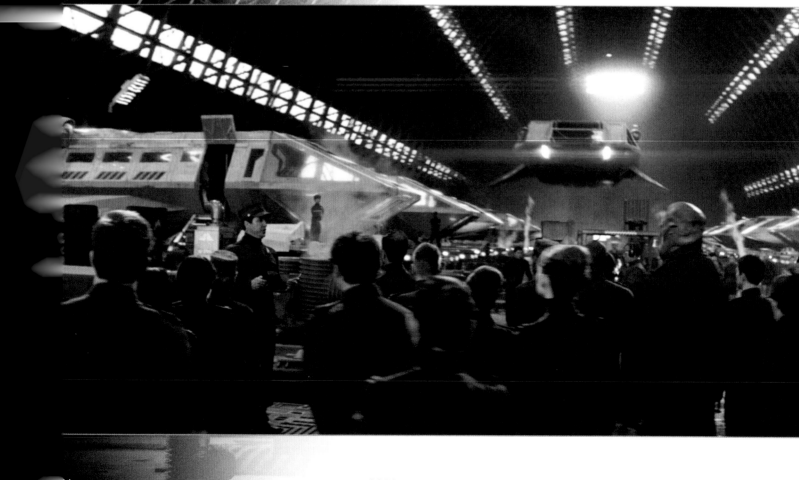

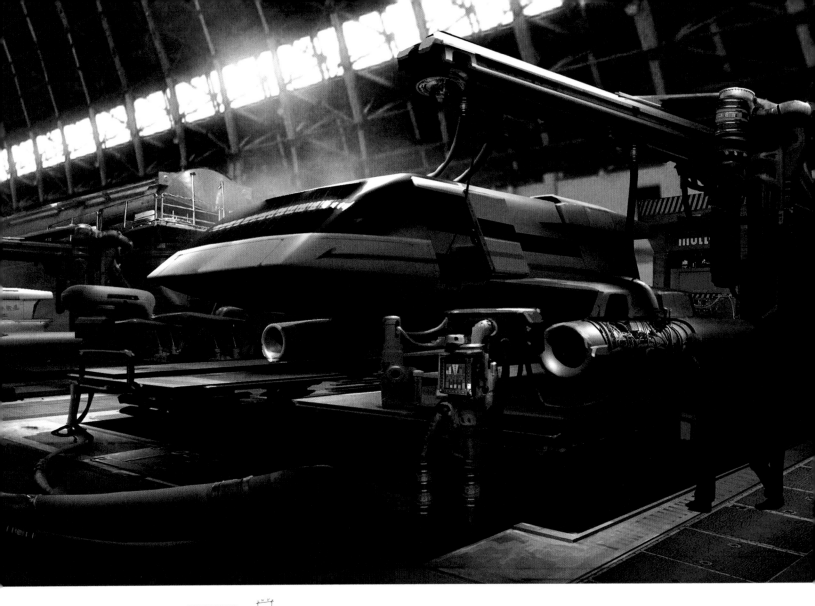

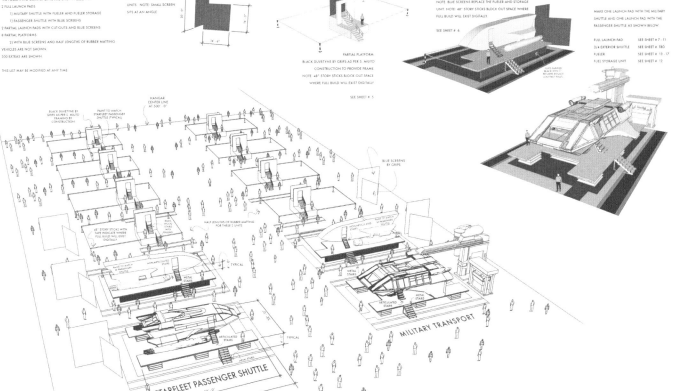

THIS SET IS COMPRISED OF A SERIES OF COMPONENTS.
THE FOLLOWING COMPONENTS ARE SHOWN BELOW...

2 FULL LAUNCH PADS

1) MILITARY SHUTTLE WITH FUELER AND FUELER STORAGE

1) PASSENGER SHUTTLE WITH BLUE SCREENS

2 PARTIAL LAUNCH PADS WITH CUT-OUTS AND BLUE SCREENS

8 PARTIAL PLATFORMS

2) WITH BLUE SCREENS AND HALF LENGTHS OF RUBBER MATTING

VEHICLES ARE NOT SHOWN.

300 EXTRAS ARE SHOWN.

THIS LIST MAY BE MODIFIED AT ANY TIME.

BLUE SCREENS STAND IN FOR
FUELER AND FUELER STORAGE
UNITS. NOTE: SMALL SCREEN
SITS AT AN ANGLE

PARTIAL PLATFORM

BLACK DUVETYNE BY GRIPS AS PER S. MILITO
CONSTRUCTION TO PROVIDE FRAME
NOTE: 48" STORY STICKS BLOCK OUT SPACE
WHERE FULL BUILD WILL EXIST DIGITALLY.

SEE SHEET # 5

PARTIAL LAUNCH PAD WITH CUT-OUT SHUTTLE.
NOTE: BLUE SCREENS REPLACE THE FUELER AND STORAGE
UNIT. NOTE: 48" STORY STICKS BLOCK OUT SPACE WHERE
FULL BUILD WILL EXIST DIGITALLY.

SEE SHEET # 6

MAKE ONE LAUNCH PAD WITH THE MILITARY
SHUTTLE AND ONE LAUNCH PAD WITH THE
PASSENGER SHUTTLE AS SHOWN BELOW

FULL LAUNCH PAD SEE SHEET # 7 - 11
3/4 EXTERIOR SHUTTLE SEE SHEET # TBD
FUELER SEE SHEET # 13 - 17
FUEL STORAGE UNIT SEE SHEET # 12

MILITARY TRANSPORT

STARFLEET PASSENGER SHUTTLE

MASTER LAYOUT - TONTO'S STAGE COACH STOP (ACTUAL BUILD)

NO SCALE

KOBAYASHI MARU

Klingon battlecruiser "Retro"

UNDER Belly Details

Neck to Body Details

VERSION TWO

The Kobayashi Maru test, the battlefield simulation training exercise in *Star Trek II: The Wrath of Khan*, provided a key scene in the new movie. "I think [screenwriters] Bob and Alex wanted to put in some bits of *Star Trek* lore," mused visual effects supervisor Guyett.

VERSION ONE

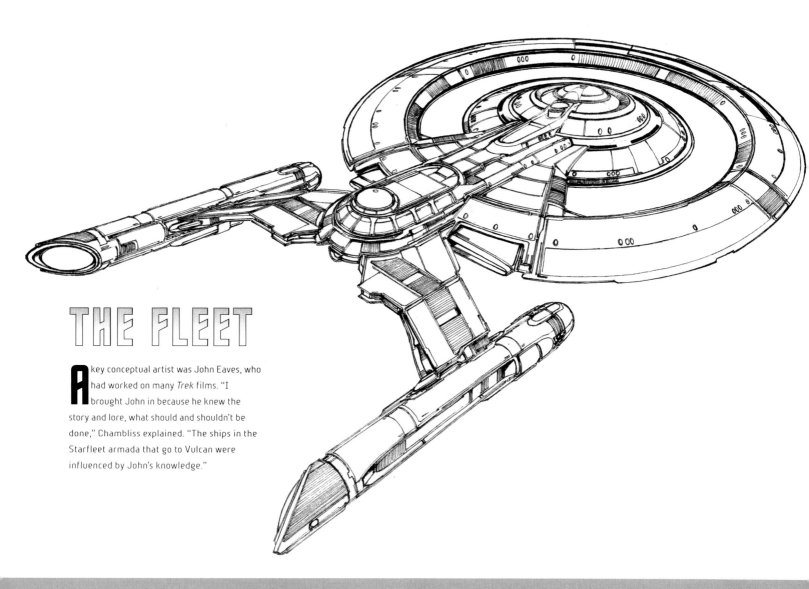

THE FLEET

A key conceptual artist was John Eaves, who had worked on many *Trek* films. "I brought John in because he knew the story and lore, what should and shouldn't be done," Chambliss explained. "The ships in the Starfleet armada that go to Vulcan were influenced by John's knowledge."

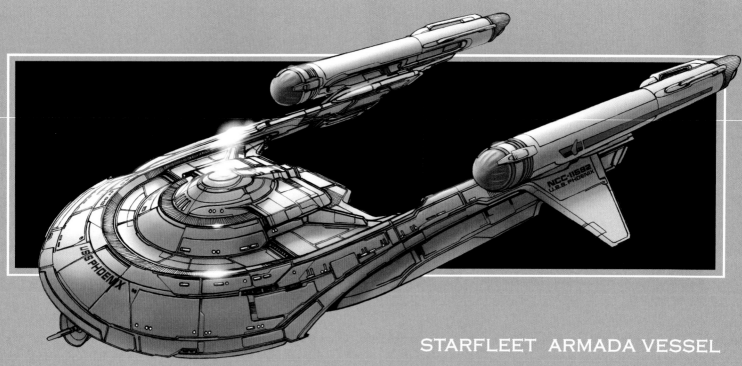

STARFLEET ARMADA VESSEL

USS NEWTON

USS MAYFLOWER

USS ARMSTRONG

USS EXCELSIOR

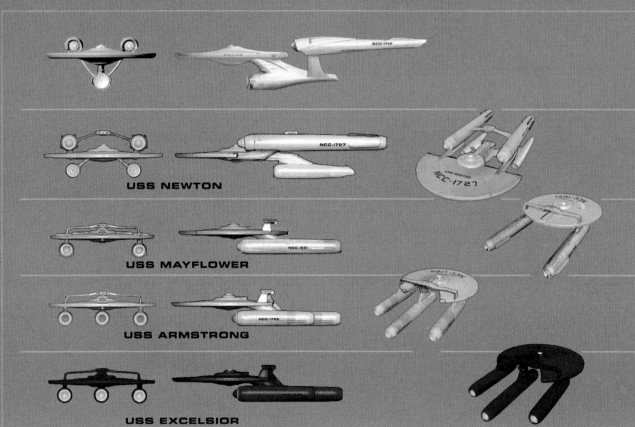

USS NEWTON

USS MAYFLOWER

USS ARMSTRONG

USS EXCELSIOR

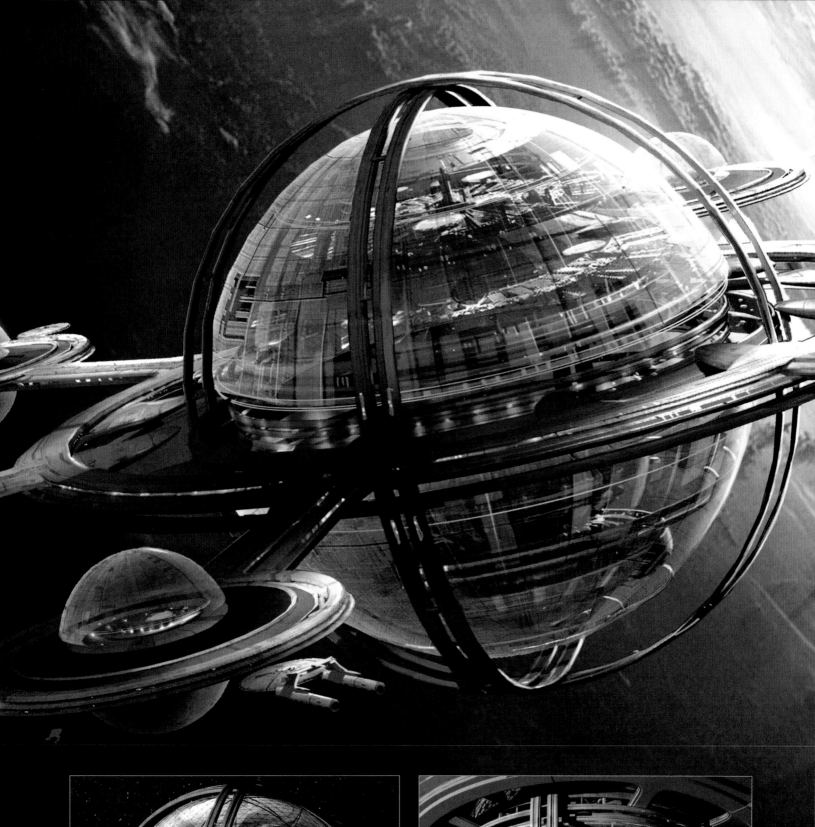

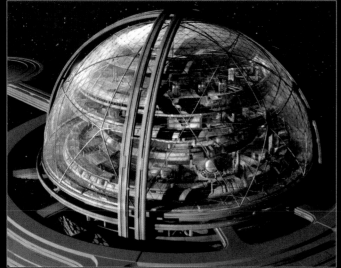

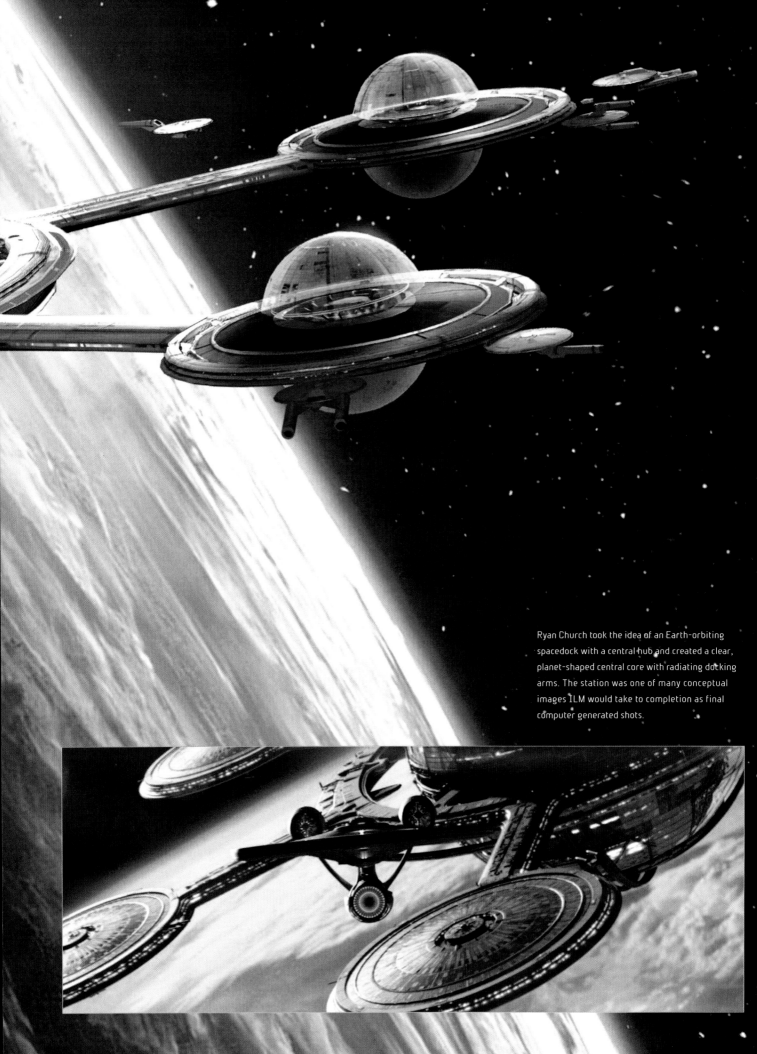

Ryan Church took the idea of an Earth-orbiting spacedock with a central hub and created a clear, planet-shaped central core with radiating docking arms. The station was one of many conceptual images ILM would take to completion as final computer generated shots.

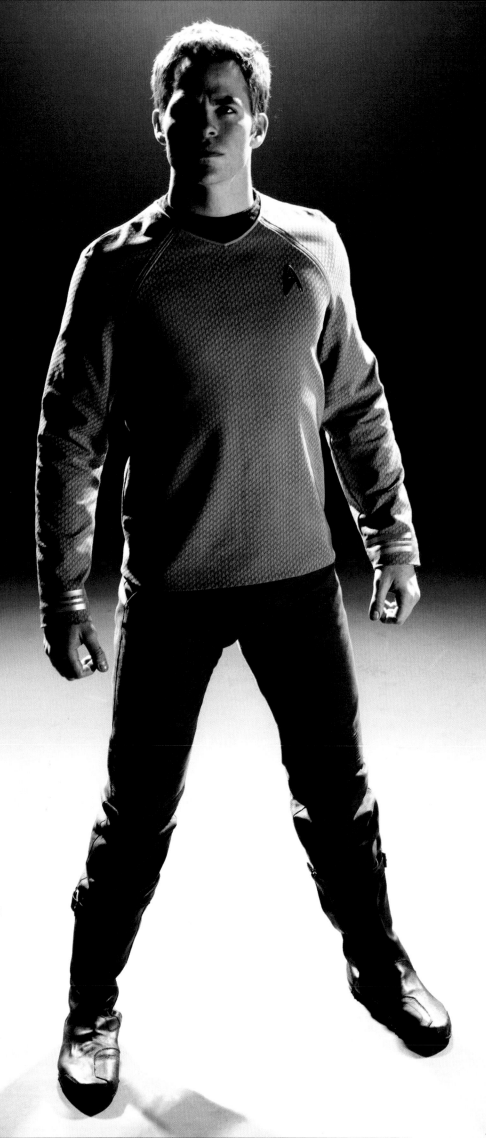

UNIFORMS

"**S**trangely, the previous movies never used the colored shirts from the series," noted Bryan Burk. "We went back to the original blue, gold, and maroon." Michael Kaplan updated fabrics and imprinted a Starfleet logo pattern on each. In a departure from the classic one-piece uniforms, a dark turtleneck served as an undershirt.

Above: The iconic insignia for the Command, Science and Engineering Divisions.

"The hair and makeup process is incredibly important for a character like Spock (right), who is so inextricably identified by his aesthetic," Zachary Quinto noted. "It informs a tremendous amount of his cultural identity. The process took about two hours, and around halfway through that time I felt a shift within myself – a kind of emergence that would bring the character to life for the remainder of the day."

"The dress Uhura wears (bottom right) was a crucial element that defined her in the series, so it helped quickly familiarize audiences with her for this movie," said Zoë Saldana, who plays Uhura. "The pony tail made her feel sharp and pompous, while the makeup added drama and expression to her eyes."

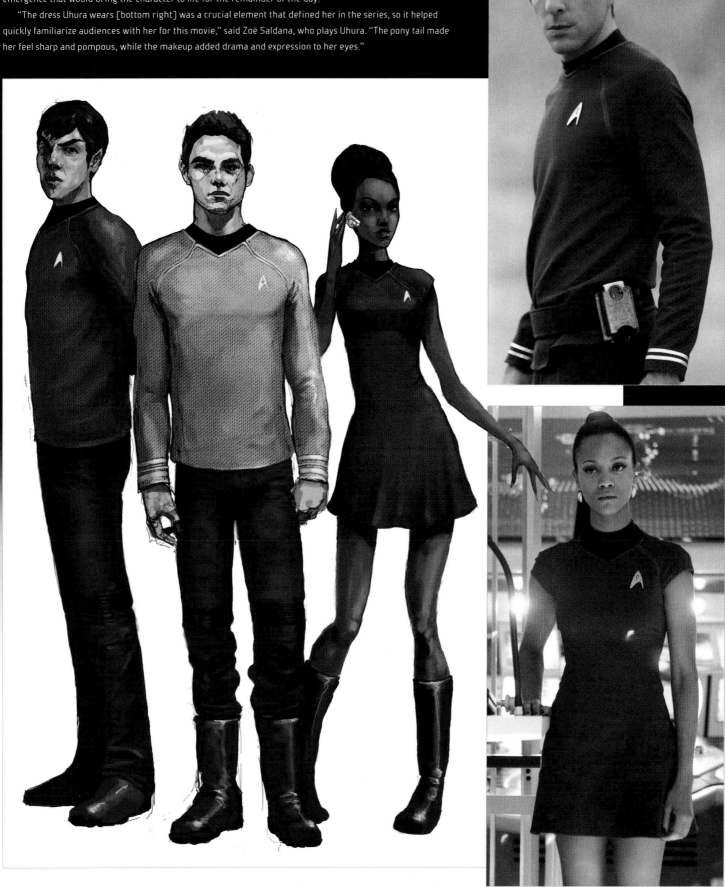

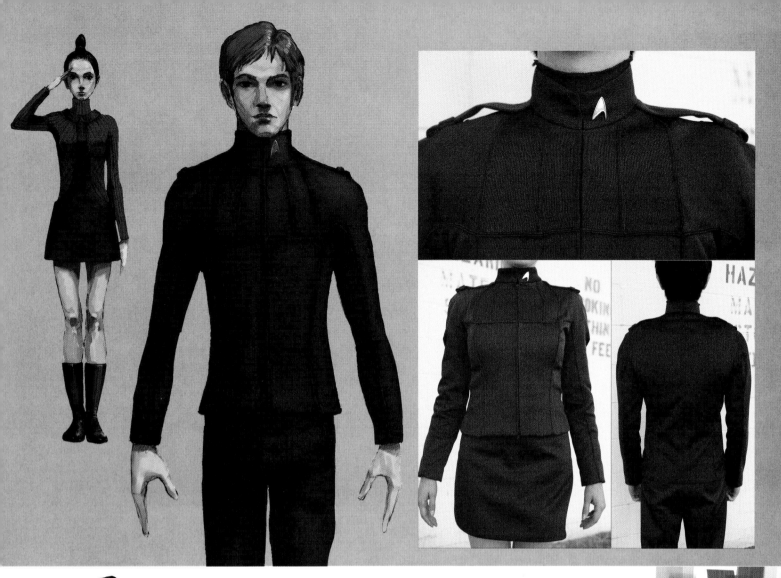

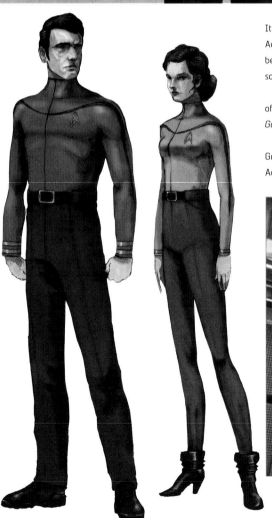

It was a "gut decision," Kaplan said, to make the Starfleet Academy uniforms red (above). "I thought it would look beautiful to see hundreds of people in red. There was something young about it, it felt patriotic and strong."

Kelvin uniforms (left and below) distilled the essence of old sci-fi, including stretch fabrics inspired by *Flash Gordon* serials.

The design for the Admiral's uniform worn by Bruce Greenwood as Christopher Pike (right) was inspired by Admiral Kirk's in *Star Trek: The Motion Picture*.

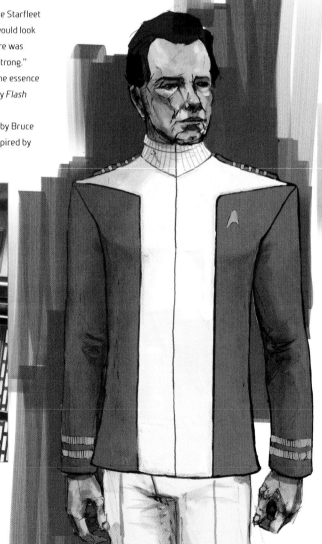

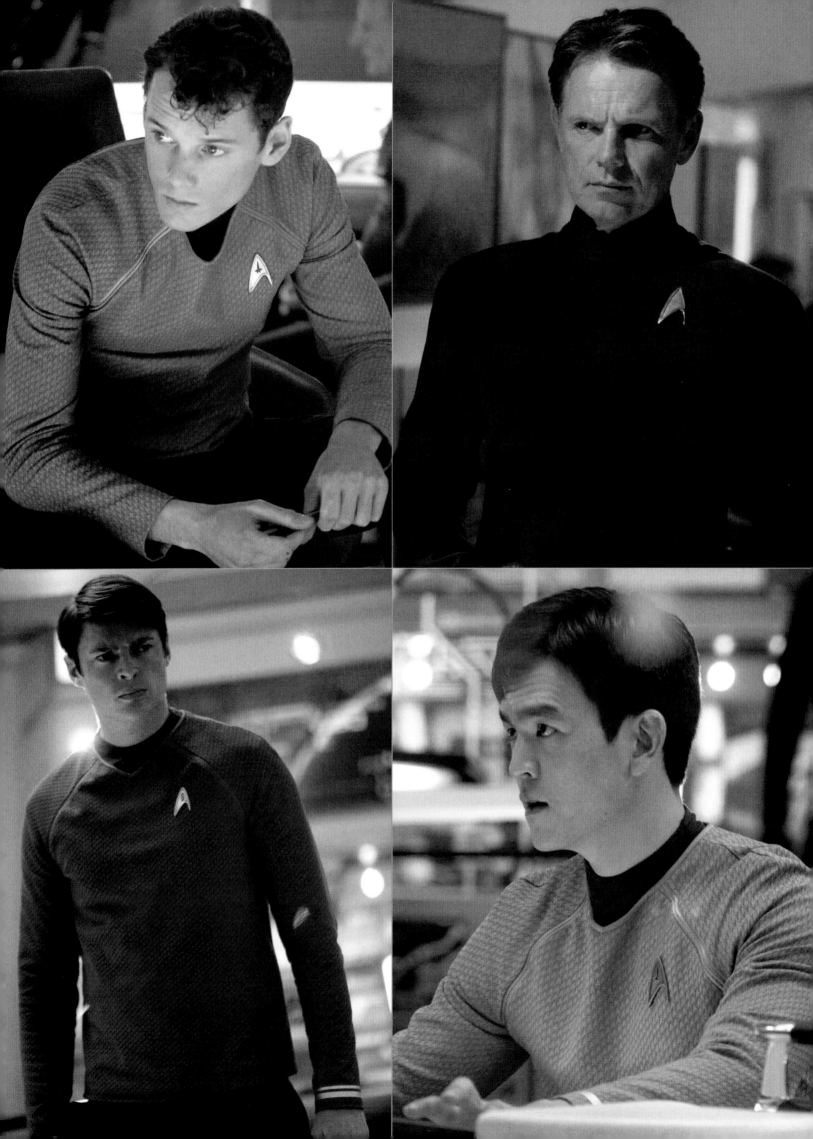

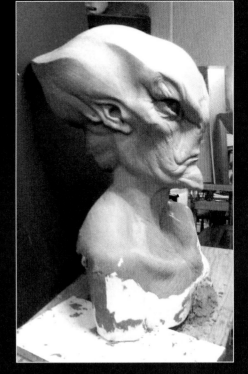

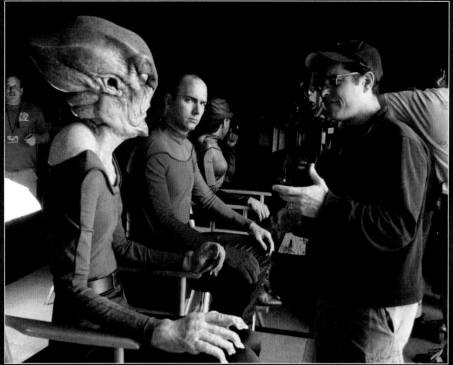

ALIENS

"**O**ur goal was to show the future with diversity in all groups and to have it look real," makeup lead Mindy Hall noted. "We used techniques that wouldn't distract the audience: subtle painting, seamless prosthetics, skin tone adjustments for each individual, particularly to accommodate high-contrast lighting effects. Individuality was key, and a true representation of life."

When J.J. Abrams put out a call for alien designs, Neville Page dusted off a classic alien "gray" design he had developed five years before. Abrams approved Page's digital sculpt and Photoshop design (opposite), which was realized by Proteus (Barney Burman of Proteus pictured below). The alien, officially known as Alnschloss K'Bentayr, was nicknamed "Kasia," for the actress who played the *Kelvin* crew member.

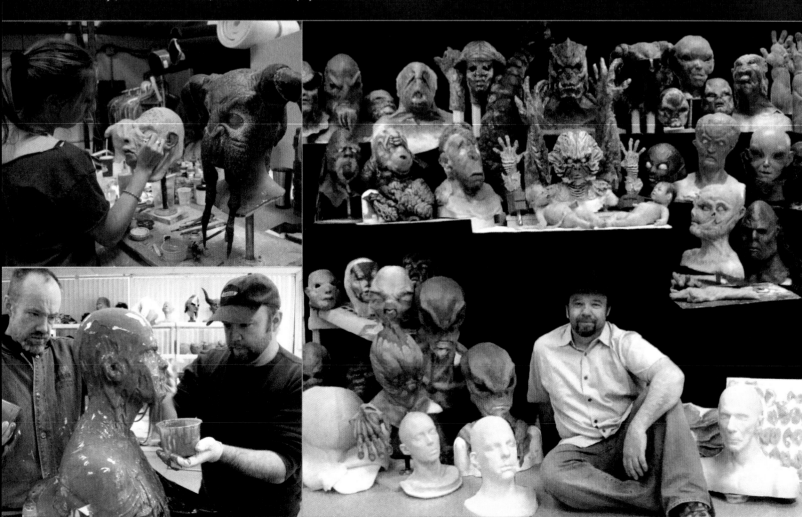

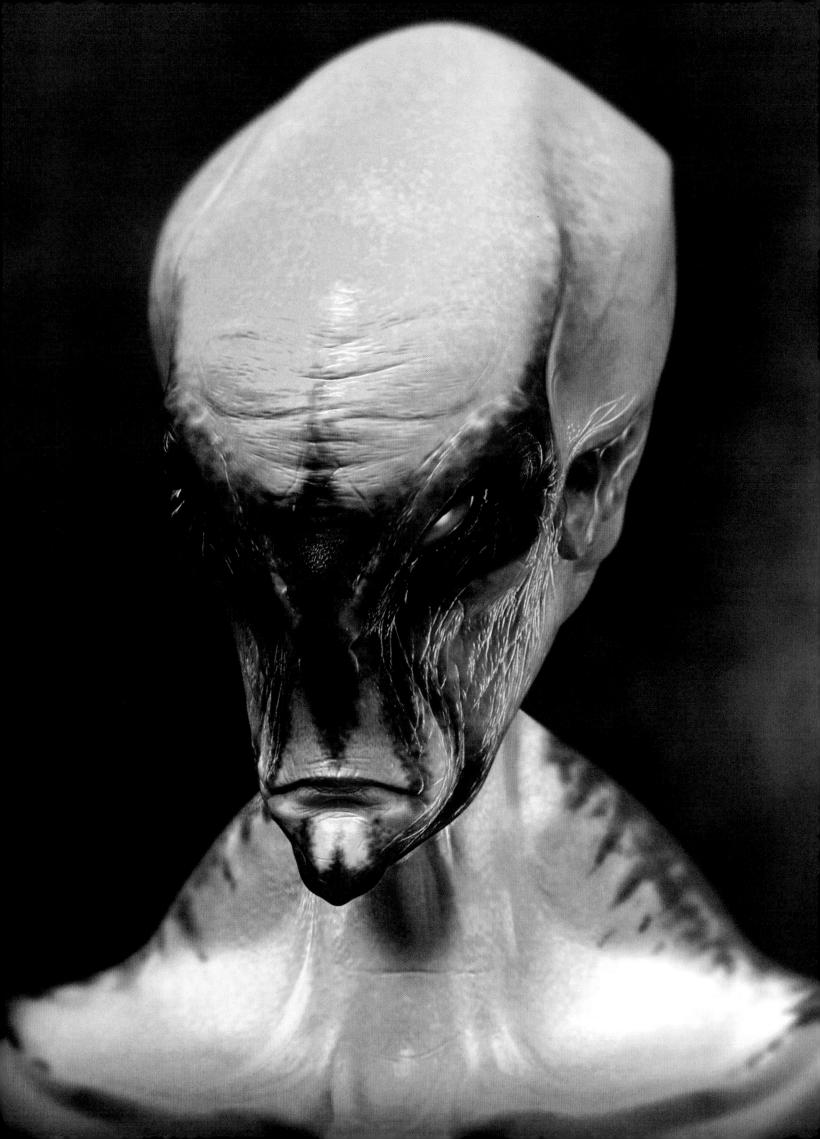

Above: Miscellaneous alien designs.

During his time at Starfleet Academy, Kirk has a fling with Gaila (Rachel Nichols). The character's design was an homage to a Kirk love interest from the classic TV show. The actress was transformed by costume designer Kaplan and makeup artist Mindy Hall.

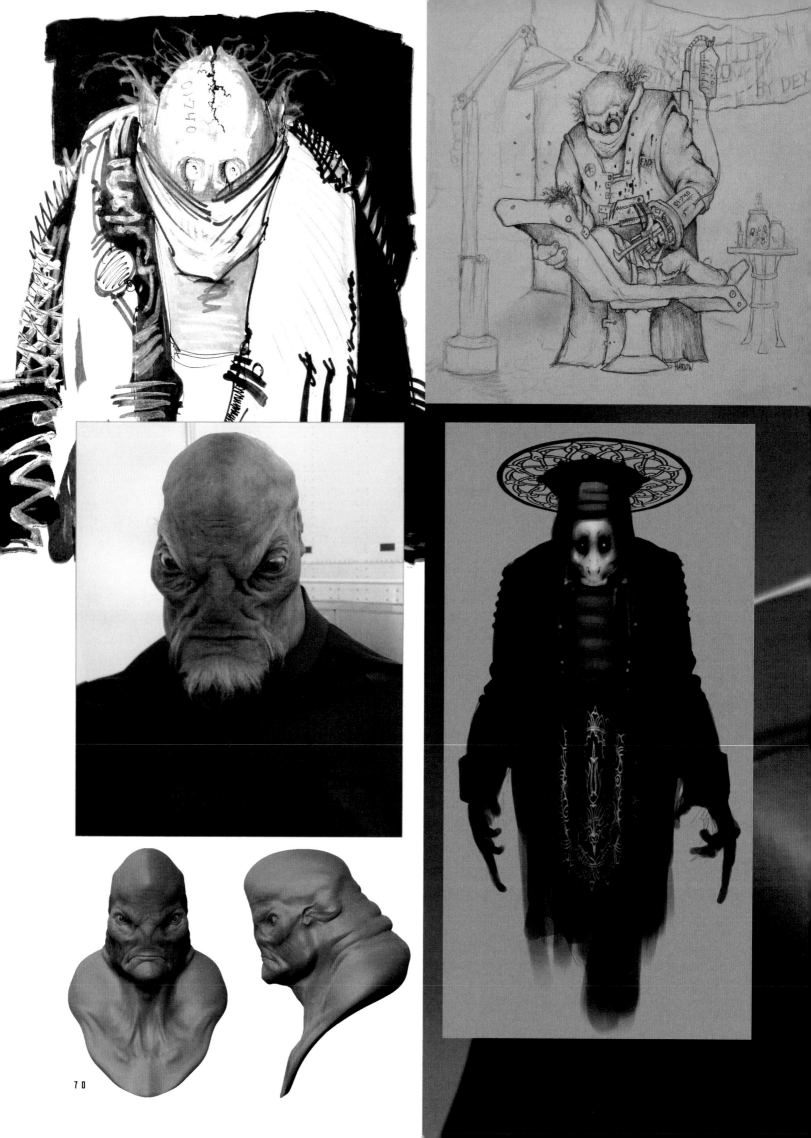

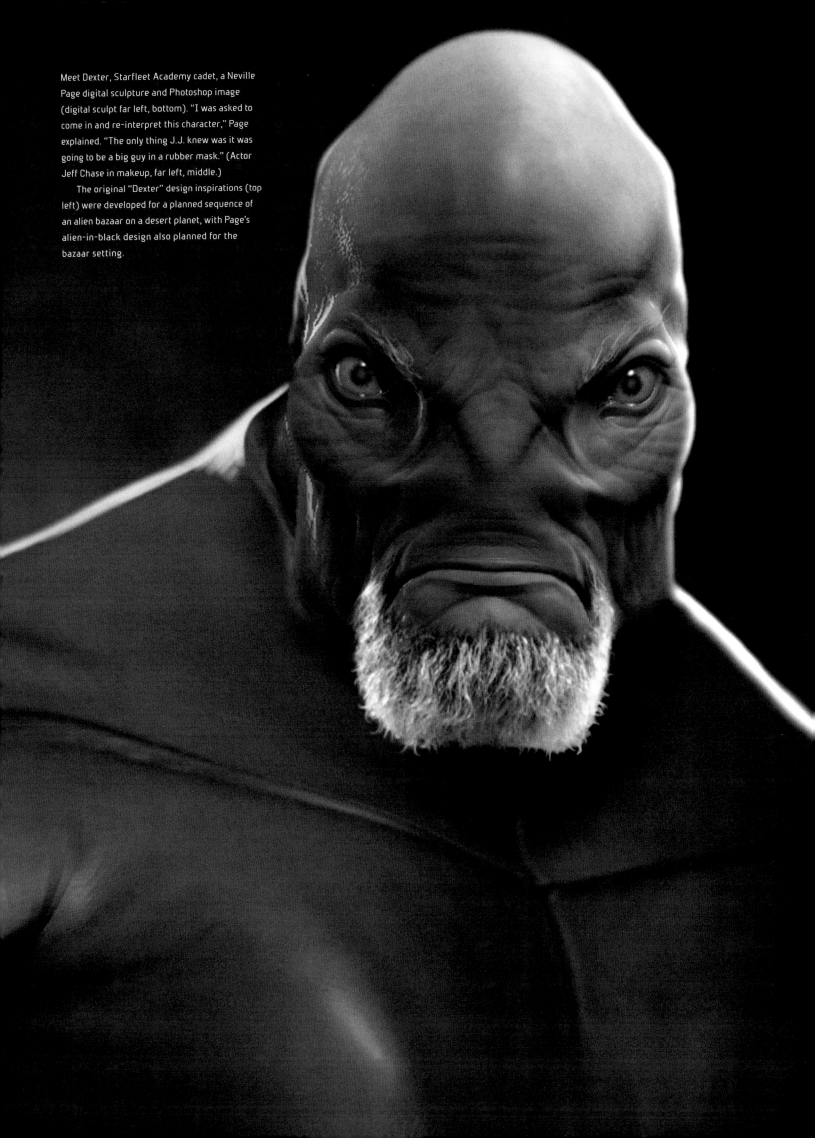

Meet Dexter, Starfleet Academy cadet, a Neville Page digital sculpture and Photoshop image (digital sculpt far left, bottom). "I was asked to come in and re-interpret this character," Page explained. "The only thing J.J. knew was it was going to be a big guy in a rubber mask." (Actor Jeff Chase in makeup, far left, middle.)

The original "Dexter" design inspirations (top left) were developed for a planned sequence of an alien bazaar on a desert planet, with Page's alien-in-black design also planned for the bazaar setting.

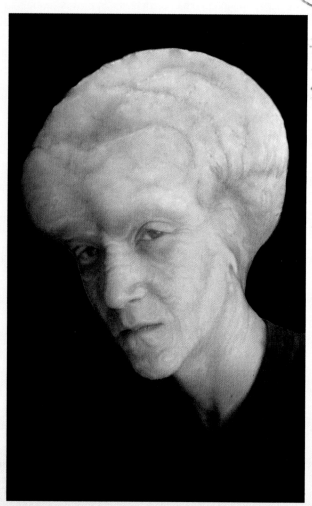

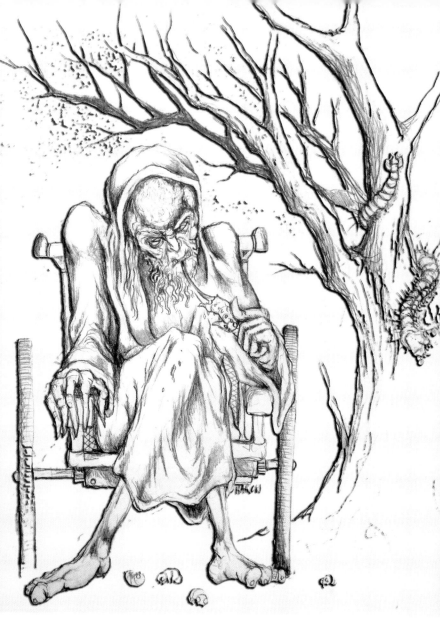

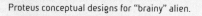

Proteus conceptual designs for "brainy" alien.

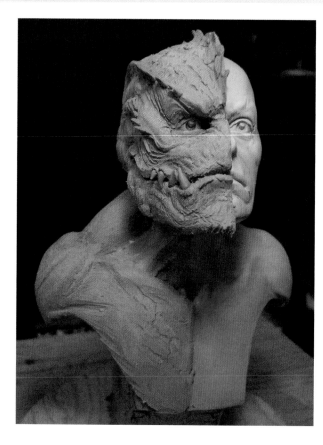

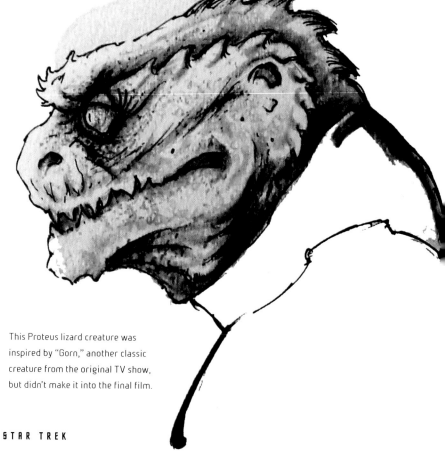

This Proteus lizard creature was inspired by "Gorn," another classic creature from the original TV show, but didn't make it into the final film.

STAR TREK

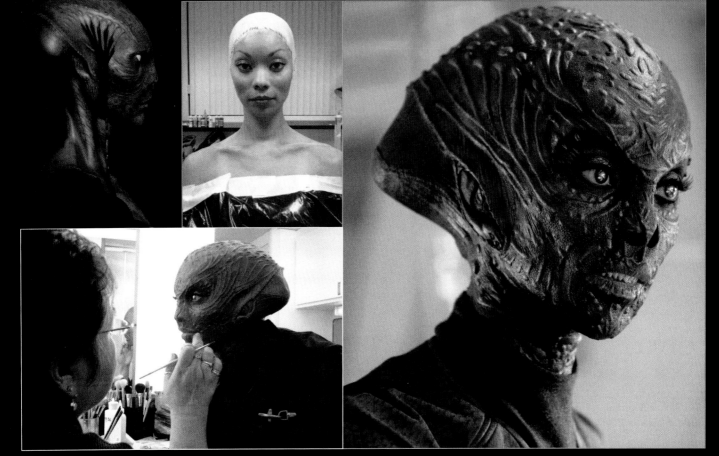

"Madeline," another Neville Page design, interpreted in final makeup by Proteus (makeup applied here to actress Kimberly Arland). "J.J. had seen an image of facial ornamentation and we went with that idea," Page explained. "My concept was tribal scarification, with a bronze finish colorization that gave her an alien quality."

Below: Proteus concept illustrations and physical clay sculpture for alien character. The green in the sketch indicates where an actor's head would be masked out and replaced with a CG effect.

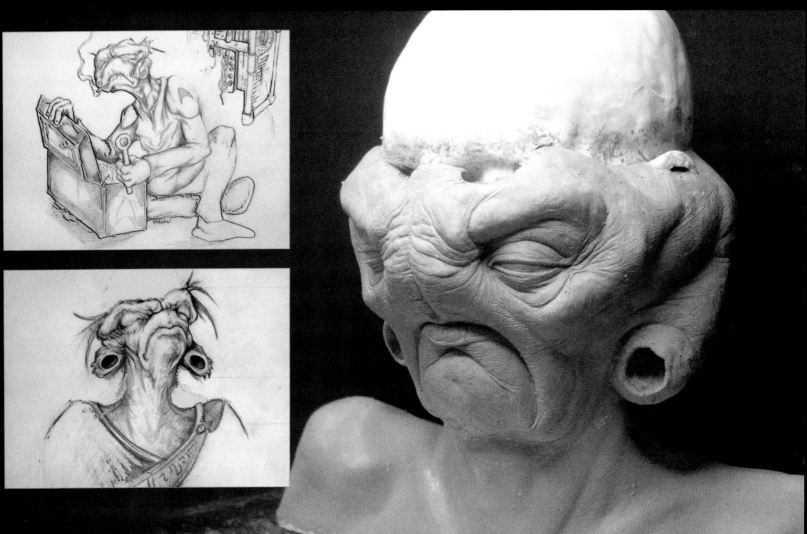

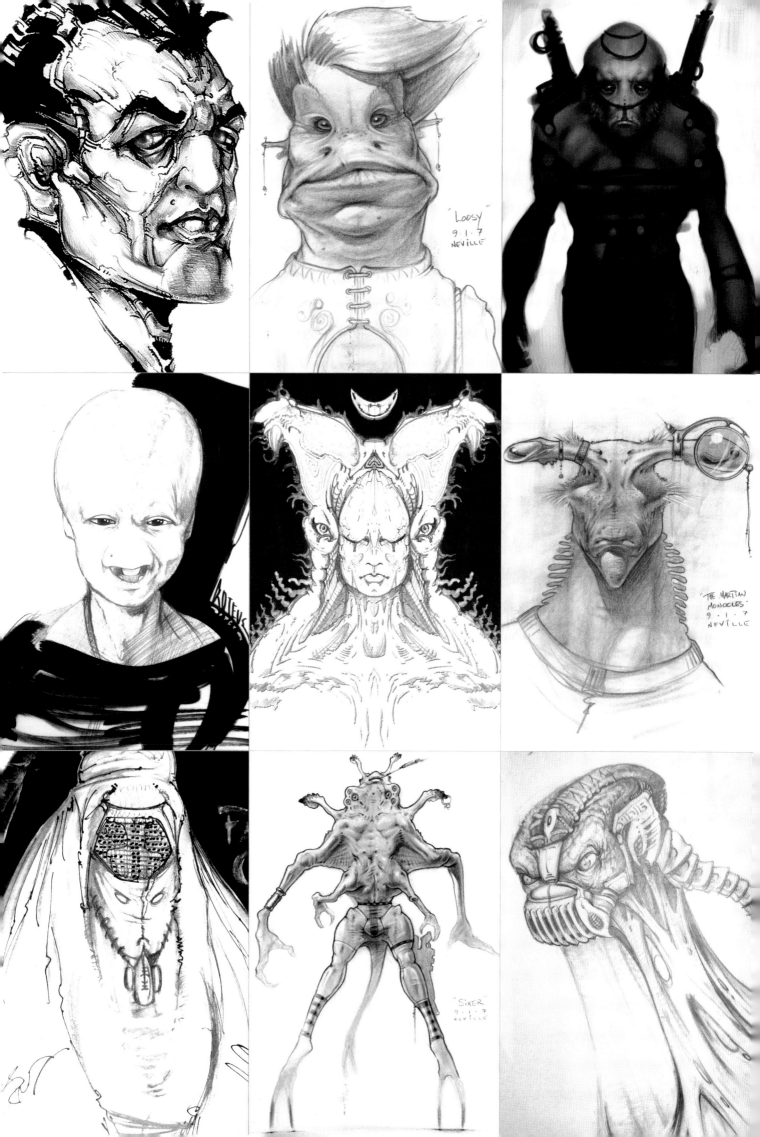

"Loosy"
9 · 1 · 7
NEVILLE

"THE MARTIAN
MONOCLES"
9 · 1 · 7
NEVILLE

"SIXER"
9 · 1 · 7
NEVILLE

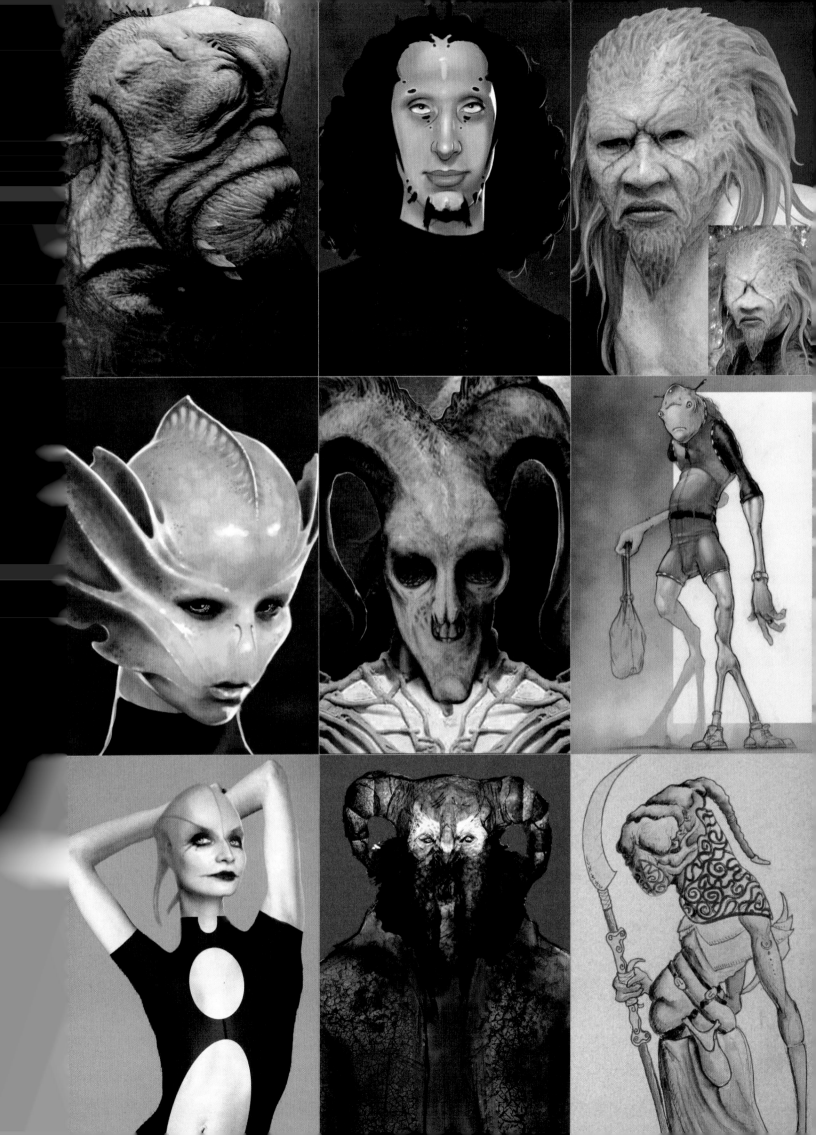

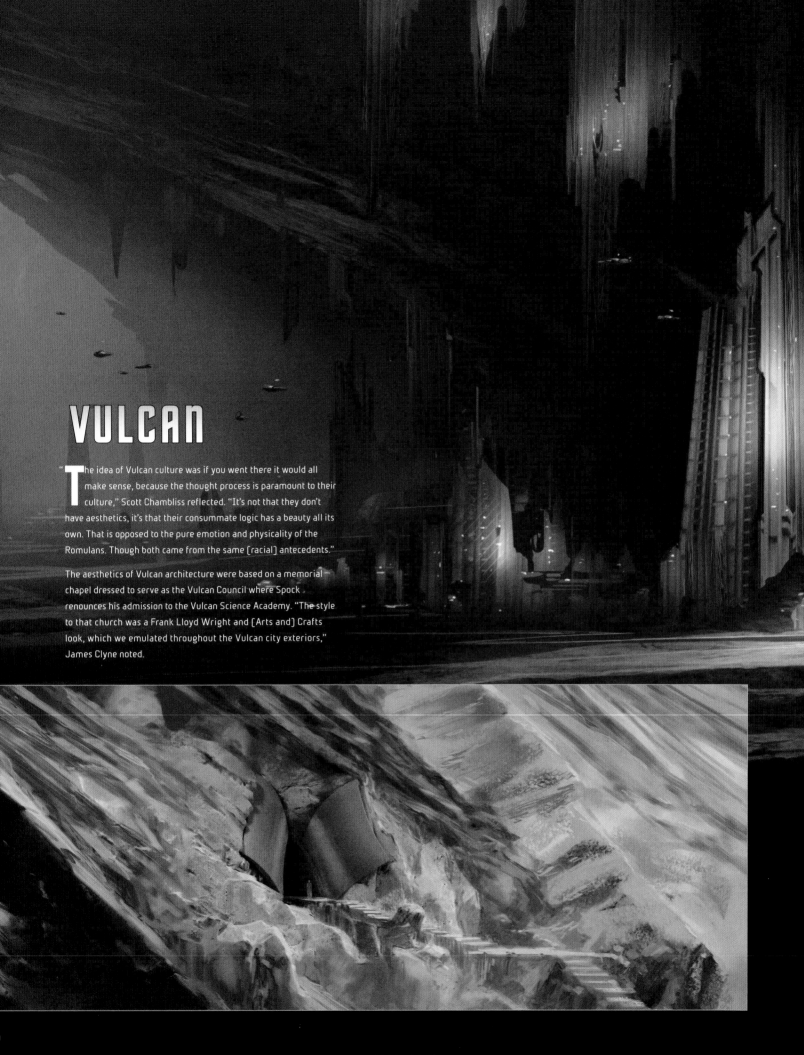

VULCAN

"The idea of Vulcan culture was if you went there it would all make sense, because the thought process is paramount to their culture," Scott Chambliss reflected. "It's not that they don't have aesthetics, it's that their consummate logic has a beauty all its own. That is opposed to the pure emotion and physicality of the Romulans. Though both came from the same [racial] antecedents."

The aesthetics of Vulcan architecture were based on a memorial chapel dressed to serve as the Vulcan Council where Spock renounces his admission to the Vulcan Science Academy. "The style to that church was a Frank Lloyd Wright and [Arts and] Crafts look, which we emulated throughout the Vulcan city exteriors," James Clyne noted.

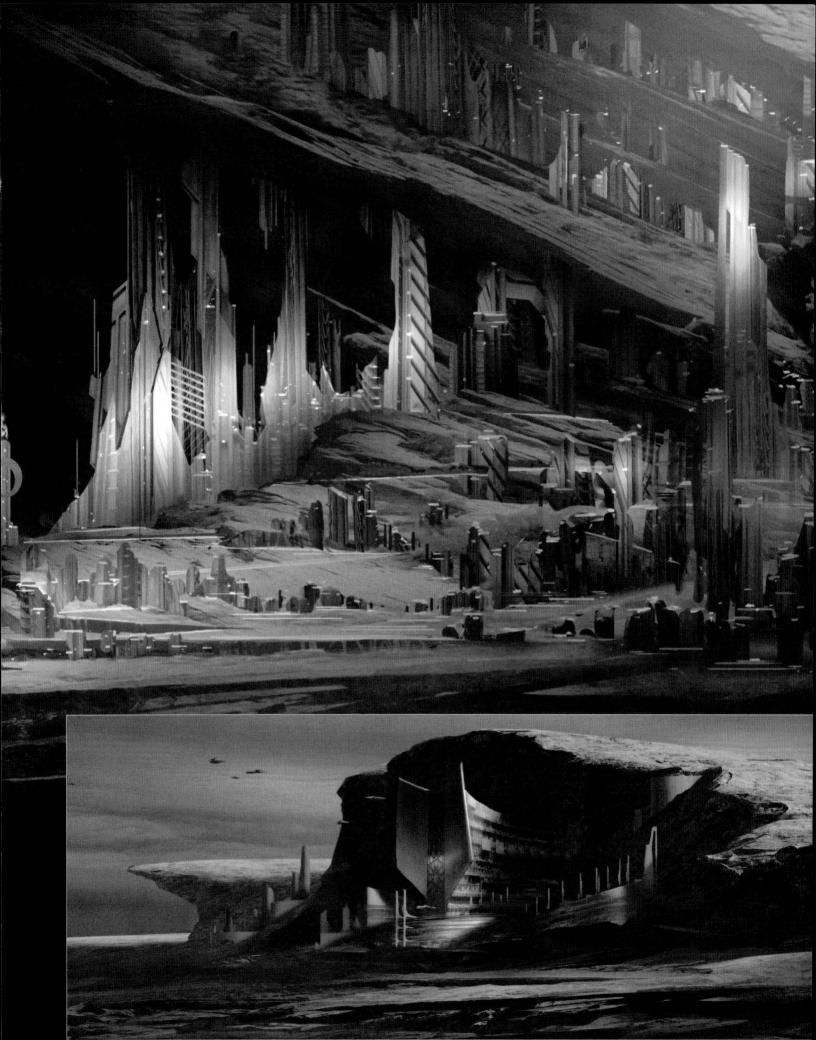

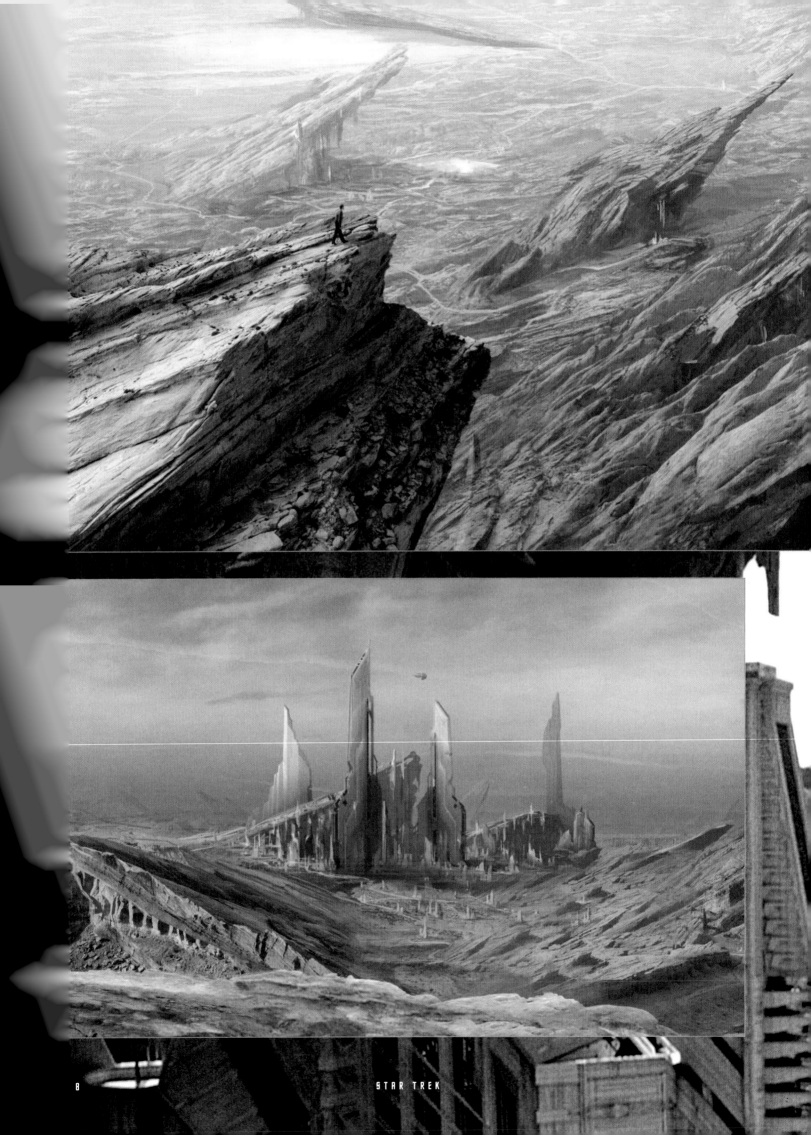

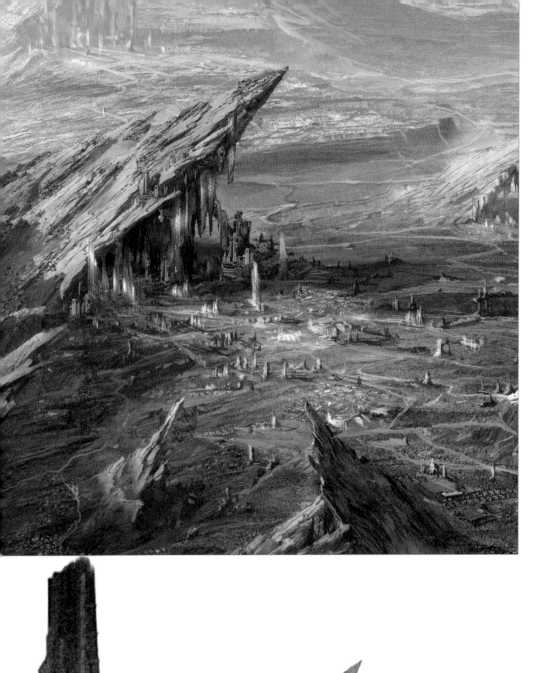

The concept for Vulcan was that it was geologically unstable, with massive earth-quakes fracturing the surface. "For Vulcan we had to go in and essentially dress tectonic plates into the images," Guyett said. "A lot of digital model work went into making that planet look the way it does, and we had to destroy it, too. [It was imagined] like the Pueblo Indians, who built their structures on the underside of rock shelves for shelter and protection. It's fun to think about their world and how technology might develop, how that affects your design choice."

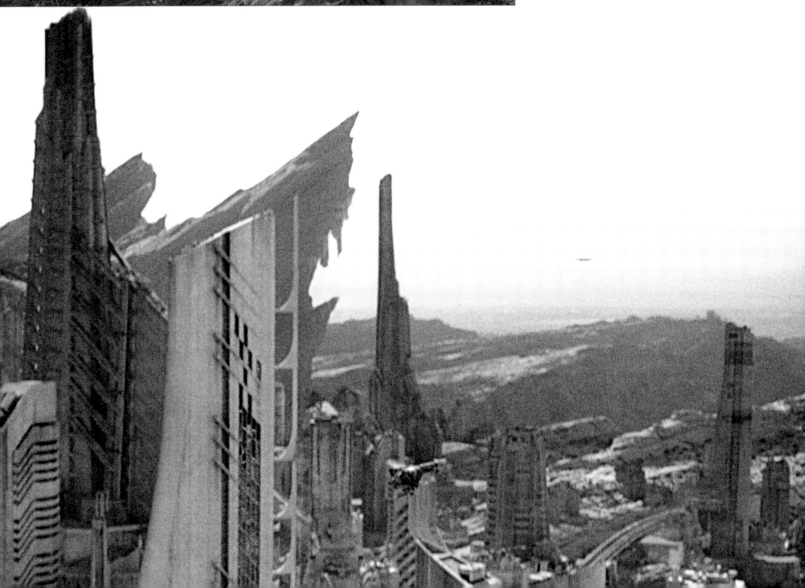

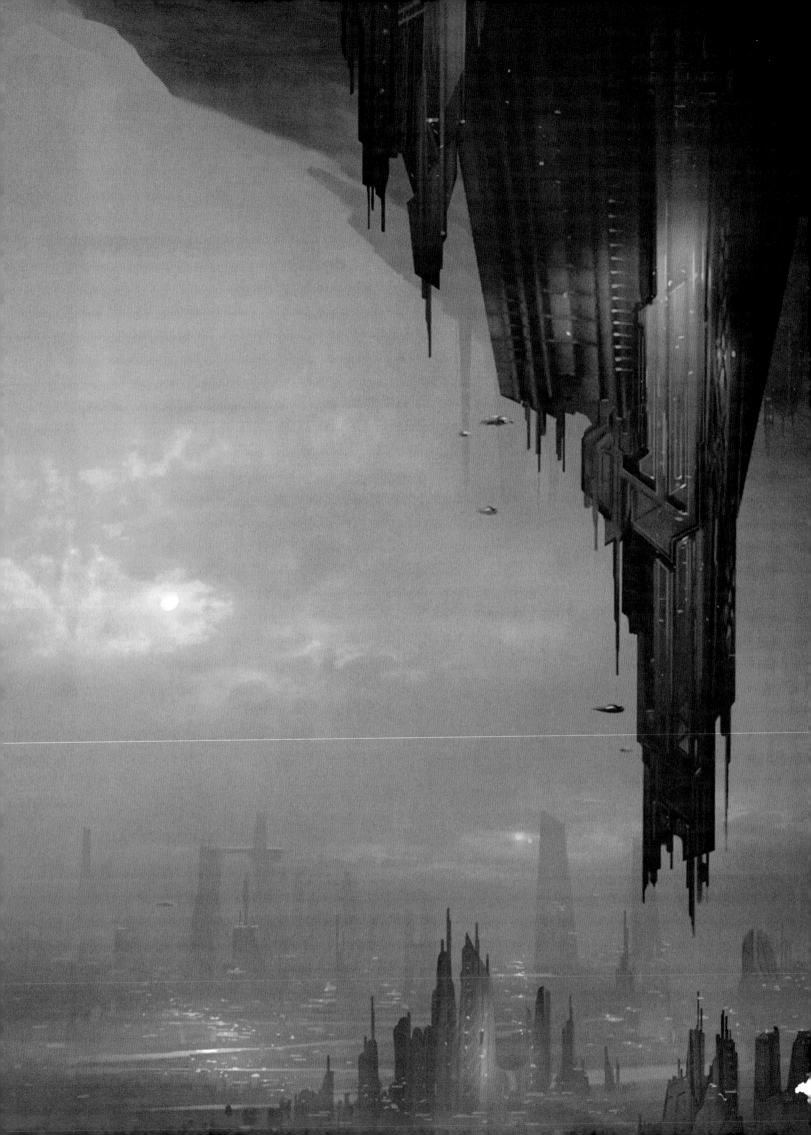

"This was the first concept sketch James and I did, based on the location of Vasquez Rocks, which has jutting planes and rock formations," Scott Chambliss explained. "I brought up the notion of city structures descending from underneath [rock formations], the notion of a whole world suspended, as well as supported. This is such a magical image, and completely informed the world."

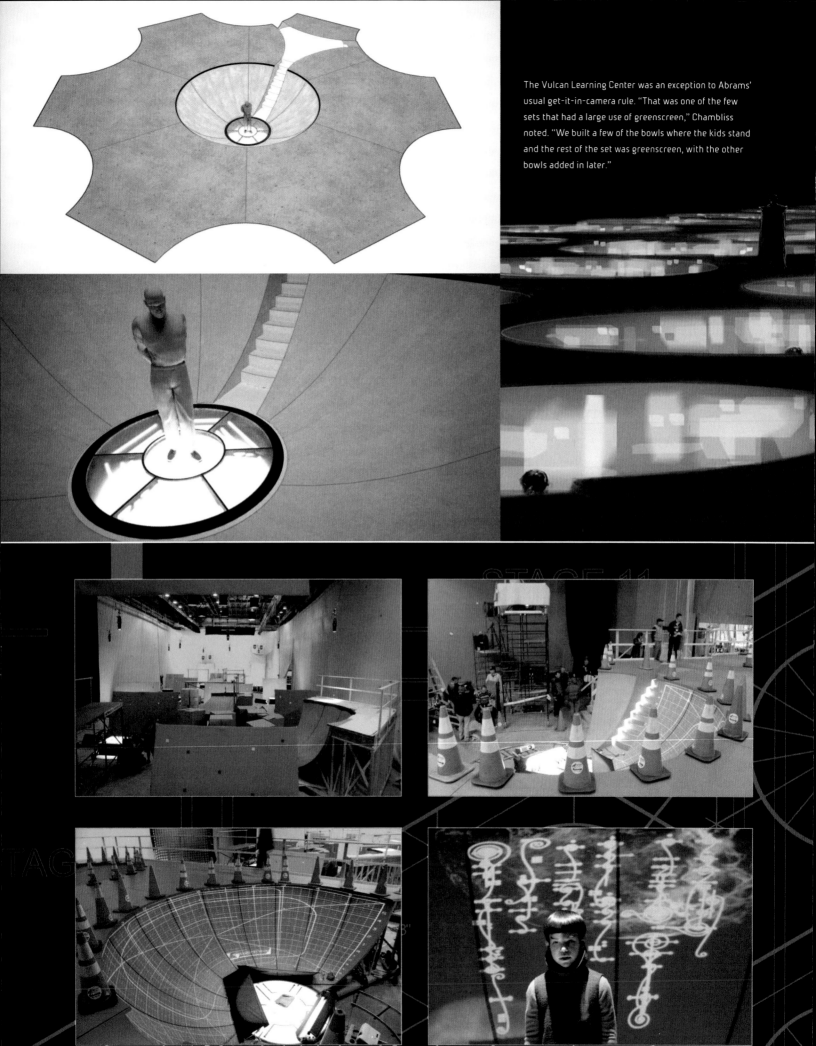

The Vulcan Learning Center was an exception to Abrams' usual get-it-in-camera rule. "That was one of the few sets that had a large use of greenscreen," Chambliss noted. "We built a few of the bowls where the kids stand and the rest of the set was greenscreen, with the other bowls added in later."

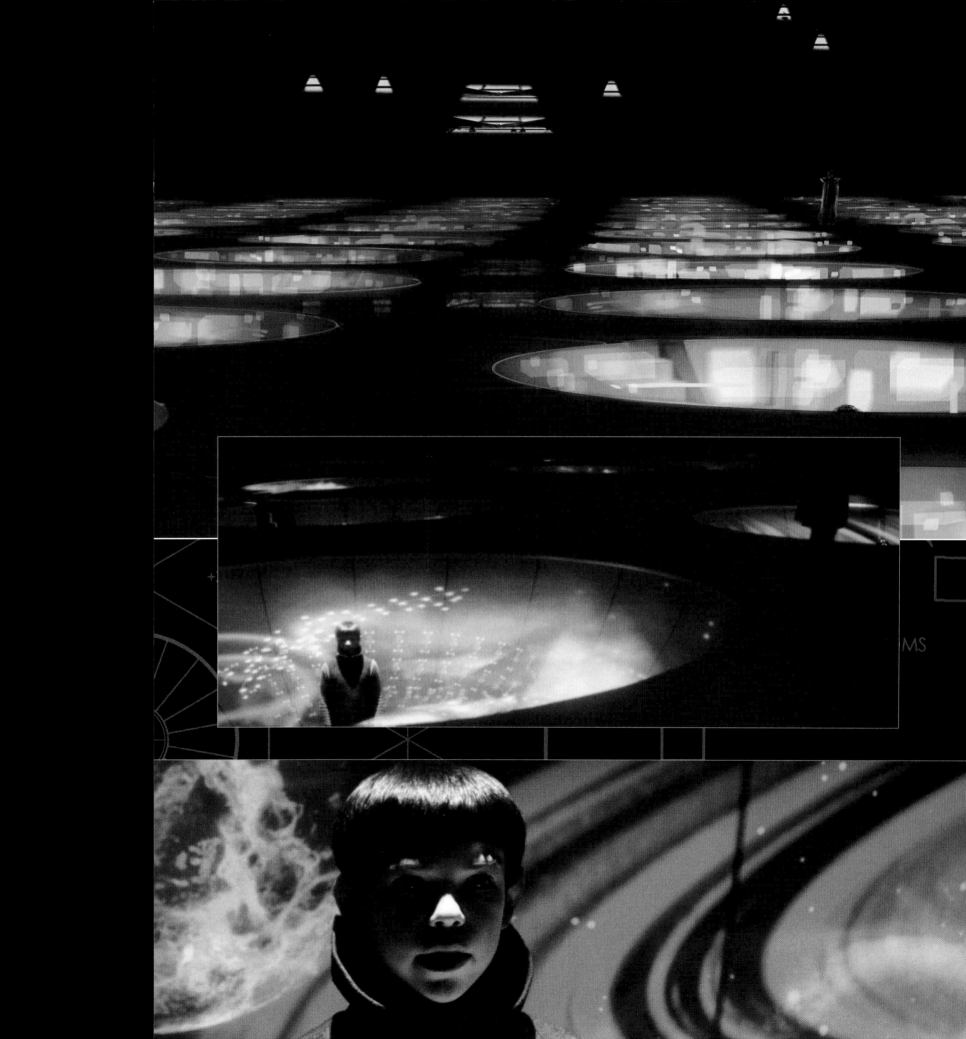

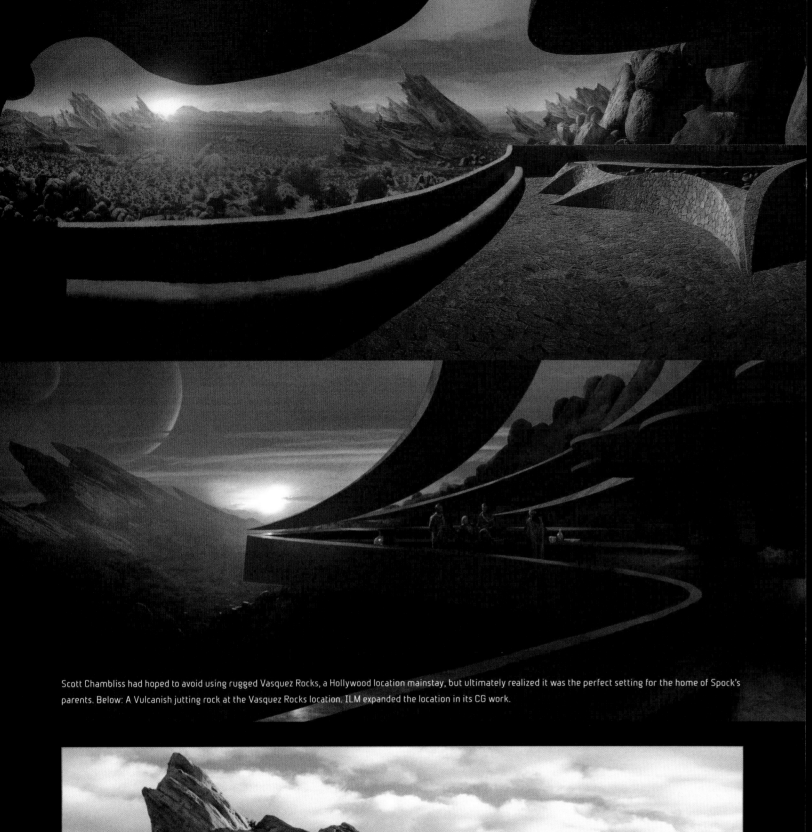

Scott Chambliss had hoped to avoid using rugged Vasquez Rocks, a Hollywood location mainstay, but ultimately realized it was the perfect setting for the home of Spock's parents. Below: A Vulcanish jutting rock at the Vasquez Rocks location. ILM expanded the location in its CG work.

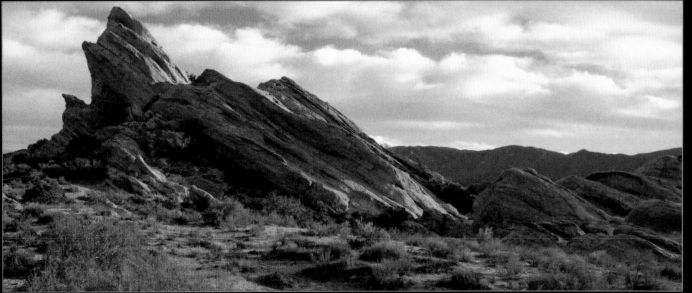

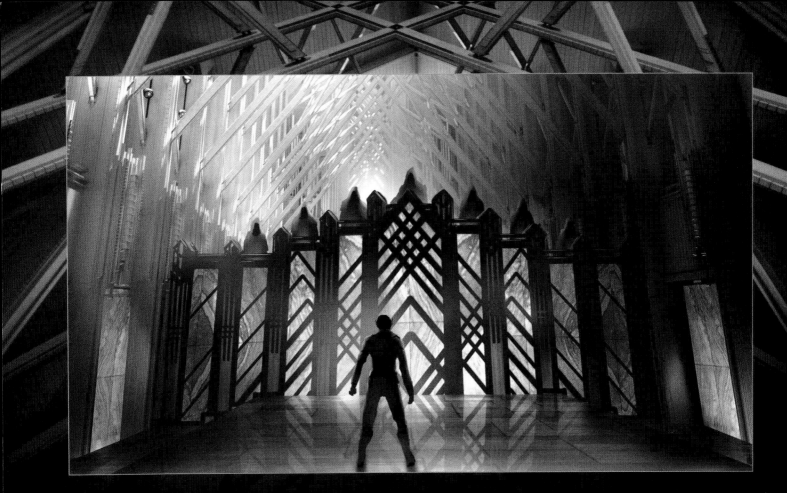

The scene of Spock facing the Vulcan Council was informed by J.J. Abrams squatting down and staring up into the roof of the location. That angle inspired the shot design of Vulcan Council members imperiously looming on high.

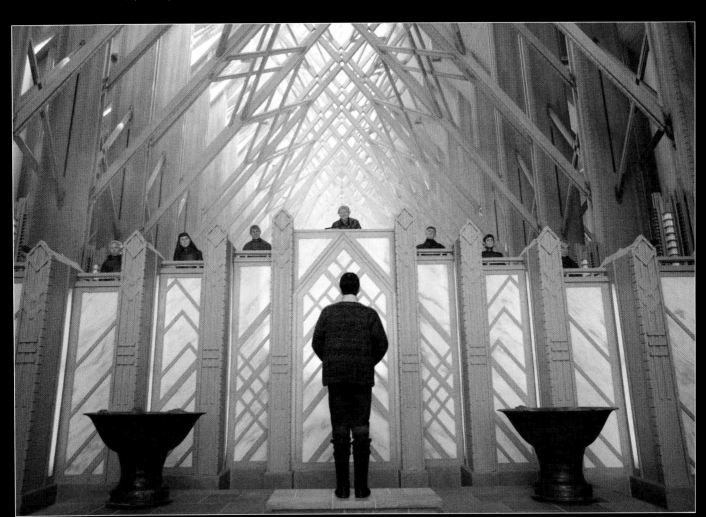

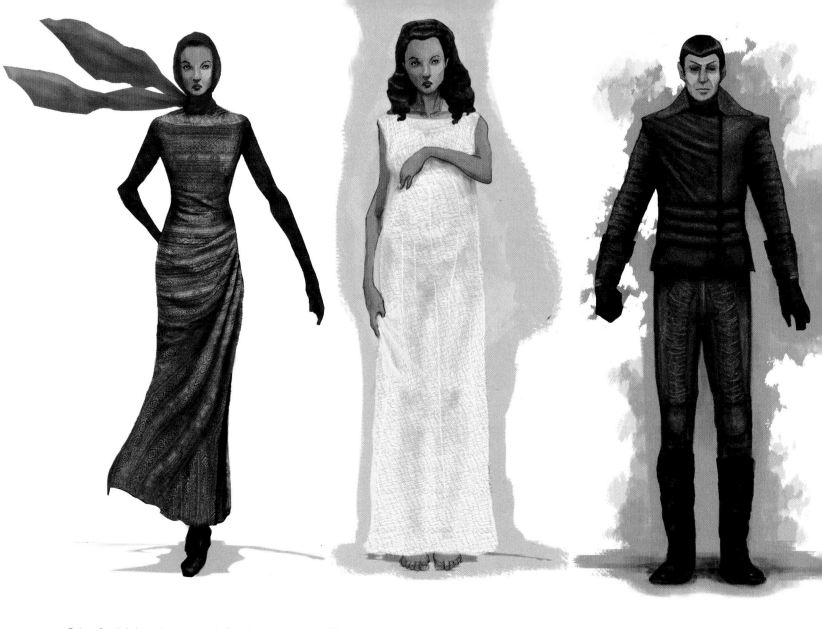

Below: Sarek (whose sleeves were designed to resemble armadillo skin) with Amanda, wearing the "birthing outfit" in which she delivers Spock. "For aliens and different people, I feel strongly each should have a specific look, that you know where they belong just by their costumes," Michael Kaplan explained. "For Vulcan, I looked for fabrics that *felt* Vulcan. I wanted their costumes to be elegant, more cerebral than emotional – all the things we know about Vulcans. A good script provides enough details about characters to provide a design direction. For me, it's about finding the truth of the individual movie you're working on."

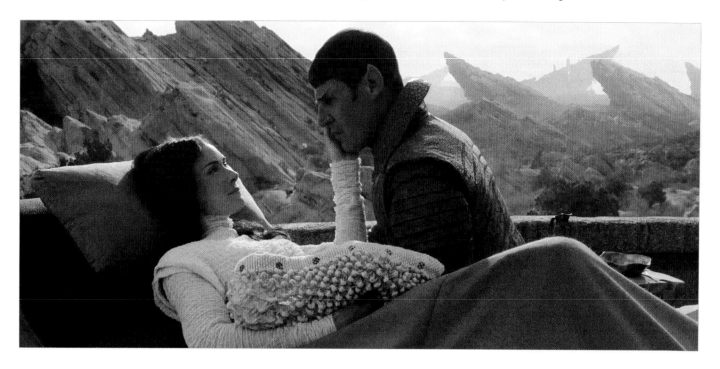

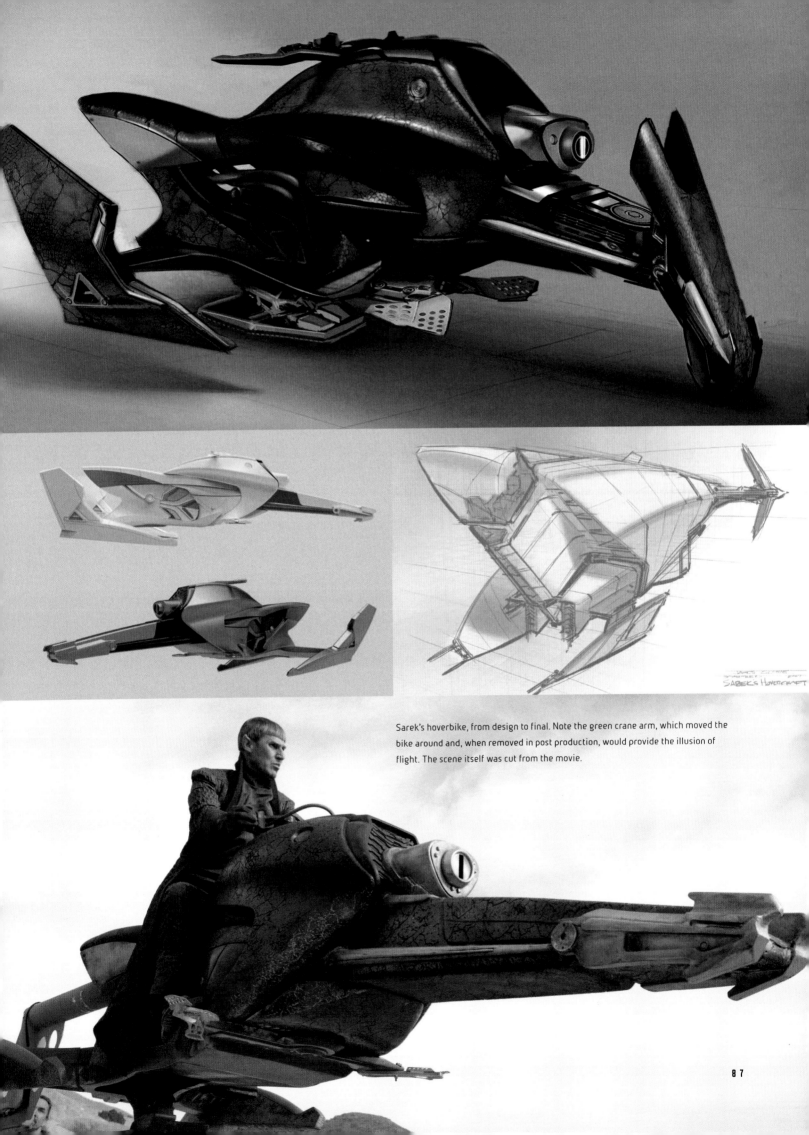

Sarek's hoverbike, from design to final. Note the green crane arm, which moved the bike around and, when removed in post production, would provide the illusion of flight. The scene itself was cut from the movie.

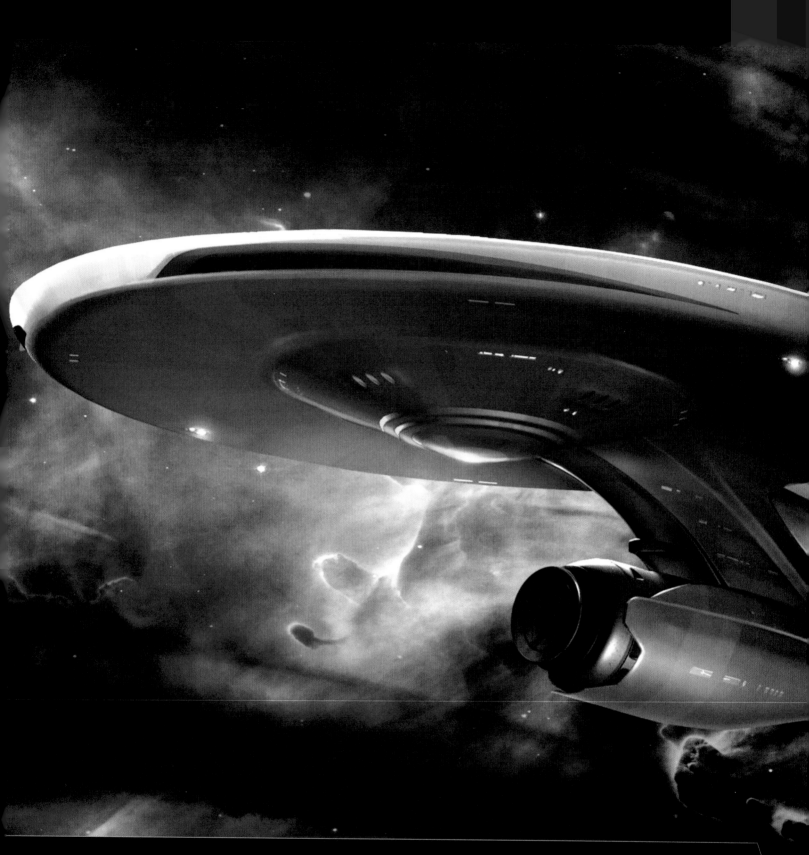

REIMAGINING THE U.S.S. ENTERPRISE

Previsualization lead David Dozoretz recalls virtually orbiting around a CG *Enterprise*, and gaining a fresh appreciation for the starship produced by visionary series creator Gene Roddenberry and his team. "It was so different from any ship that came before it and is probably the most photographed spaceship ever," Dozoretz noted. "This film's entire visual look is what I'd call 'polished realism.' I credit Scott, Ryan, James, and all the designers, because it was so tricky to do a 2009 version of the '60s." Ryan Church's final design of the *Enterprise* hewed to the iconic form of the original starship. However, unlike the static physical model from the classic series, the new

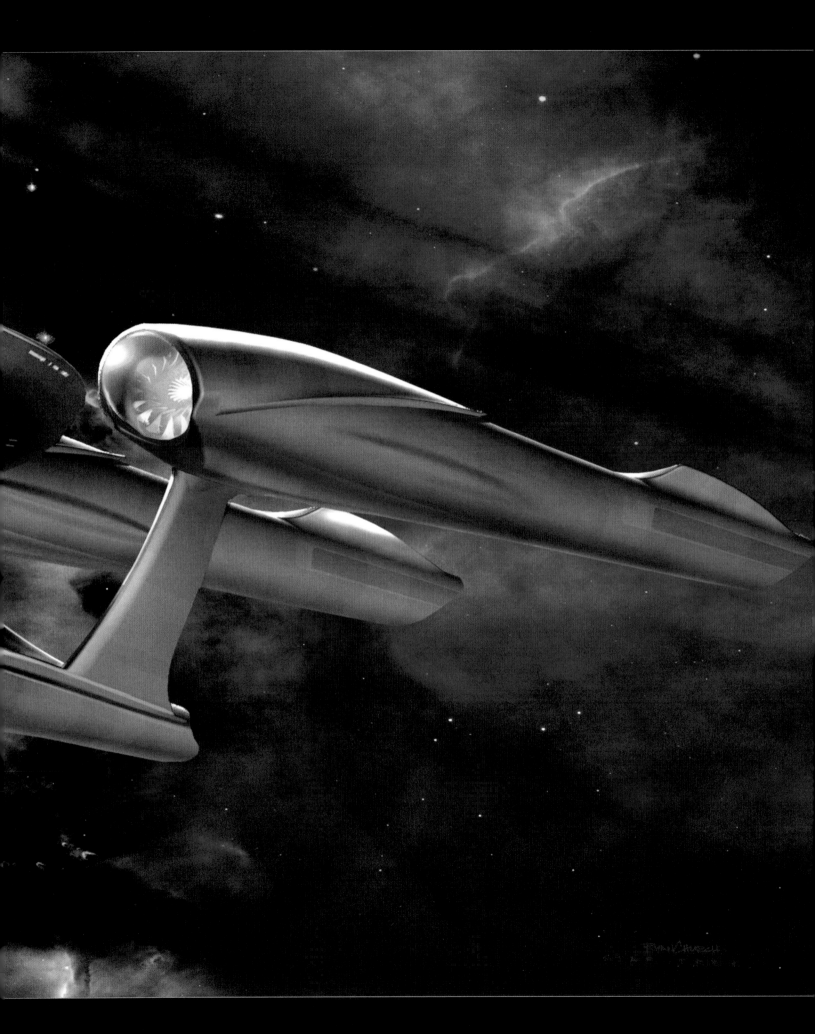

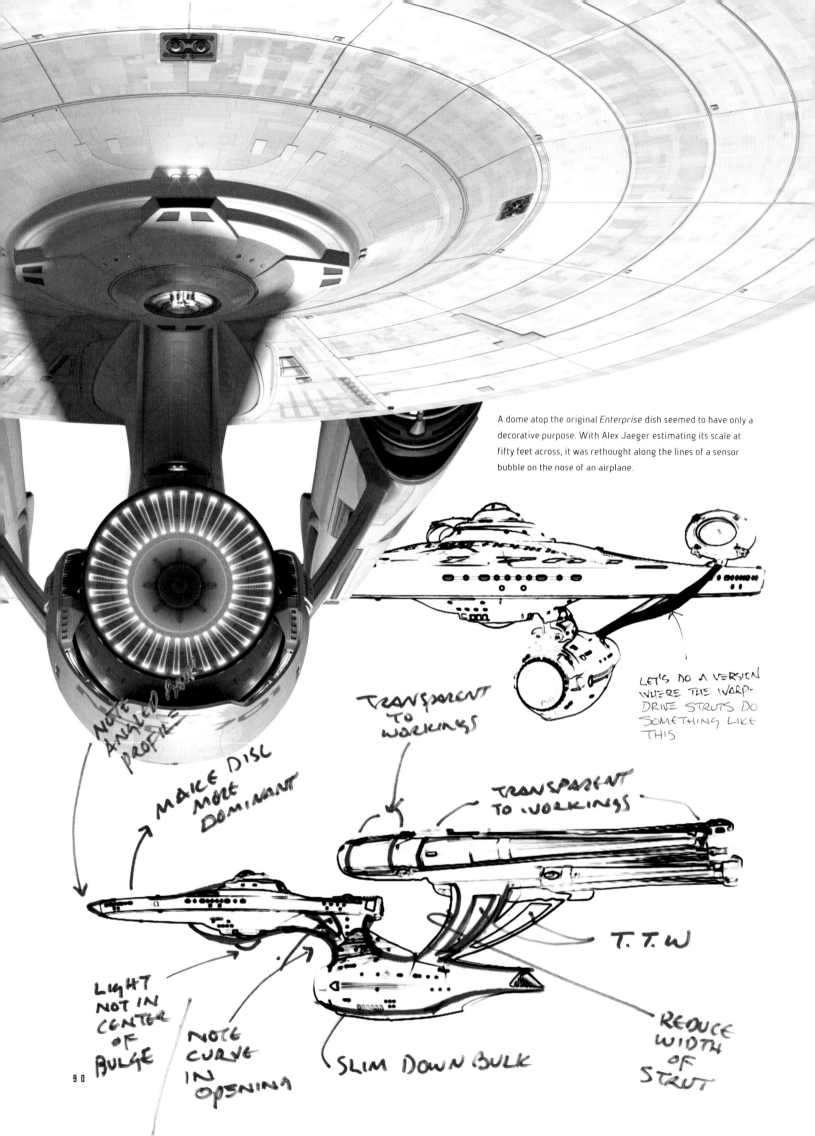

A dome atop the original *Enterprise* dish seemed to have only a decorative purpose. With Alex Jaeger estimating its scale at fifty feet across, it was rethought along the lines of a sensor bubble on the nose of an airplane.

NOTE ANGLED PROFILES

MAKE DISC MORE DOMINANT

TRANSPARENT TO WORKINGS

LET'S DO A VERSION WHERE THE WARP-DRIVE STRUTS DO SOMETHING LIKE THIS

TRANSPARENT TO WORKINGS

T. T. W

LIGHT NOT IN CENTER OF BULGE

NOTE CURVE IN OPENING

SLIM DOWN BULK

REDUCE WIDTH OF STRUT

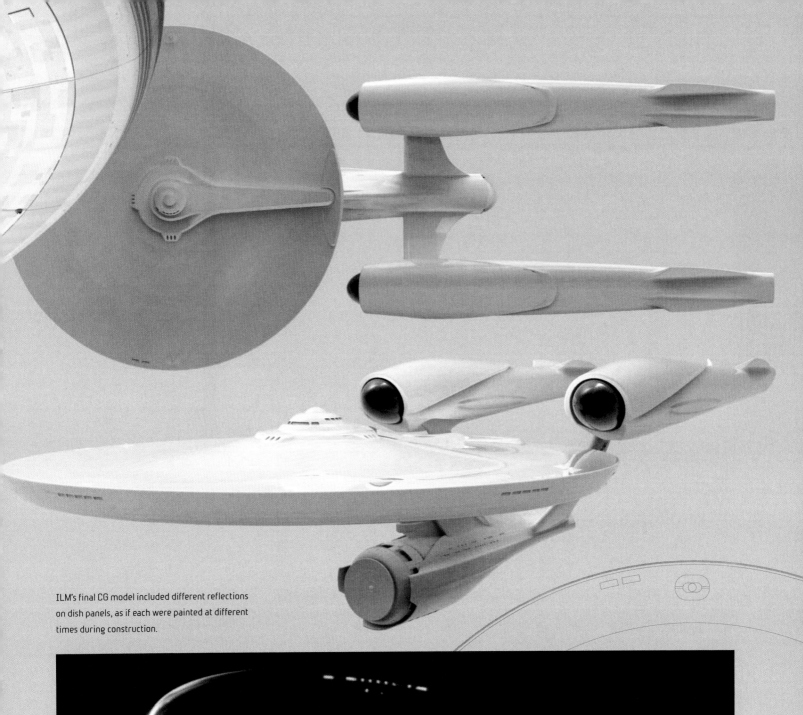

ILM's final CG model included different reflections on dish panels, as if each were painted at different times during construction.

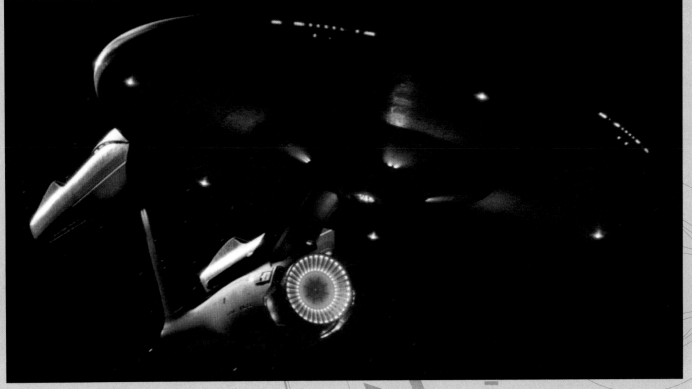

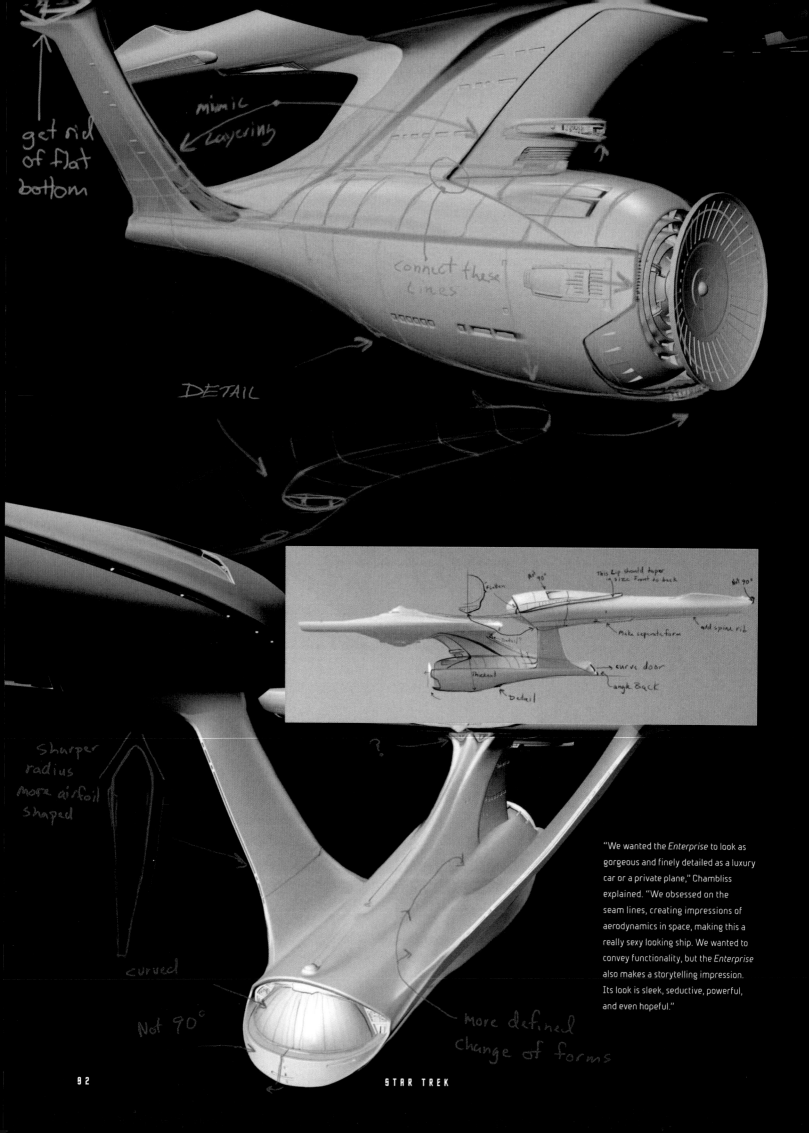

get rid
of flat
bottom

mimic
Layering

connect these
lines

DETAIL

This Lip should taper
in size Front to back

Hit 90°

Flatten

Hit 90°

add spine rib

Make separate form

curve door
angle Back

Thicken

Detail?

Detail

Sharper
radius
more airfoil
shaped

curved

Not 90°

more defined
change of forms

"We wanted the *Enterprise* to look as
gorgeous and finely detailed as a luxury
car or a private plane," Chambliss
explained. "We obsessed on the
seam lines, creating impressions of
aerodynamics in space, making this a
really sexy looking ship. We wanted to
convey functionality, but the *Enterprise*
also makes a storytelling impression.
Its look is sleek, seductive, powerful,
and even hopeful."

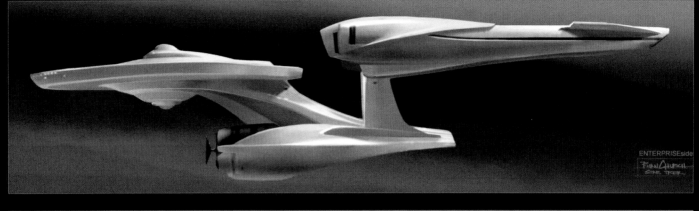

ENTERPRISEside

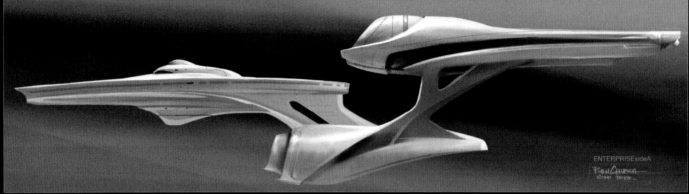

ENTERPRISEsideA

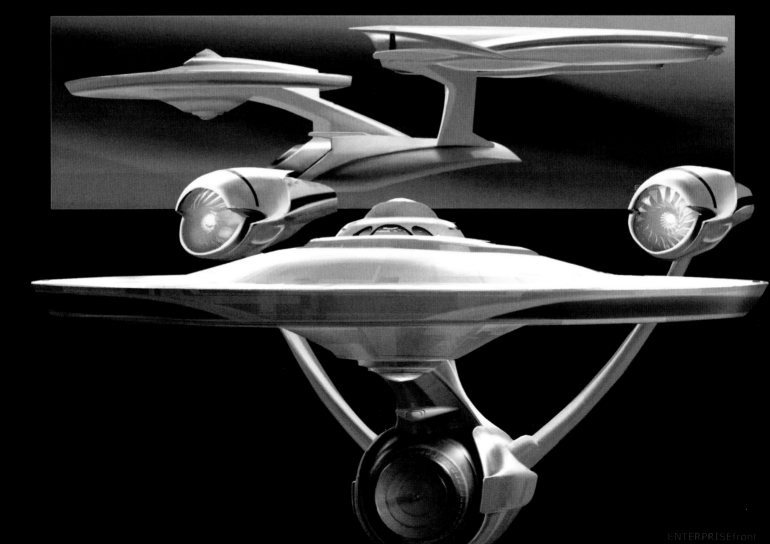

ENTERPRISEfront

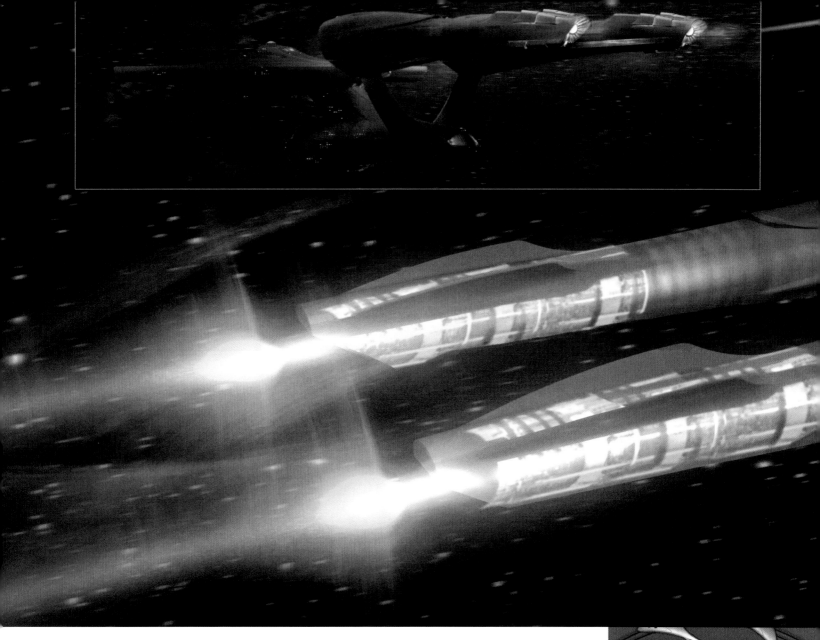

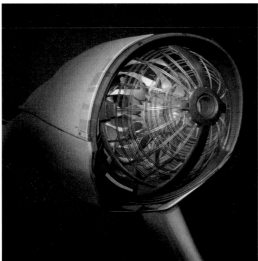

Nacelle Front Structure (Bussard Collector)
in OFF / Construction state.
Dome cage holds a series of emitters.
There is no physical glass dome.

CHQ Cantina Details 12/07/07 A. Jaeger ILM

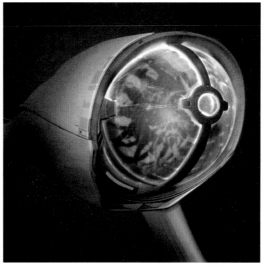

Nacelle Front Structure (Bussard Collector)
in ON / Flight state.
The dome shell is actually a field of energy that
collects particles to power the engine. Animation
comes from the revolving blades behind and the
particles passing through the field creating hot spots..

STAR TREK

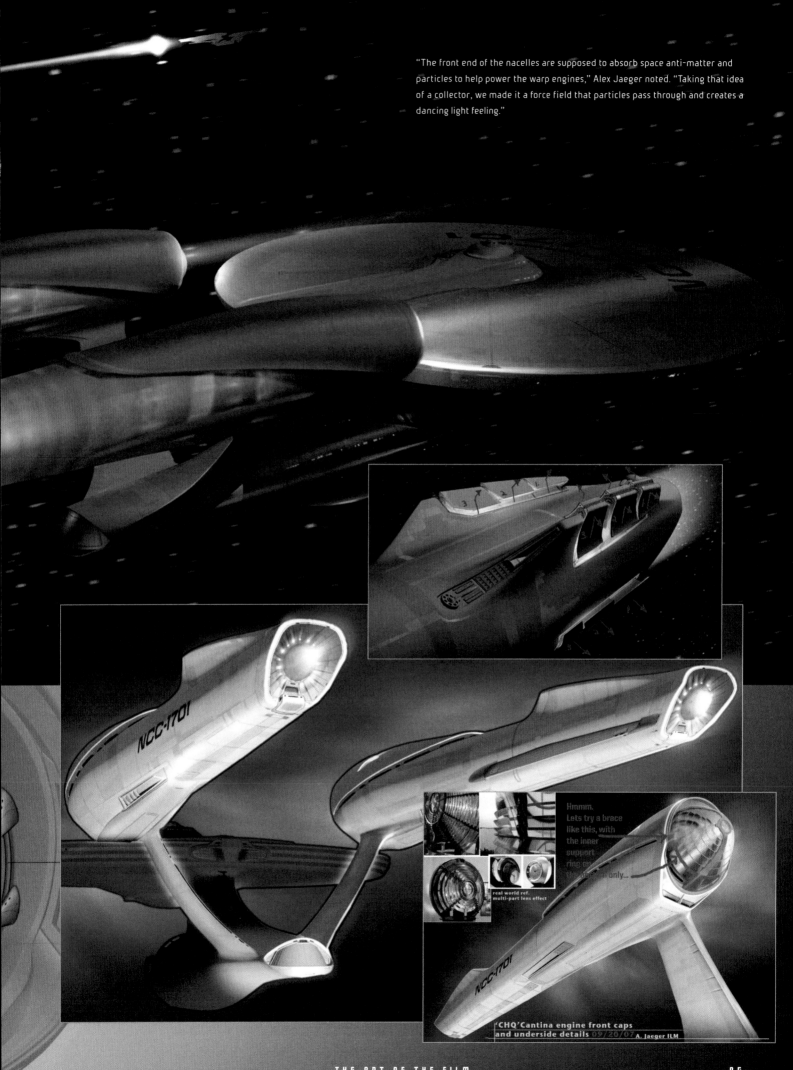

"The front end of the nacelles are supposed to absorb space anti-matter and particles to help power the warp engines," Alex Jaeger noted. "Taking that idea of a collector, we made it a force field that particles pass through and creates a dancing light feeling."

NCC-1701

NCC-1701

Hmmm.
Lets try a brace like this, with the inner support ring cut two sided only...

real world ref.
multi-part lens effect

'CHQ'Cantina engine front caps
and underside details 09/20/07 A. Jaeger ILM

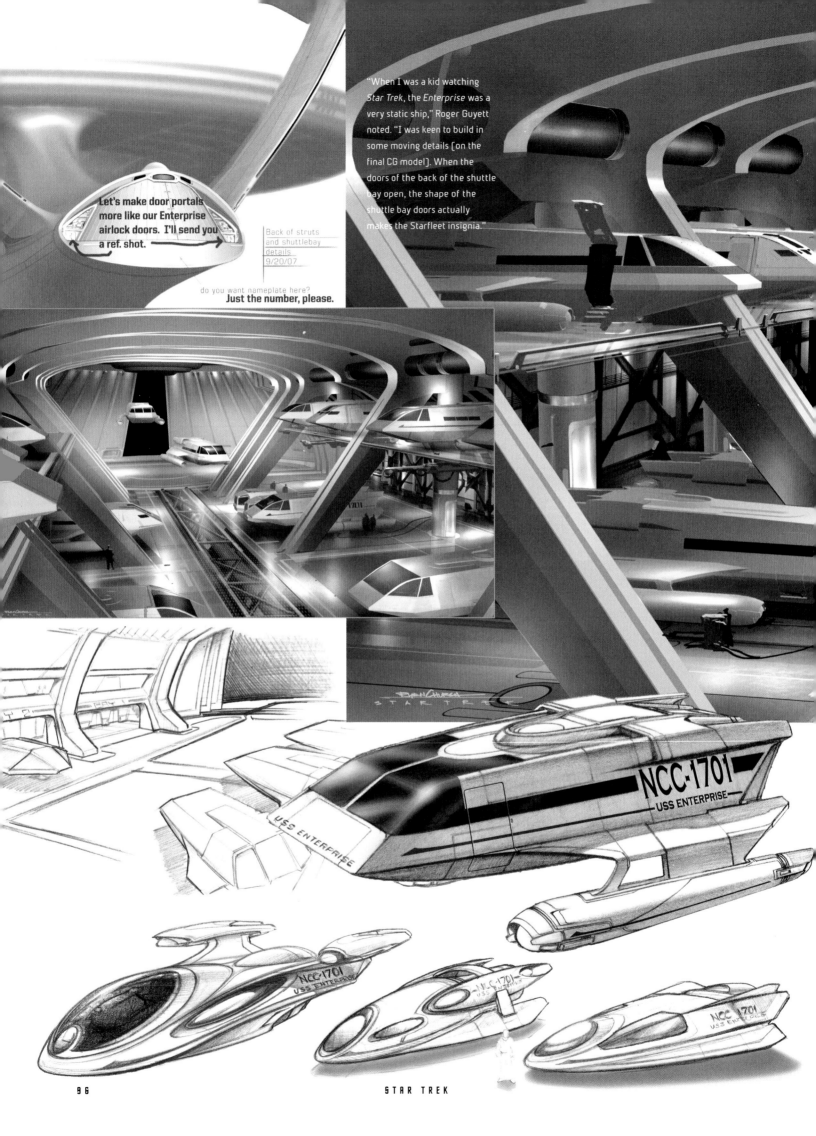

Let's make door portals more like our Enterprise airlock doors. I'll send you a ref. shot. →

Back of struts and shuttlebay details 9/20/07

do you want nameplate here? **Just the number, please.**

"When I was a kid watching *Star Trek*, the *Enterprise* was a very static ship," Roger Guyett noted. "I was keen to build in some moving details (on the final CG model). When the doors of the back of the shuttle bay open, the shape of the shuttle bay doors actually makes the Starfleet insignia."

NCC-1701
USS ENTERPRISE

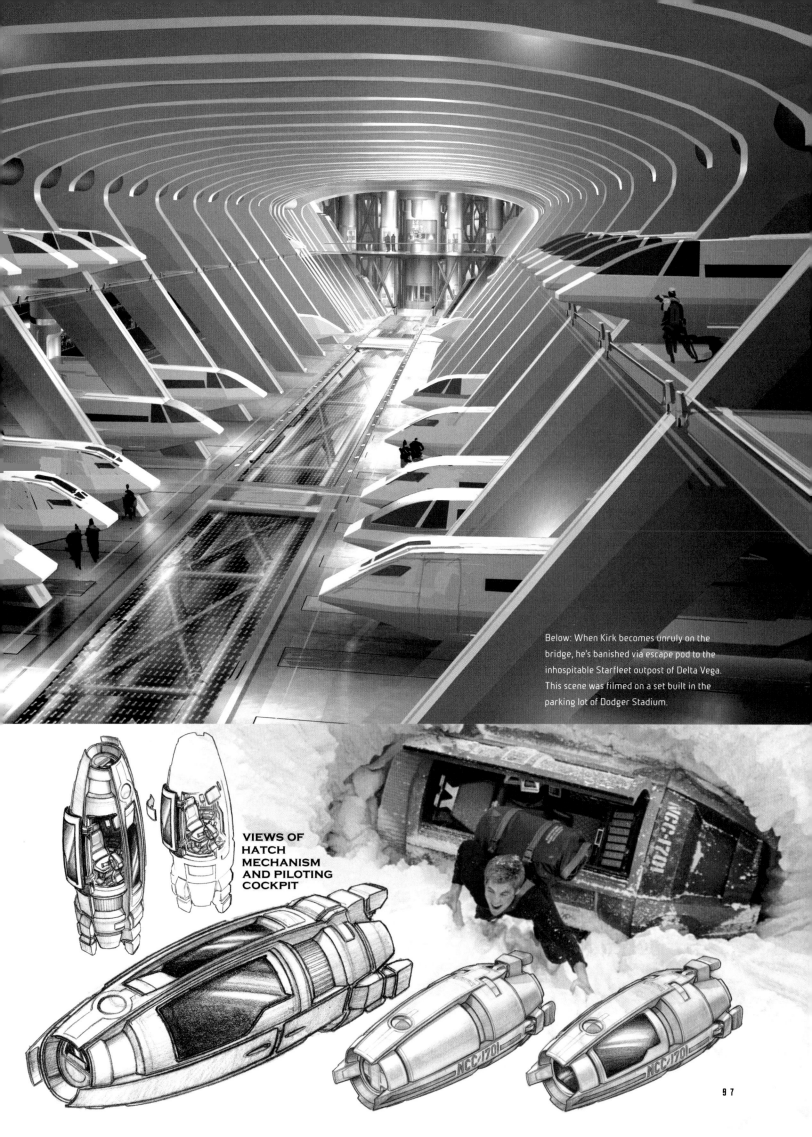

Below: When Kirk becomes unruly on the bridge, he's banished via escape pod to the inhospitable Starfleet outpost of Delta Vega. This scene was filmed on a set built in the parking lot of Dodger Stadium.

VIEWS OF HATCH MECHANISM AND PILOTING COCKPIT

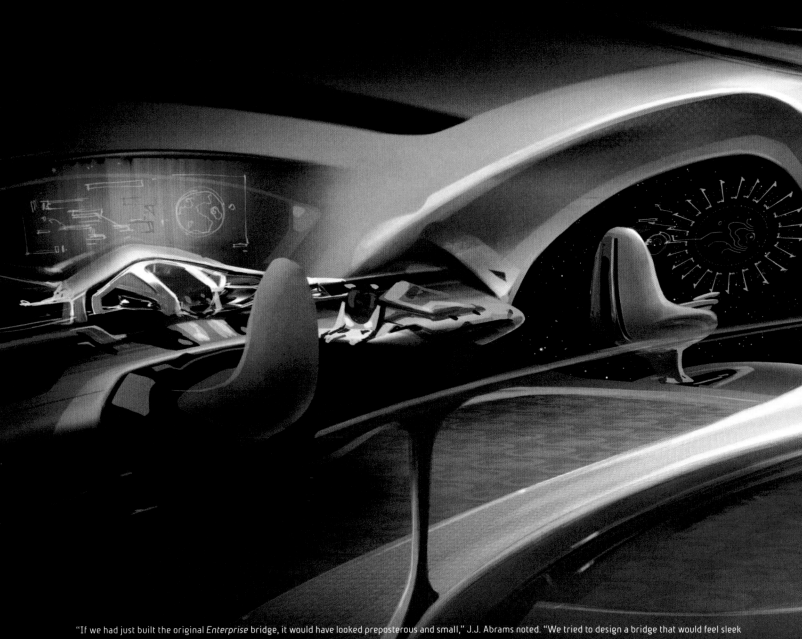

"If we had just built the original *Enterprise* bridge, it would have looked preposterous and small," J.J. Abrams noted. "We tried to design a bridge that would feel sleek and modern in comparison to the submarine-like, almost Soviet-era design of the *Kelvin*."

Ryan Church's early designs had the iconic central captain's chair, work stations, and view screen, with shapes flowing in a stylized, integrated, and functional design.

Far right: Production designer Scott Chambliss on the final set.

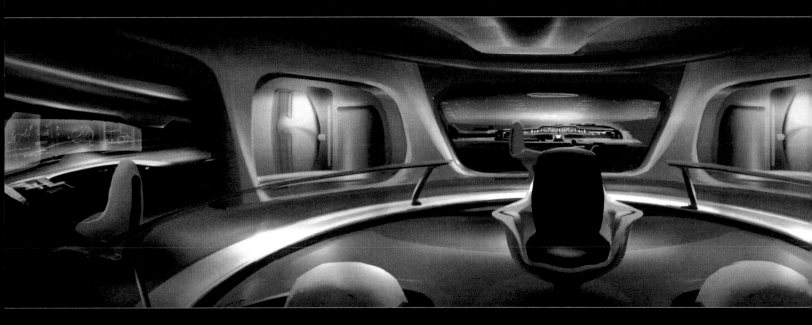

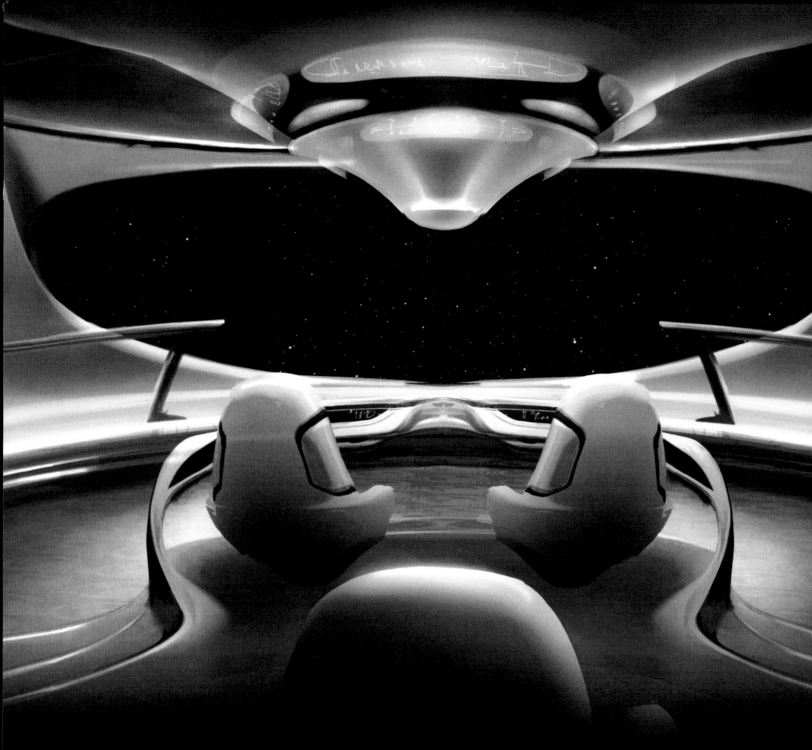

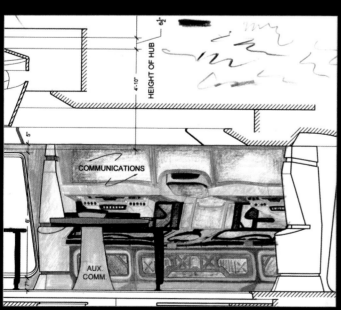

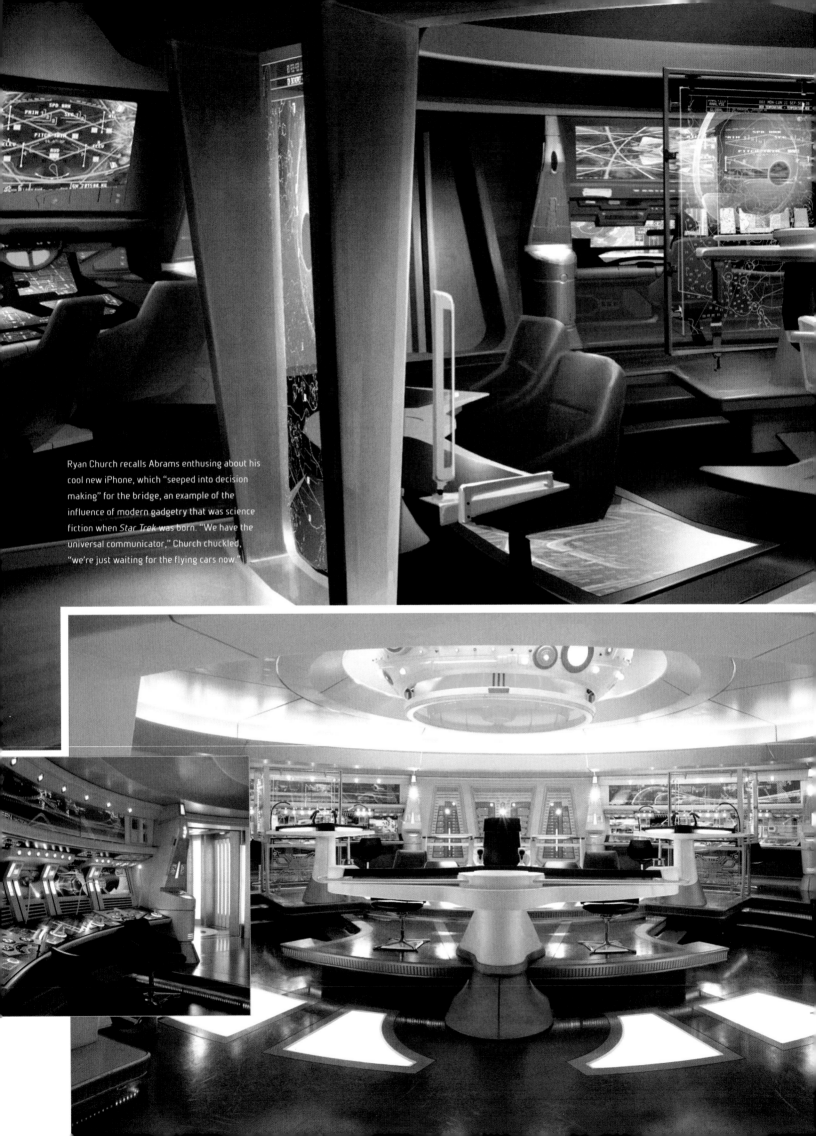

Ryan Church recalls Abrams enthusing about his cool new iPhone, which "seeped into decision making" for the bridge, an example of the influence of modern gadgetry that was science fiction when *Star Trek* was born. "We have the universal communicator," Church chuckled, "we're just waiting for the flying cars now."

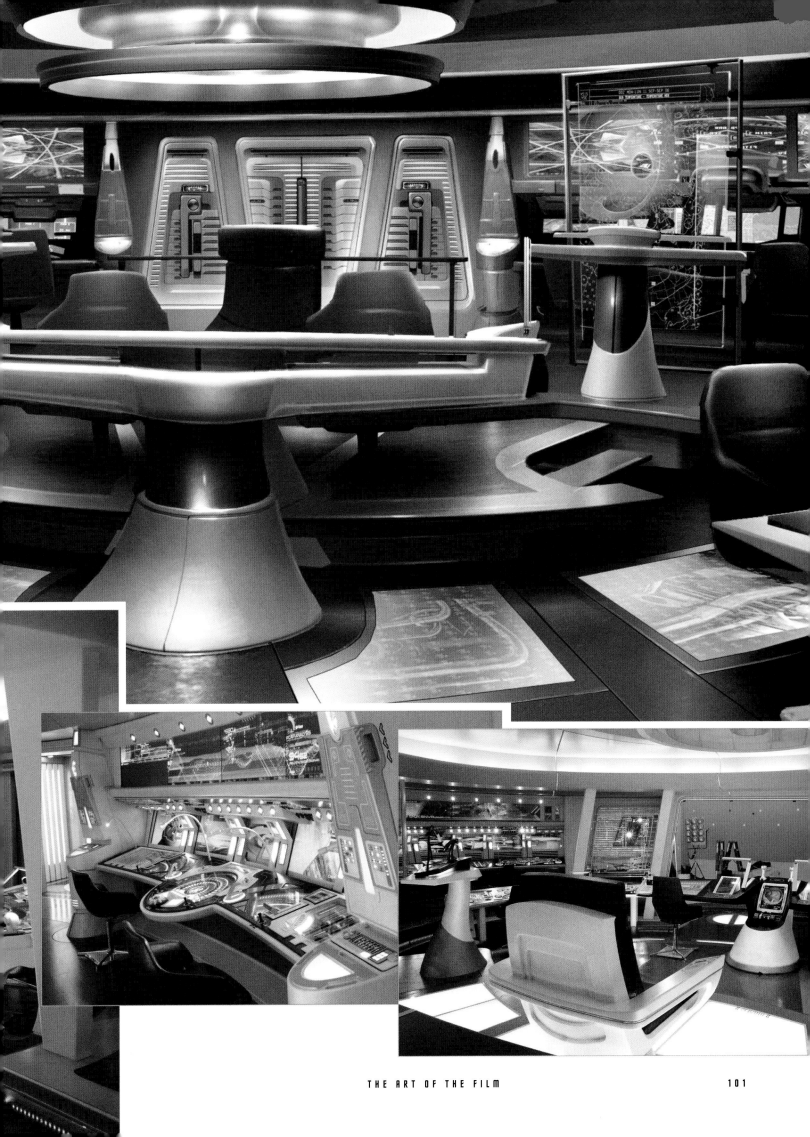

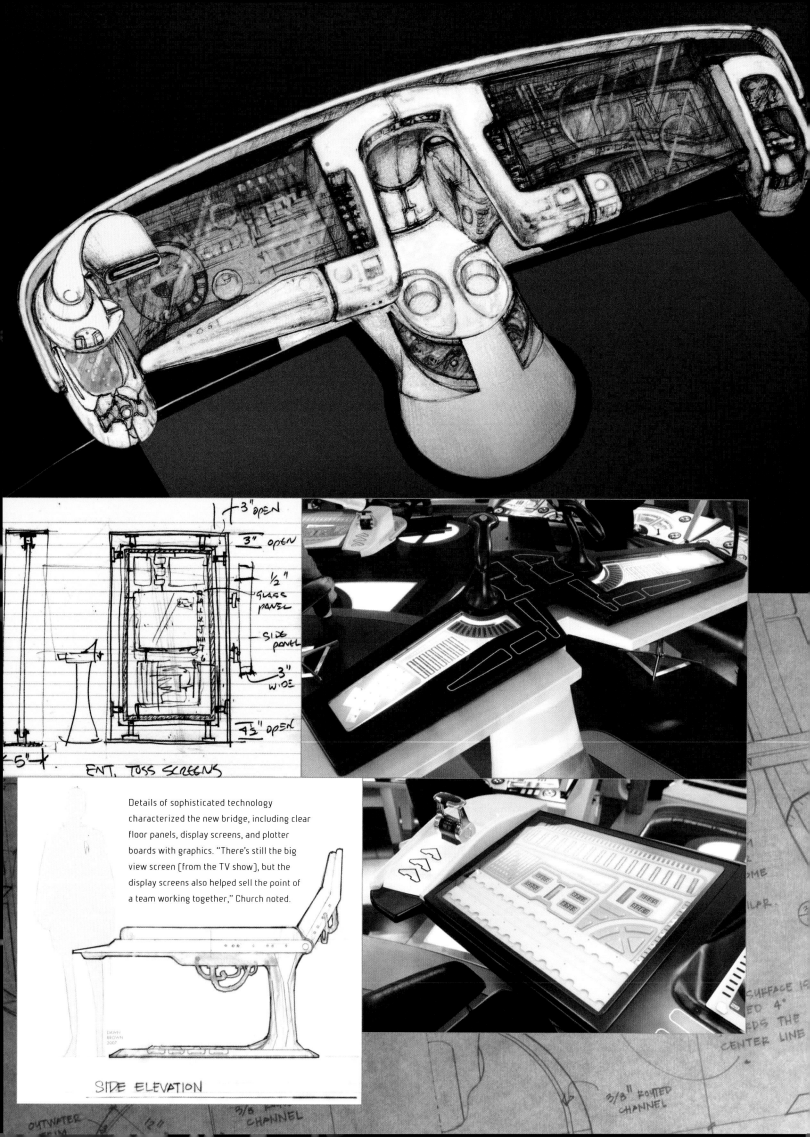

Details of sophisticated technology characterized the new bridge, including clear floor panels, display screens, and plotter boards with graphics. "There's still the big view screen (from the TV show), but the display screens also helped sell the point of a team working together," Church noted.

SIDE ELEVATION

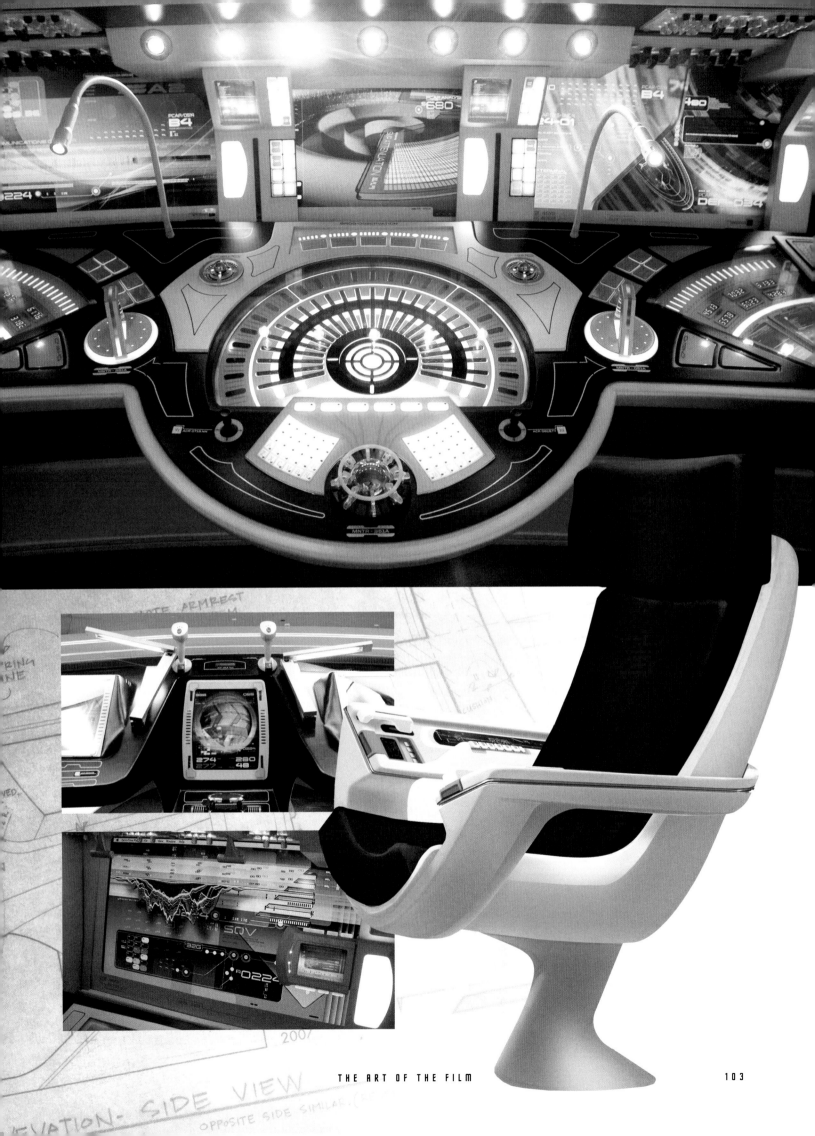

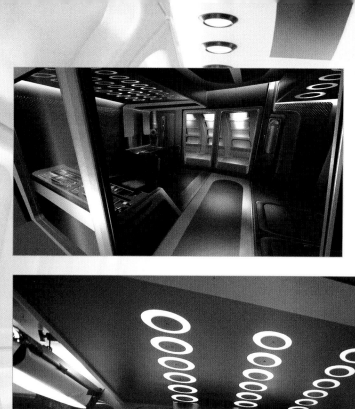

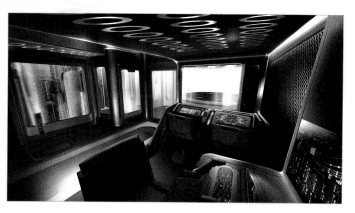

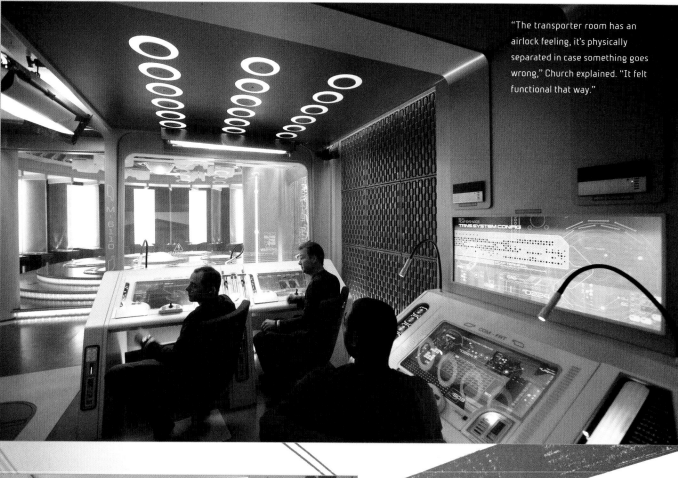

"The transporter room has an airlock feeling, it's physically separated in case something goes wrong," Church explained. "It felt functional that way."

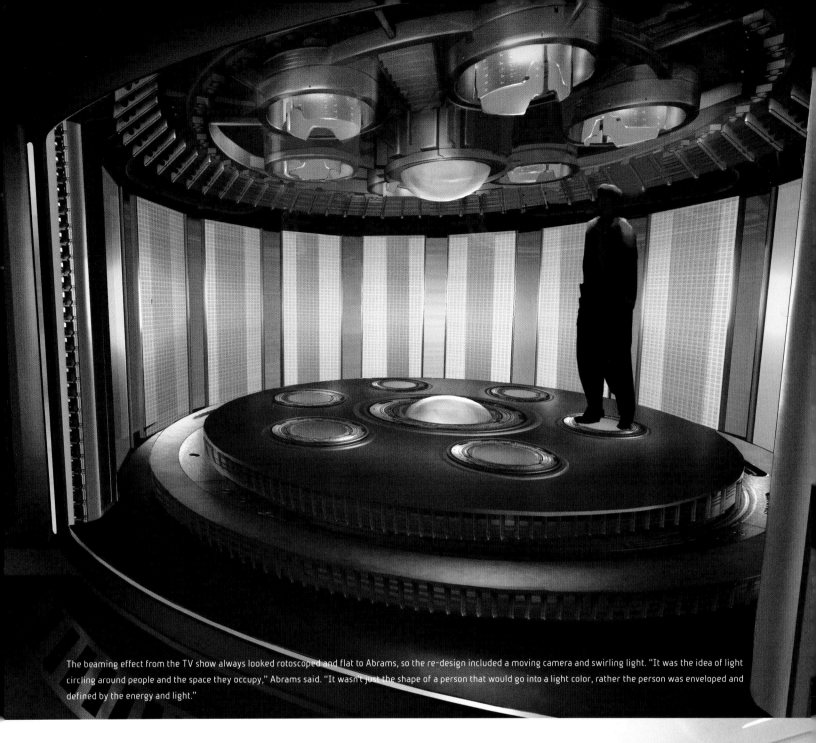

The beaming effect from the TV show always looked rotoscoped and flat to Abrams, so the re-design included a moving camera and swirling light. "It was the idea of light circling around people and the space they occupy," Abrams said. "It wasn't just the shape of a person that would go into a light color, rather the person was enveloped and defined by the energy and light."

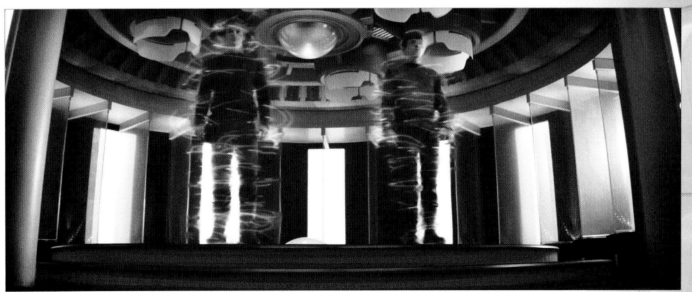

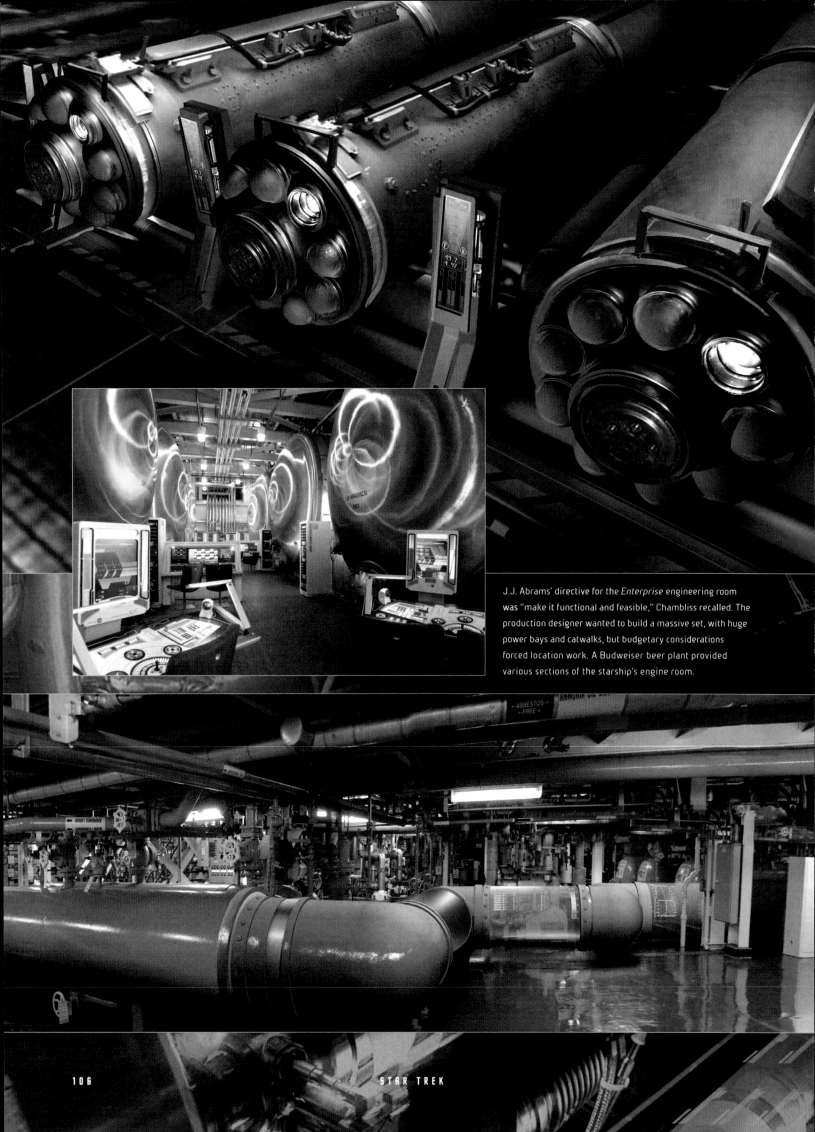

J.J. Abrams' directive for the *Enterprise* engineering room was "make it functional and feasible," Chambliss recalled. The production designer wanted to build a massive set, with huge power bays and catwalks, but budgetary considerations forced location work. A Budweiser beer plant provided various sections of the starship's engine room.

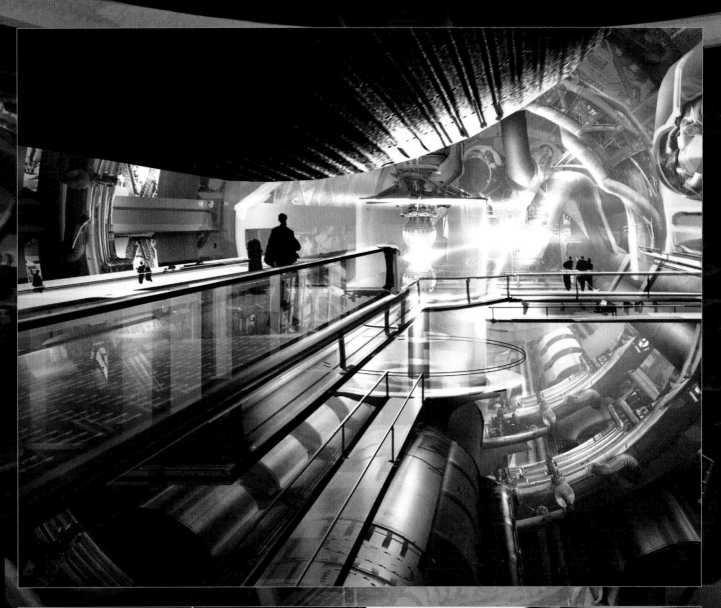

1. Explosive bolts break the seal in the roof doors. This should look like small white bursts.

2. The doors are then sucked out into space along with any debris from the explosive bolt charges

3. Guid rails stop half way up and the core continues out through the holes in the roof.

CHQ BH1390 WARP CORE EJECT SEQUENCE OF EVENTS

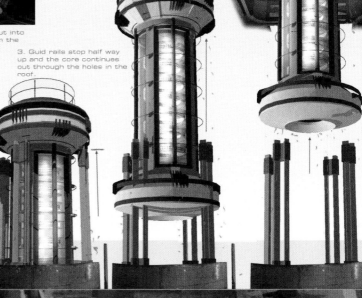

2.Core and top of canister pop up and connecting pipes break. Guid rails move up with core.

1. Eplosive bolts break the seal Panels in the roof explode off in the same manner. (The doors fly off into space)

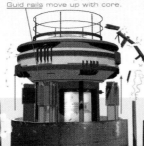

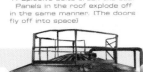

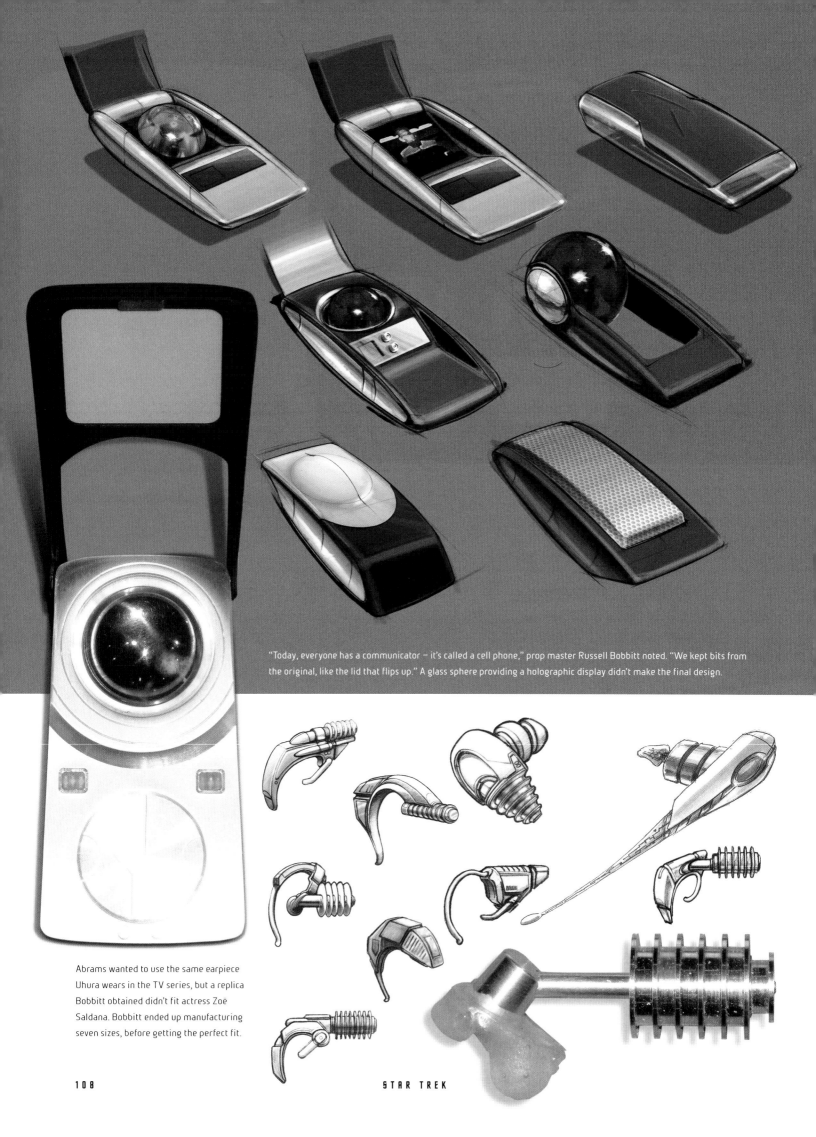

"Today, everyone has a communicator – it's called a cell phone," prop master Russell Bobbitt noted. "We kept bits from the original, like the lid that flips up." A glass sphere providing a holographic display didn't make the final design.

Abrams wanted to use the same earpiece Uhura wears in the TV series, but a replica Bobbitt obtained didn't fit actress Zoë Saldana. Bobbitt ended up manufacturing seven sizes, before getting the perfect fit.

STAR TREK

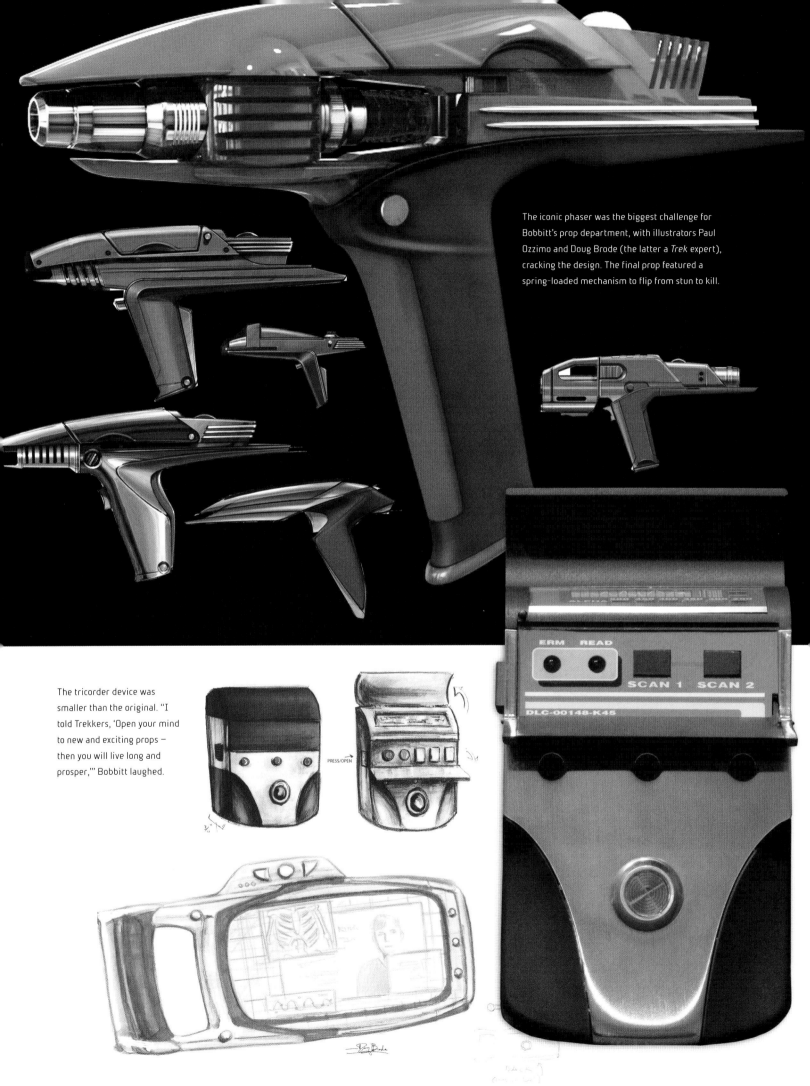

The iconic phaser was the biggest challenge for Bobbitt's prop department, with illustrators Paul Ozzimo and Doug Brode (the latter a *Trek* expert), cracking the design. The final prop featured a spring-loaded mechanism to flip from stun to kill.

The tricorder device was smaller than the original. "I told Trekkers, 'Open your mind to new and exciting props — then you will live long and prosper,'" Bobbitt laughed.

PRESS/OPEN

ERM READ

SCAN 1 SCAN 2

DLC-00148-K45

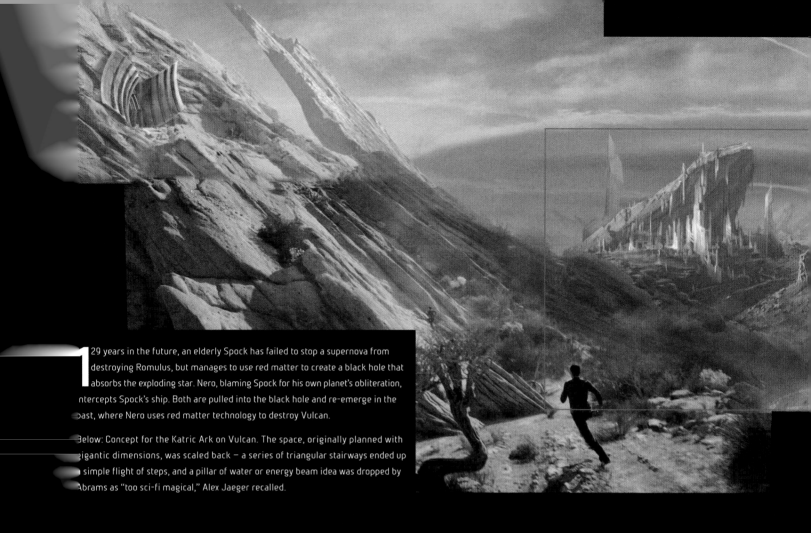

129 years in the future, an elderly Spock has failed to stop a supernova from destroying Romulus, but manages to use red matter to create a black hole that absorbs the exploding star. Nero, blaming Spock for his own planet's obliteration, intercepts Spock's ship. Both are pulled into the black hole and re-emerge in the past, where Nero uses red matter technology to destroy Vulcan.

Below: Concept for the Katric Ark on Vulcan. The space, originally planned with gigantic dimensions, was scaled back – a series of triangular stairways ended up a simple flight of steps, and a pillar of water or energy beam idea was dropped by Abrams as "too sci-fi magical," Alex Jaeger recalled.

THE DESTRUCTION OF VULCAN

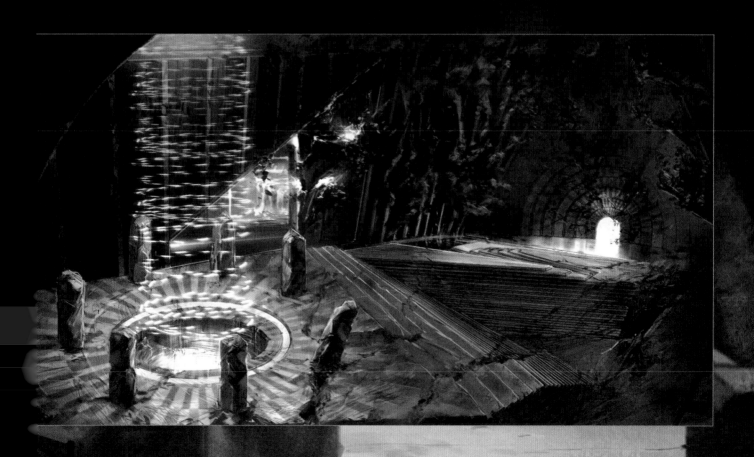

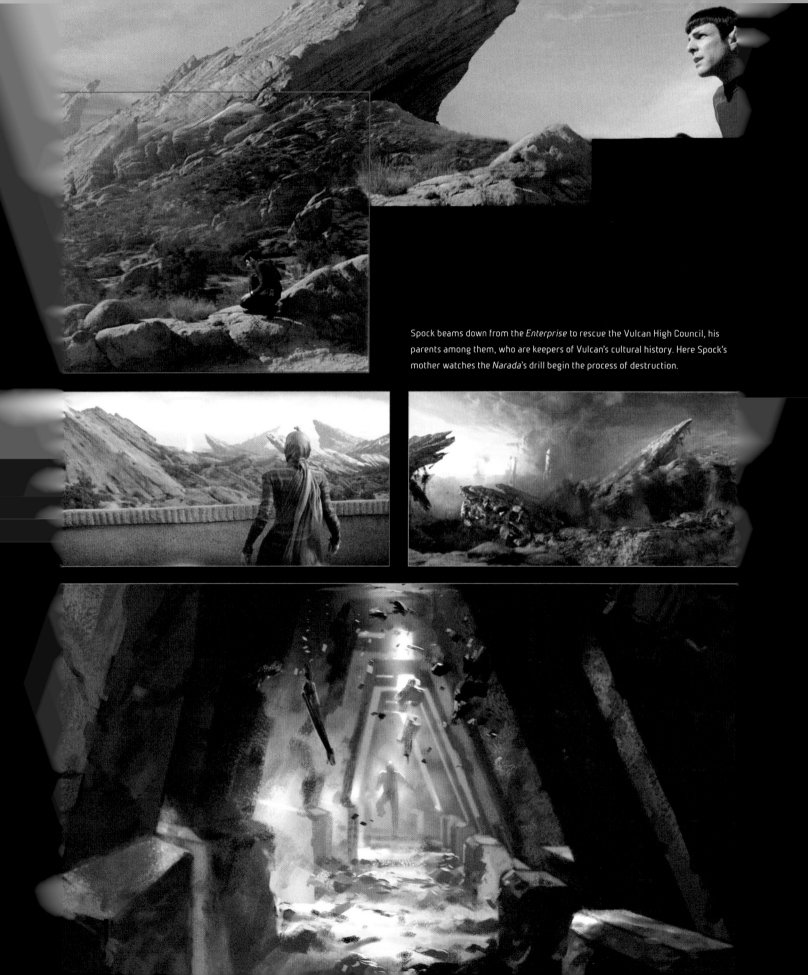

Spock beams down from the *Enterprise* to rescue the Vulcan High Council, his parents among them, who are keepers of Vulcan's cultural history. Here Spock's mother watches the *Narada*'s drill begin the process of destruction.

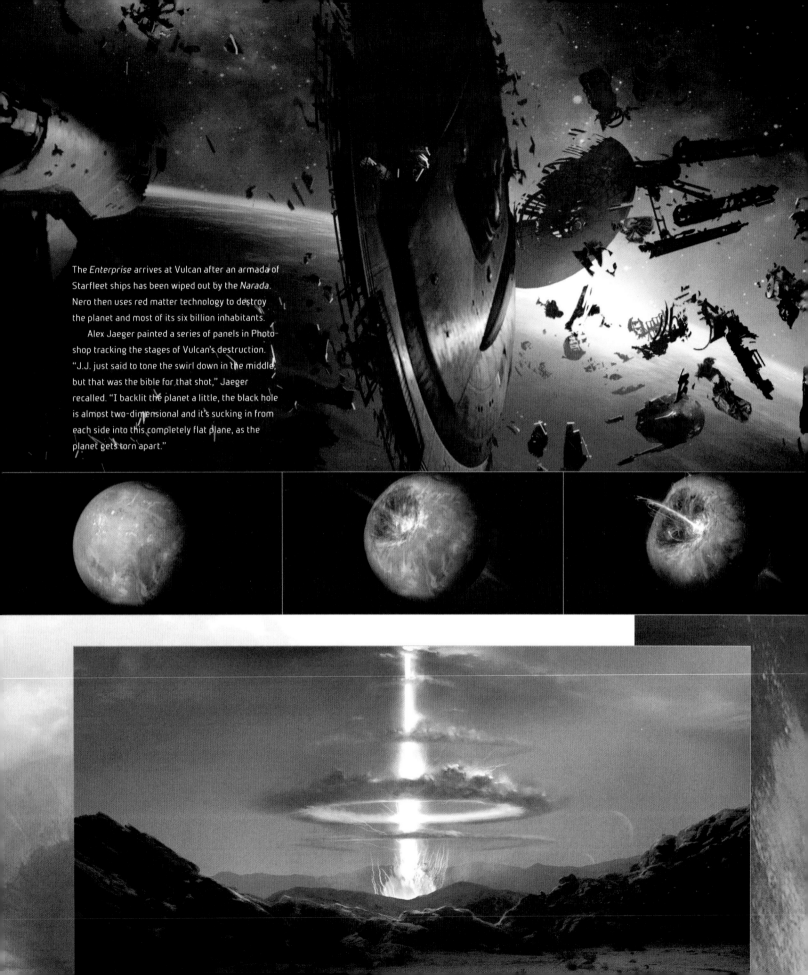

The *Enterprise* arrives at Vulcan after an armada of Starfleet ships has been wiped out by the *Narada*. Nero then uses red matter technology to destroy the planet and most of its six billion inhabitants.

Alex Jaeger painted a series of panels in Photoshop tracking the stages of Vulcan's destruction. "J.J. just said to tone the swirl down in the middle, but that was the bible for that shot," Jaeger recalled. "I backlit the planet a little, the black hole is almost two-dimensional and it's sucking in from each side into this completely flat plane, as the planet gets torn apart."

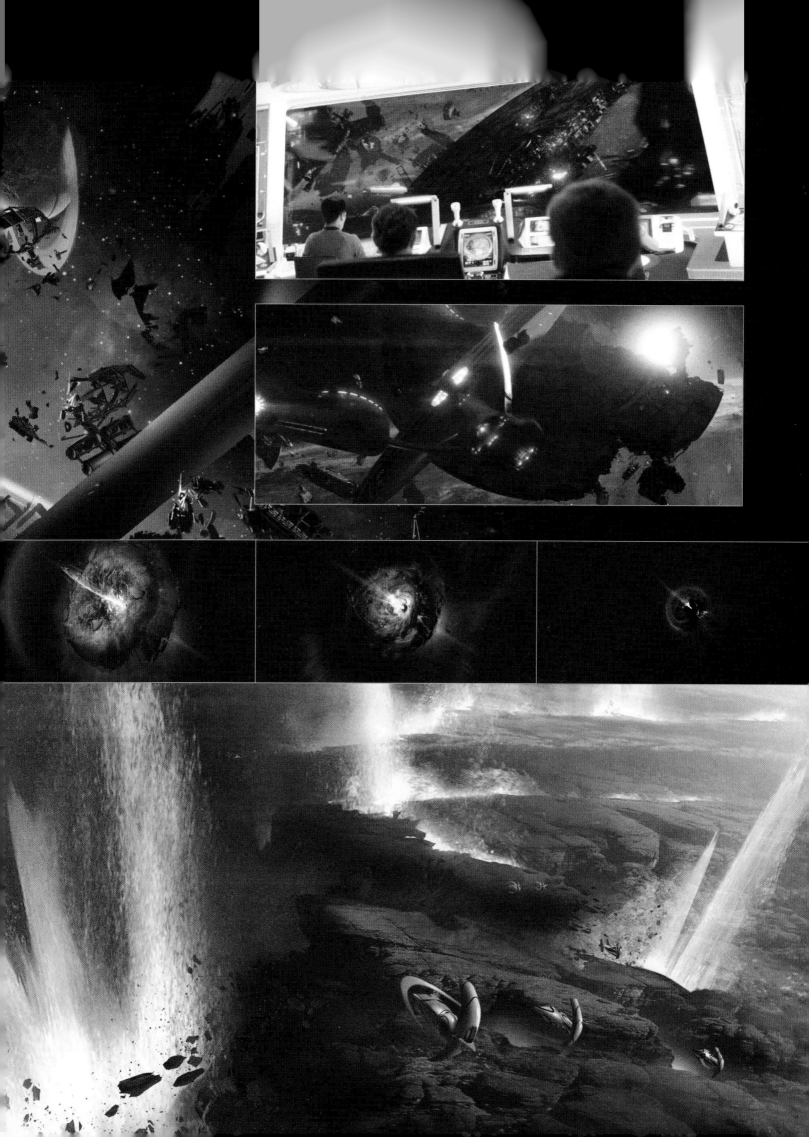

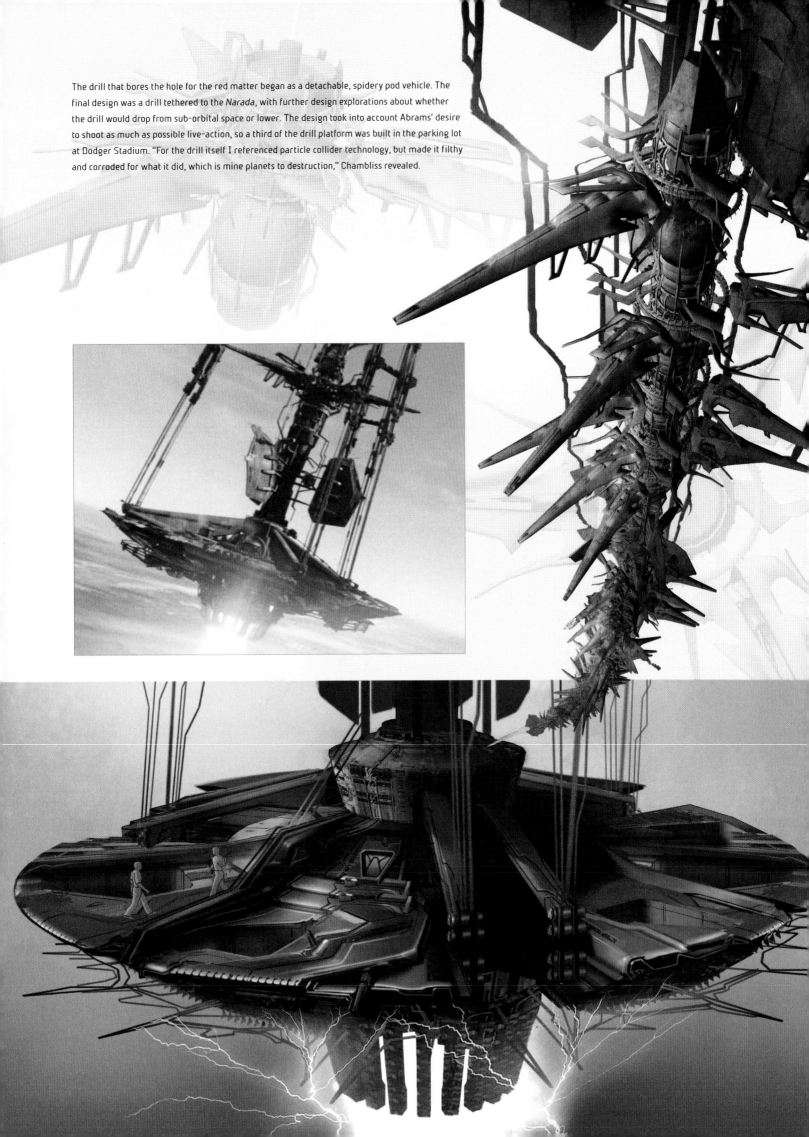

The drill that bores the hole for the red matter began as a detachable, spidery pod vehicle. The final design was a drill tethered to the *Narada*, with further design explorations about whether the drill would drop from sub-orbital space or lower. The design took into account Abrams' desire to shoot as much as possible live-action, so a third of the drill platform was built in the parking lot at Dodger Stadium. "For the drill itself I referenced particle collider technology, but made it filthy and corroded for what it did, which is mine planets to destruction," Chambliss revealed.

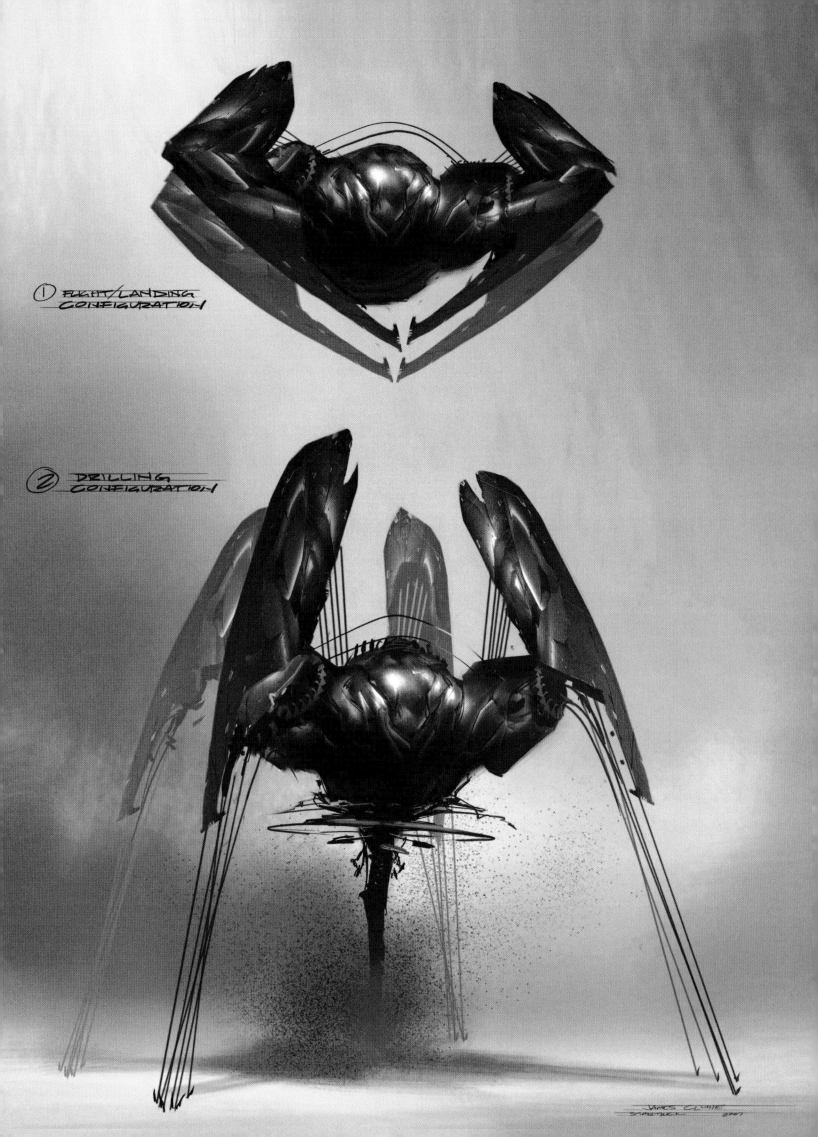

① FLIGHT/LANDING
CONFIGURATION

② DRILLING
CONFIGURATION

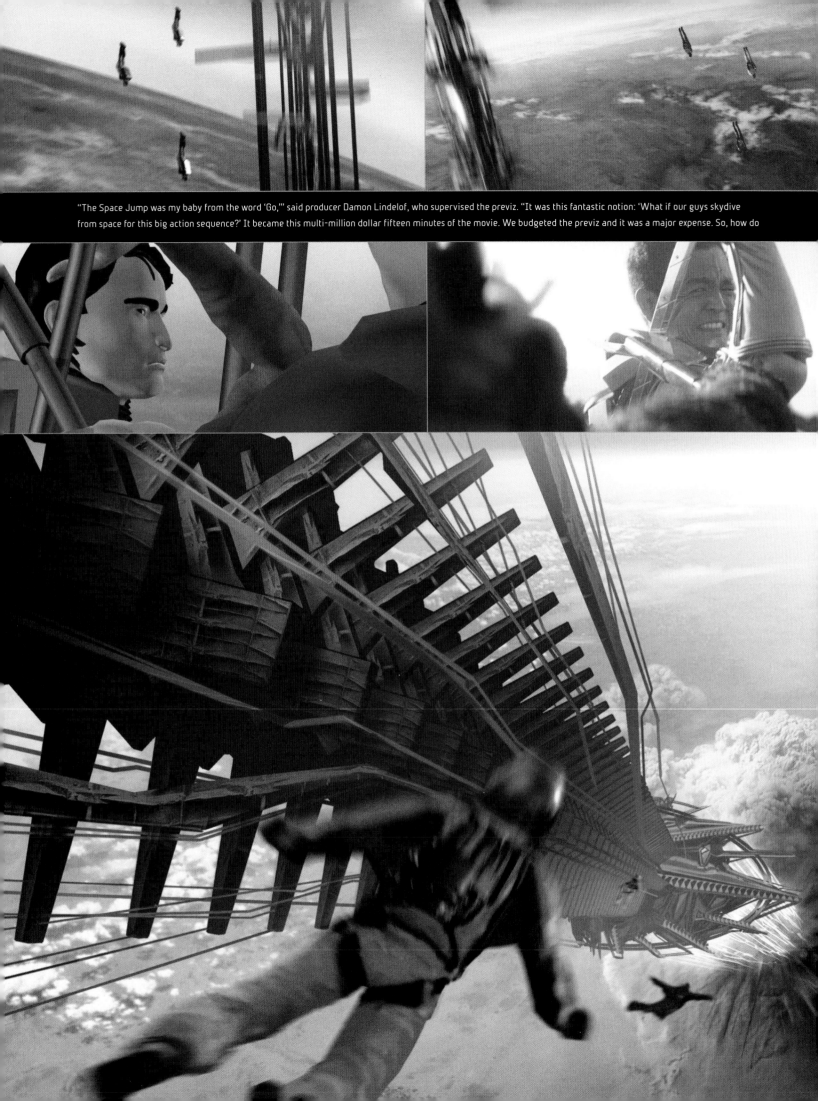

"The Space Jump was my baby from the word 'Go,'" said producer Damon Lindelof, who supervised the previz. "It was this fantastic notion: 'What if our guys skydive from space for this big action sequence?' It became this multi-million dollar fifteen minutes of the movie. We budgeted the previz and it was a major expense. So, how do

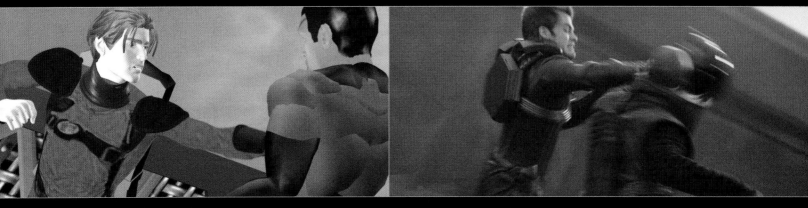

we tell the same story with less visual effects shots? The phrase I kept hearing was, 'We need to get this in a box.' As a result of the work I did with incredibly talented effects people, we got it in the box and J.J. hit it out of the ballpark."

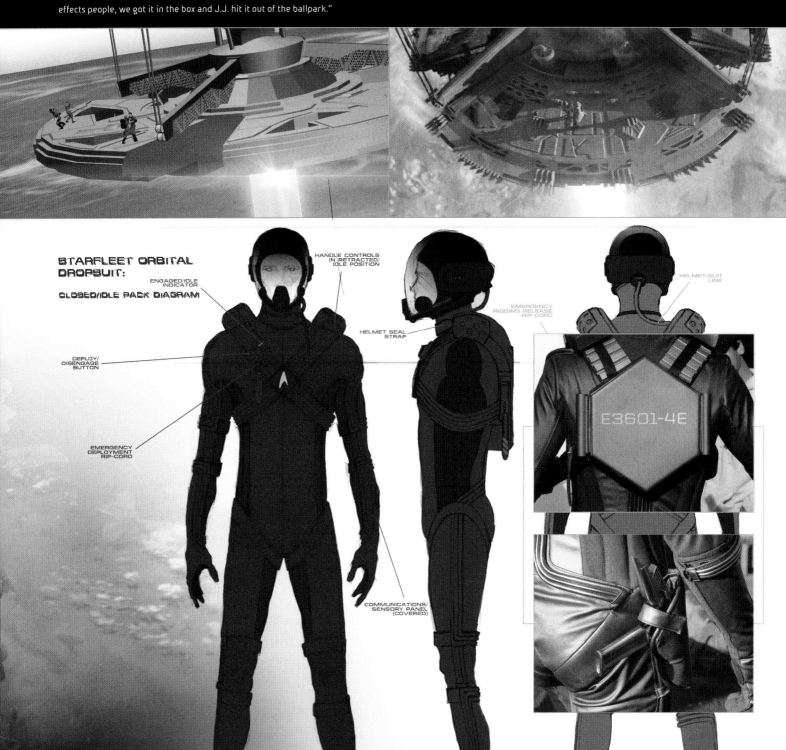

STARFLEET ORBITAL DROPSUIT:

CLOSED/IDLE PACK DIAGRAM

ENGAGED/IDLE INDICATOR

HANDLE CONTROLS IN RETRACTED/ IDLE POSITION

HELMET SEAL STRAP

EMERGENCY RIGGING RELEASE RIP-CORD

HELMET-SUIT LINK

DEPLOY/ DISENGAGE BUTTON

EMERGENCY DEPLOYMENT RIP-CORD

COMMUNICATIONS/ SENSORY PANEL (COVERED)

E3601-4E

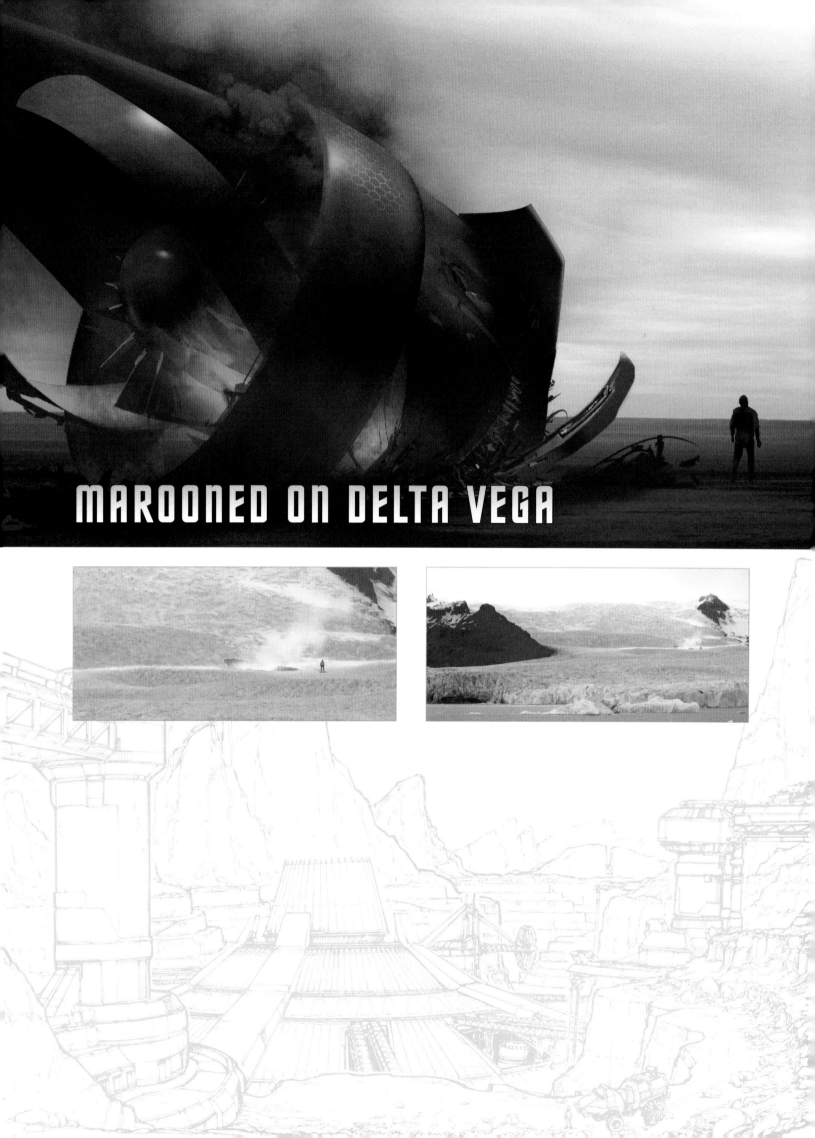

MAROONED ON DELTA VEGA

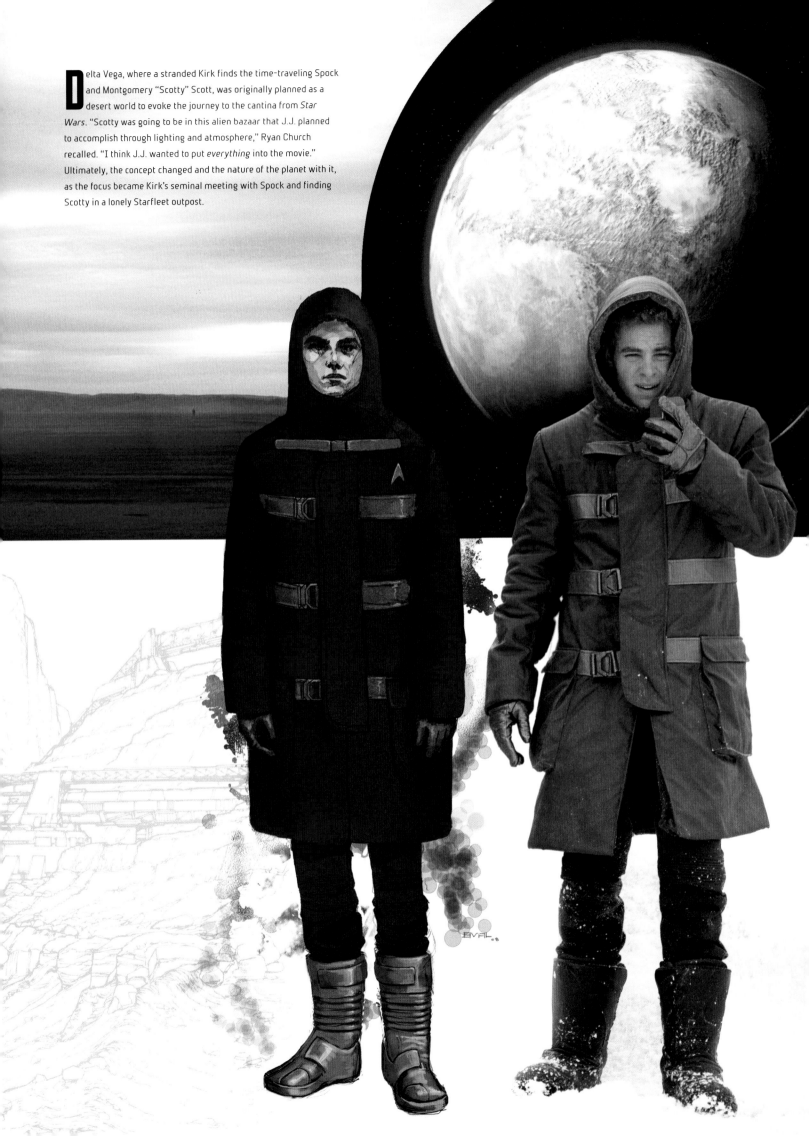

Delta Vega, where a stranded Kirk finds the time-traveling Spock and Montgomery "Scotty" Scott, was originally planned as a desert world to evoke the journey to the cantina from *Star Wars*. "Scotty was going to be in this alien bazaar that J.J. planned to accomplish through lighting and atmosphere," Ryan Church recalled. "I think J.J. wanted to put *everything* into the movie." Ultimately, the concept changed and the nature of the planet with it, as the focus became Kirk's seminal meeting with Spock and finding Scotty in a lonely Starfleet outpost.

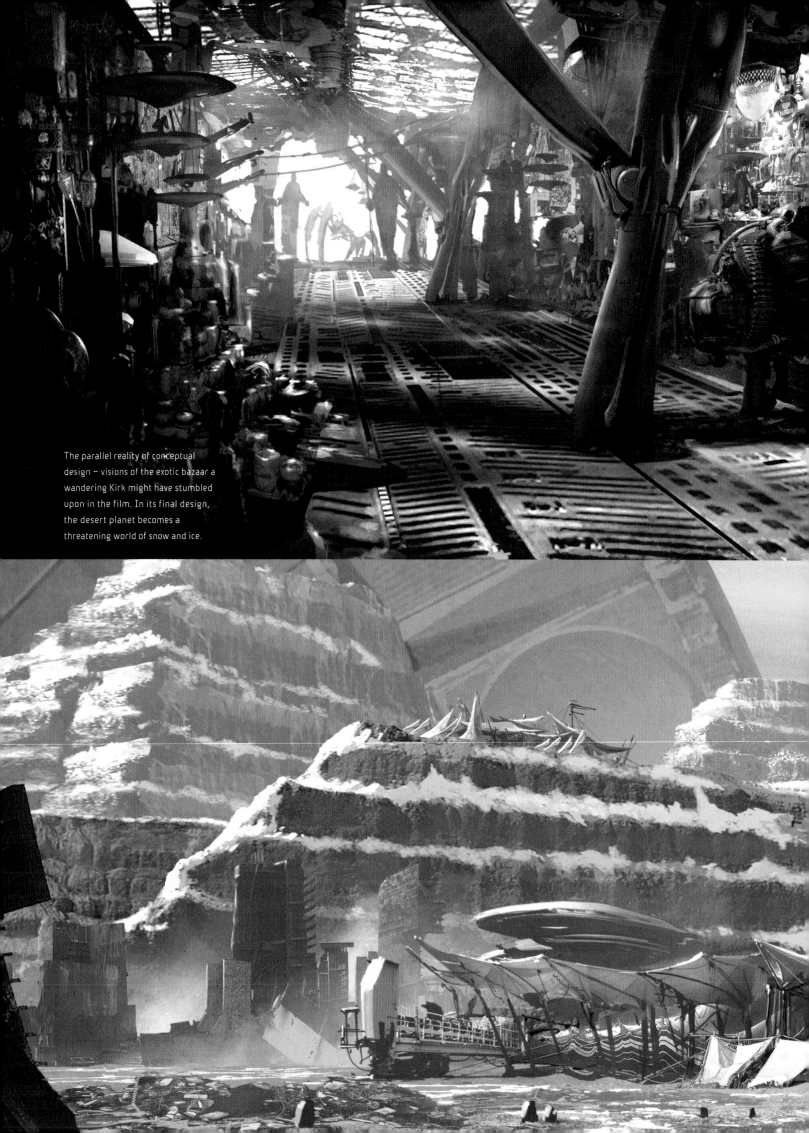

The parallel reality of conceptual design – visions of the exotic bazaar a wandering Kirk might have stumbled upon in the film. In its final design, the desert planet becomes a threatening world of snow and ice.

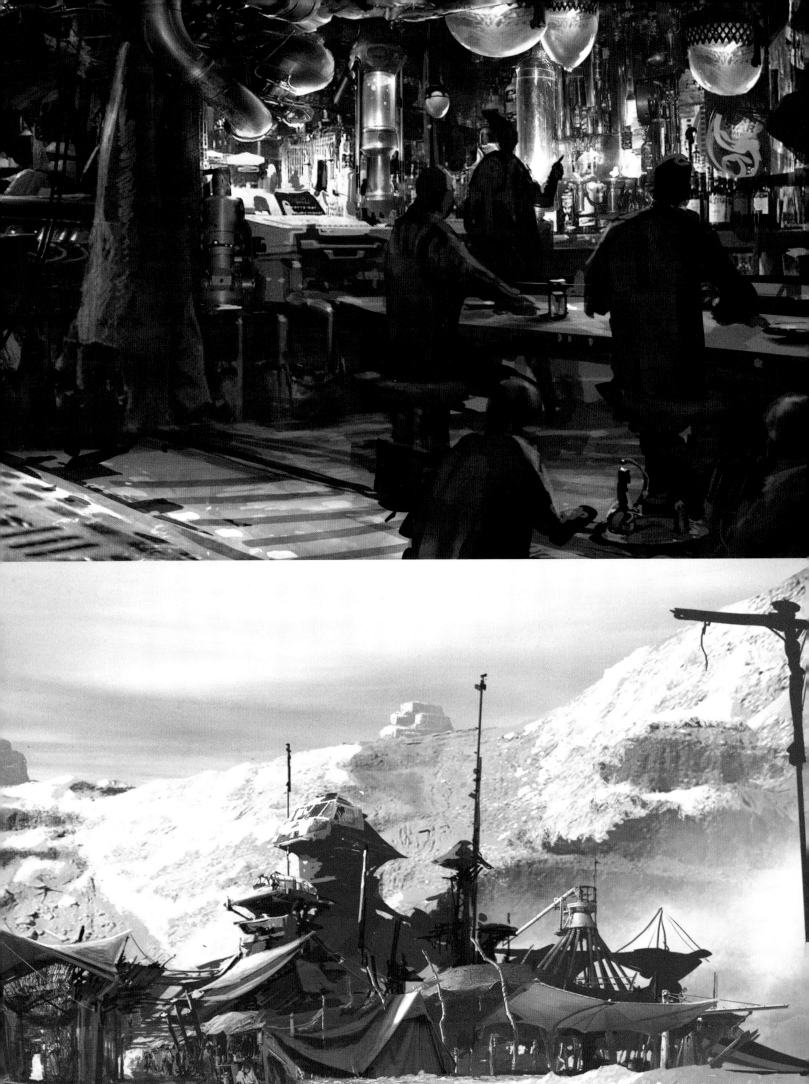

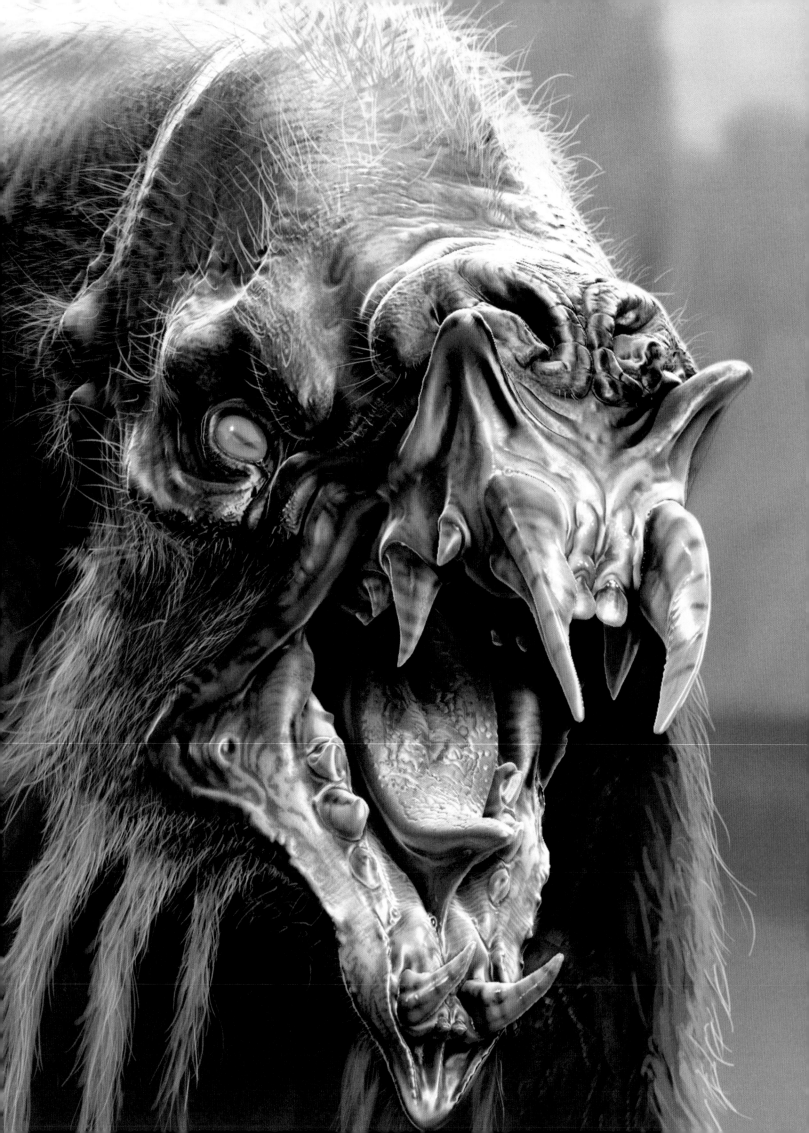

EST. SHOT OF ICE PLANET

CLOSE UP, "WHERE AM I"?

PULL OUT REVEALS KIRK ON ICE SHEET

"THUMP" A BUMP FROM BELOW

ABOVE KIRK ON ICE, SOMETHING MOVES BELOW

UNAWARE, KIRK INVESTIGATES "MOUND"

WE EXPECT IT TO BLOW THROUGH IN FOREGROUND, BUT INSTEAD.....

THE CHASE BEGINS

This Neville Page creature began with his proposal to Abrams for a "red herring" situation on Delta Vega in which a big snow creature is about to eat Kirk, but is instead eaten by a bigger red monster. The final design, a combination polar bear and gorilla, embodied its nickname, "Polarilla," though its canonical name is Drakoulias.

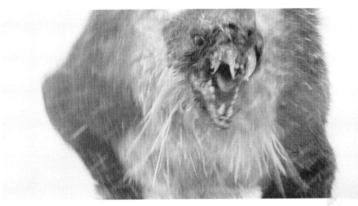

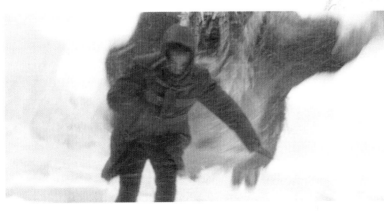

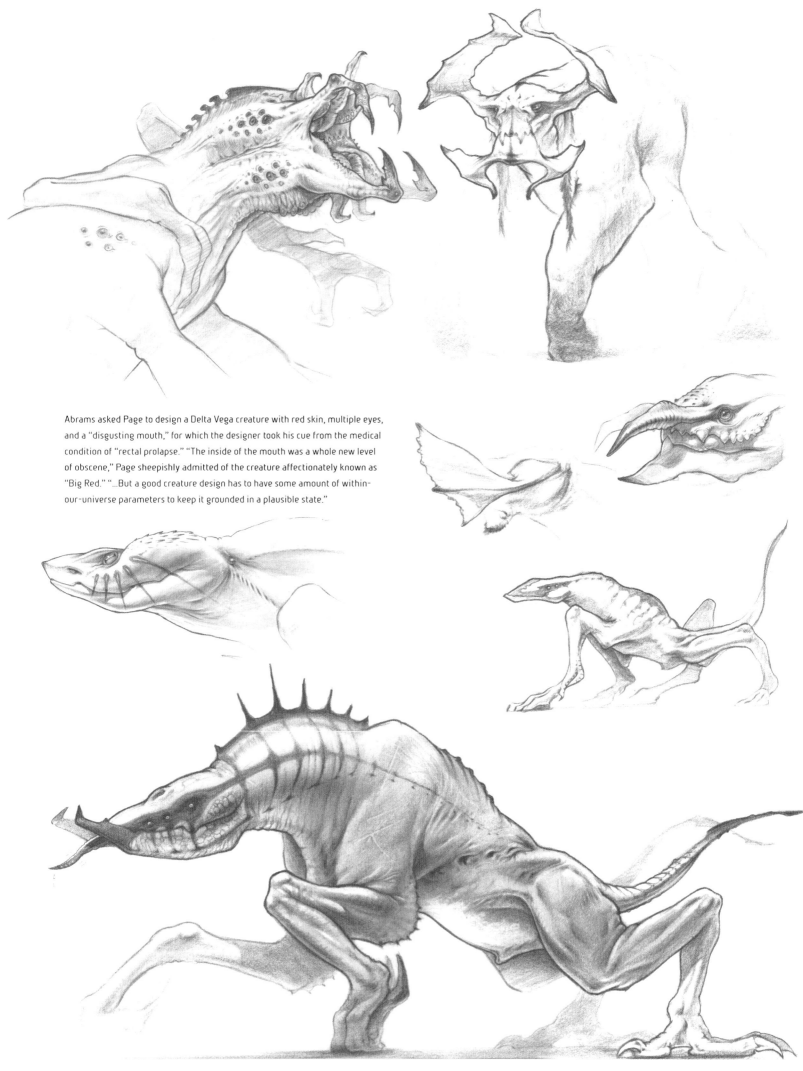

Abrams asked Page to design a Delta Vega creature with red skin, multiple eyes, and a "disgusting mouth," for which the designer took his cue from the medical condition of "rectal prolapse." "The inside of the mouth was a whole new level of obscene," Page sheepishly admitted of the creature affectionately known as "Big Red." "...But a good creature design has to have some amount of within-our-universe parameters to keep it grounded in a plausible state."

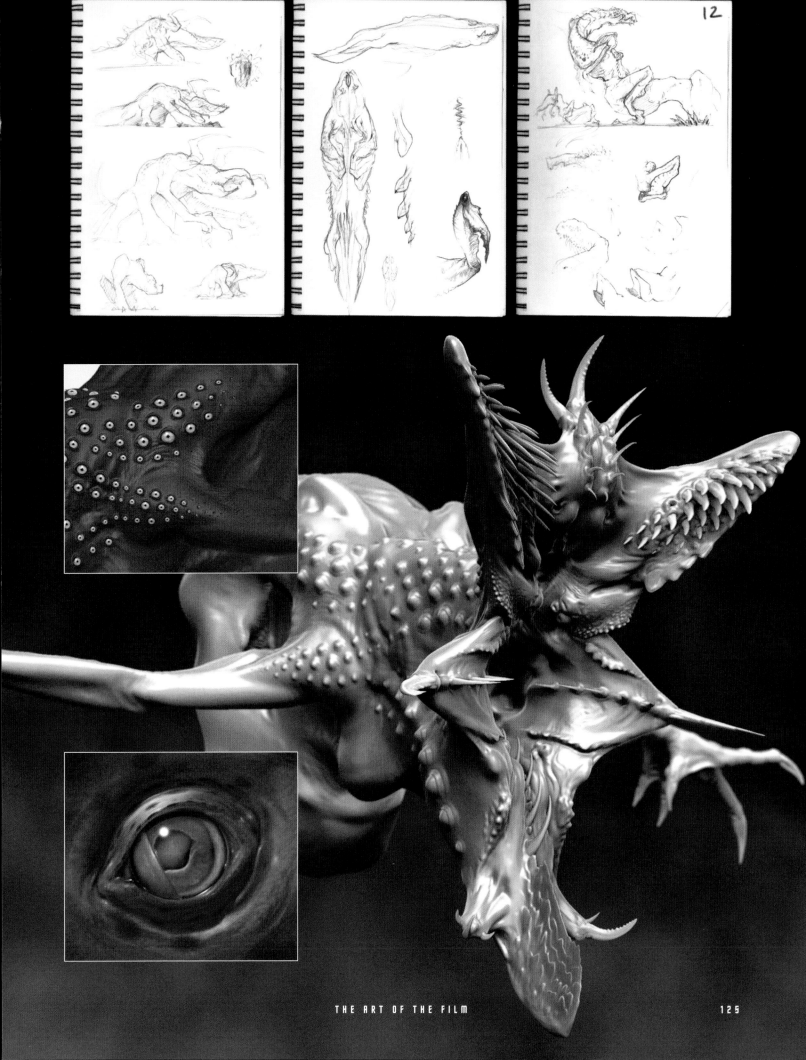

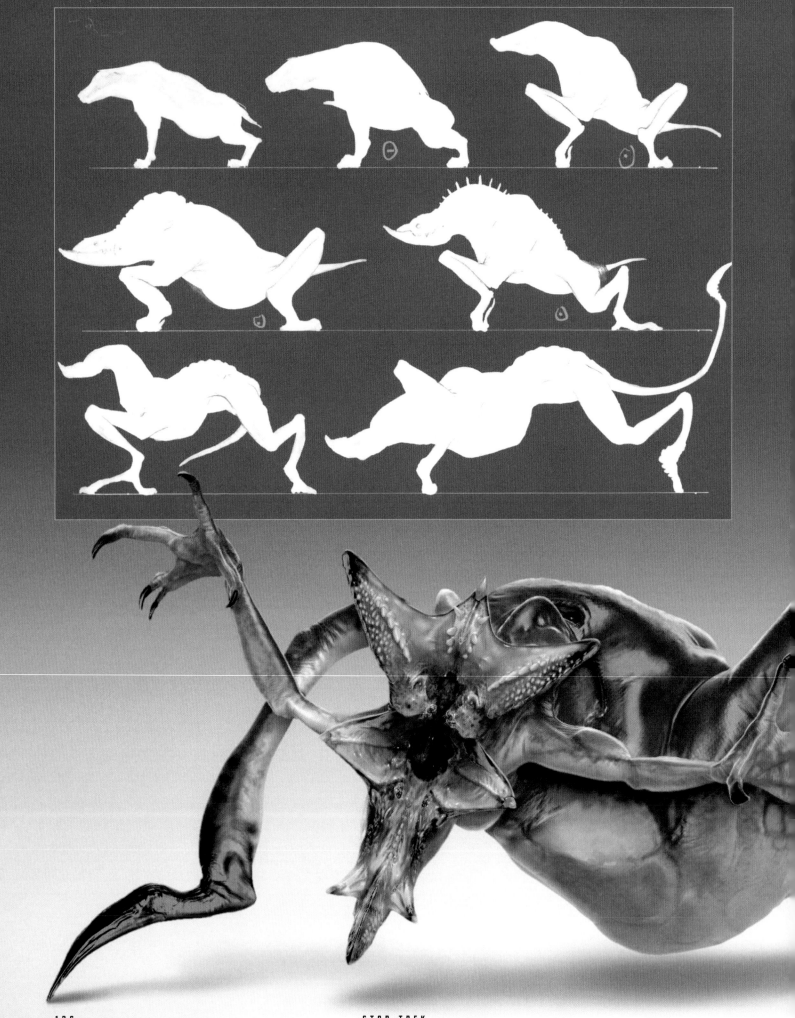

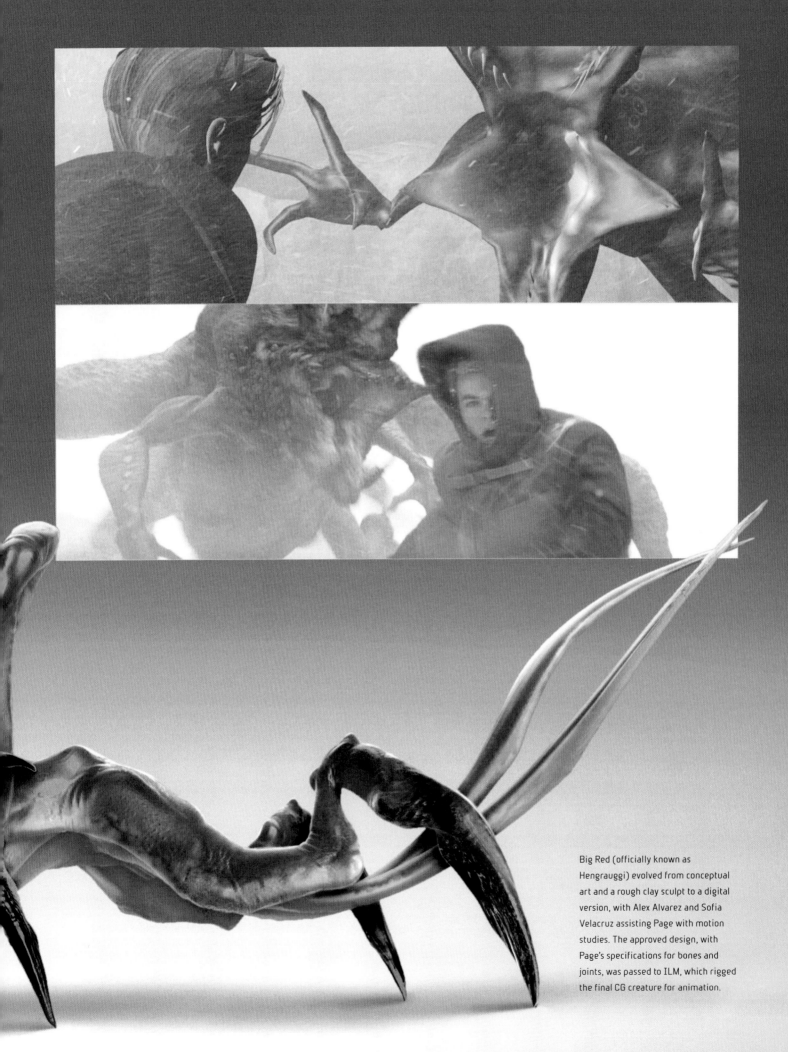

Big Red (officially known as
Hengrauggi) evolved from conceptual
art and a rough clay sculpt to a digital
version, with Alex Alvarez and Sofia
Velacruz assisting Page with motion
studies. The approved design, with
Page's specifications for bones and
joints, was passed to ILM, which rigged
the final CG creature for animation.

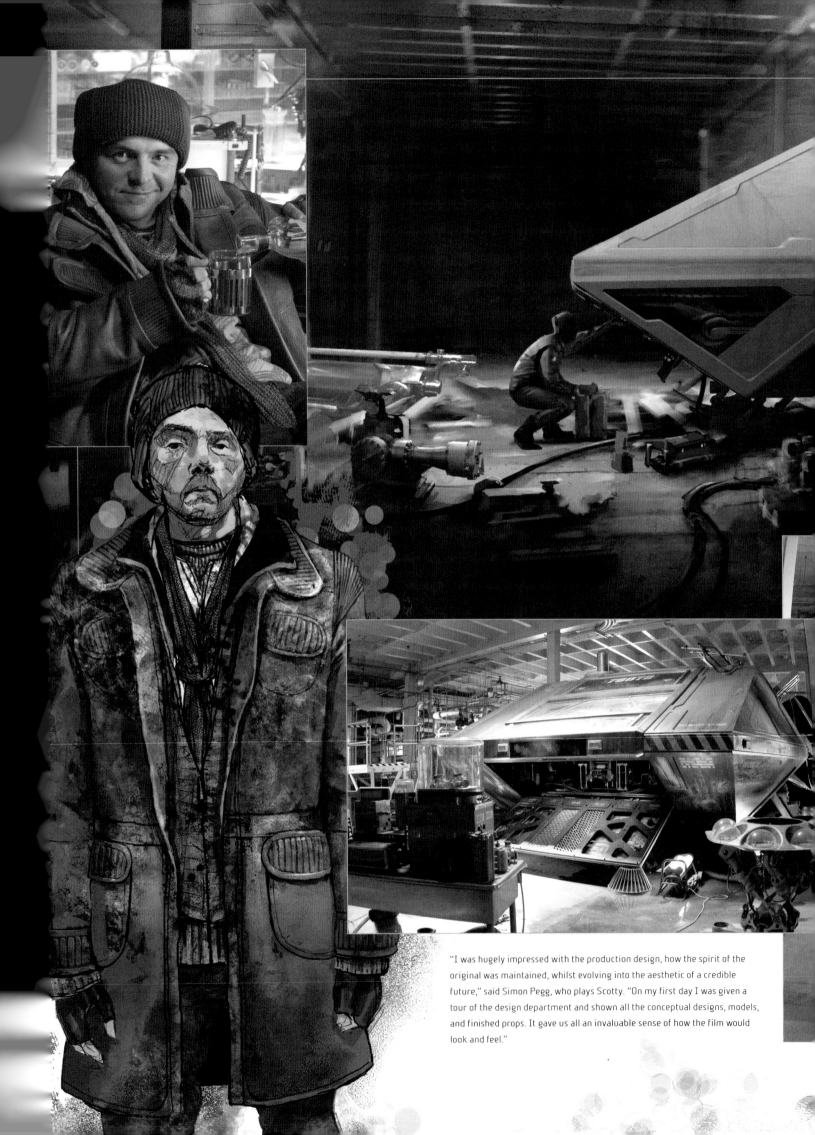

"I was hugely impressed with the production design, how the spirit of the original was maintained, whilst evolving into the aesthetic of a credible future," said Simon Pegg, who plays Scotty. "On my first day I was given a tour of the design department and shown all the conceptual designs, models, and finished props. It gave us all an invaluable sense of how the film would look and feel."

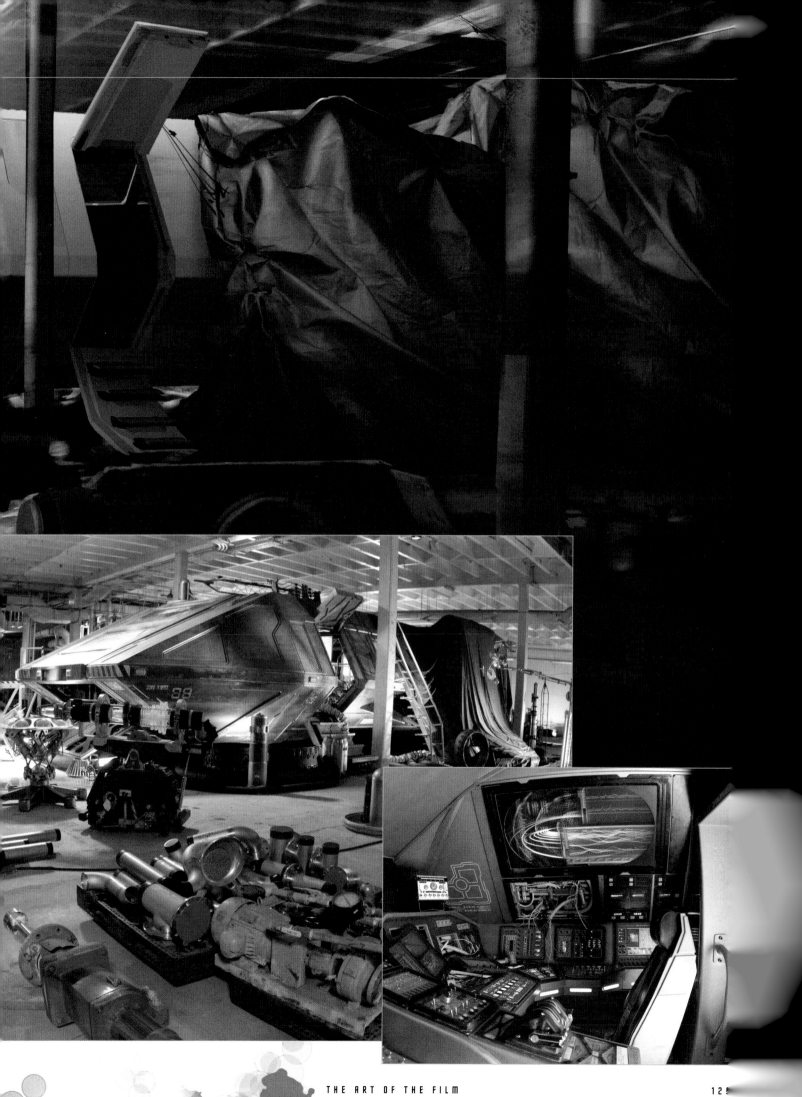

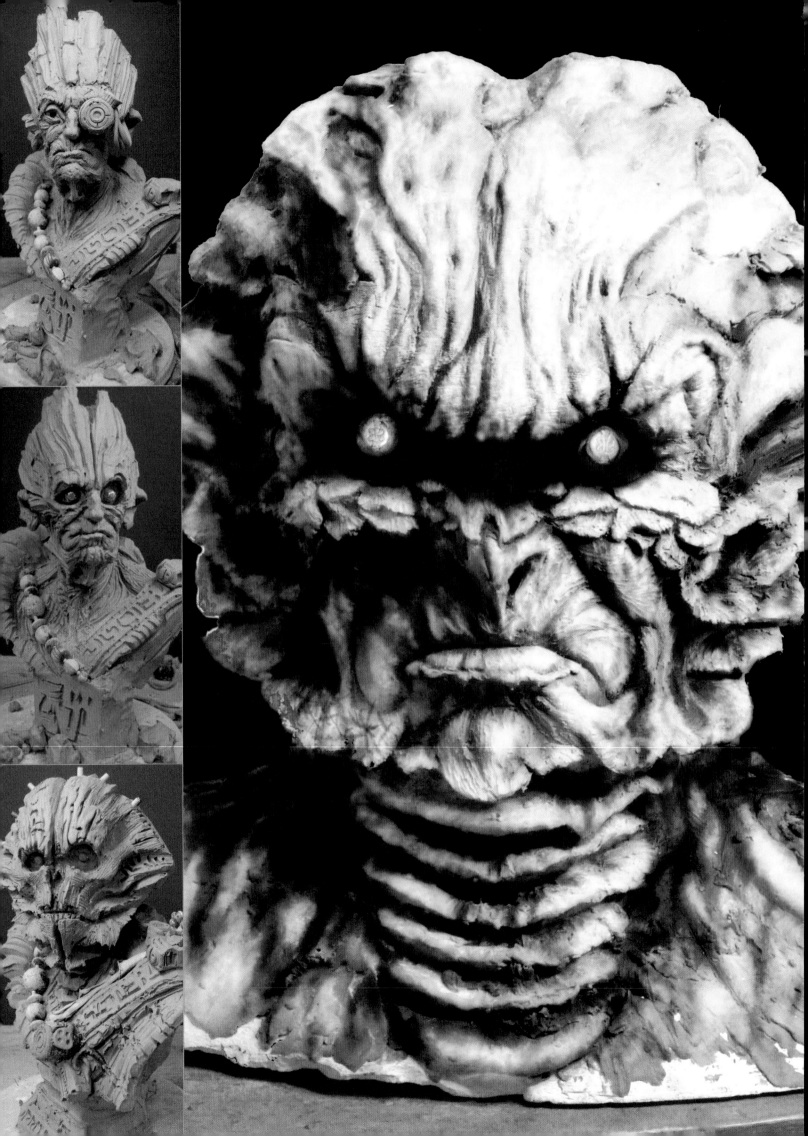

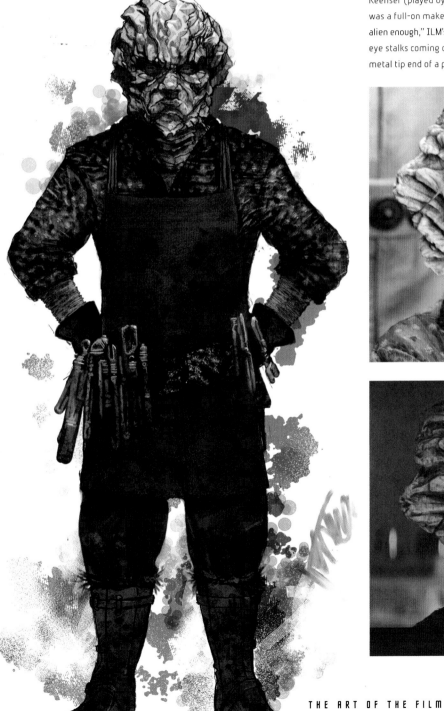

Keenser (played by Deep Roy), the alien who shares Scotty's lonely vigil on Delta Vega, was a full-on makeup creation, except for the eyes. "Seeing human eyes, it didn't look alien enough," ILM's Jaeger explained. "To take it out of that realm, we added reflective eye stalks coming out of this dark void. J.J. had described what he wanted as like the metal tip end of a pencil."

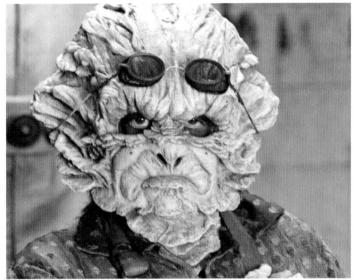

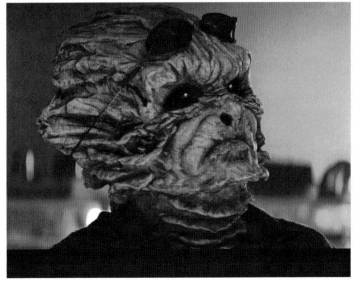

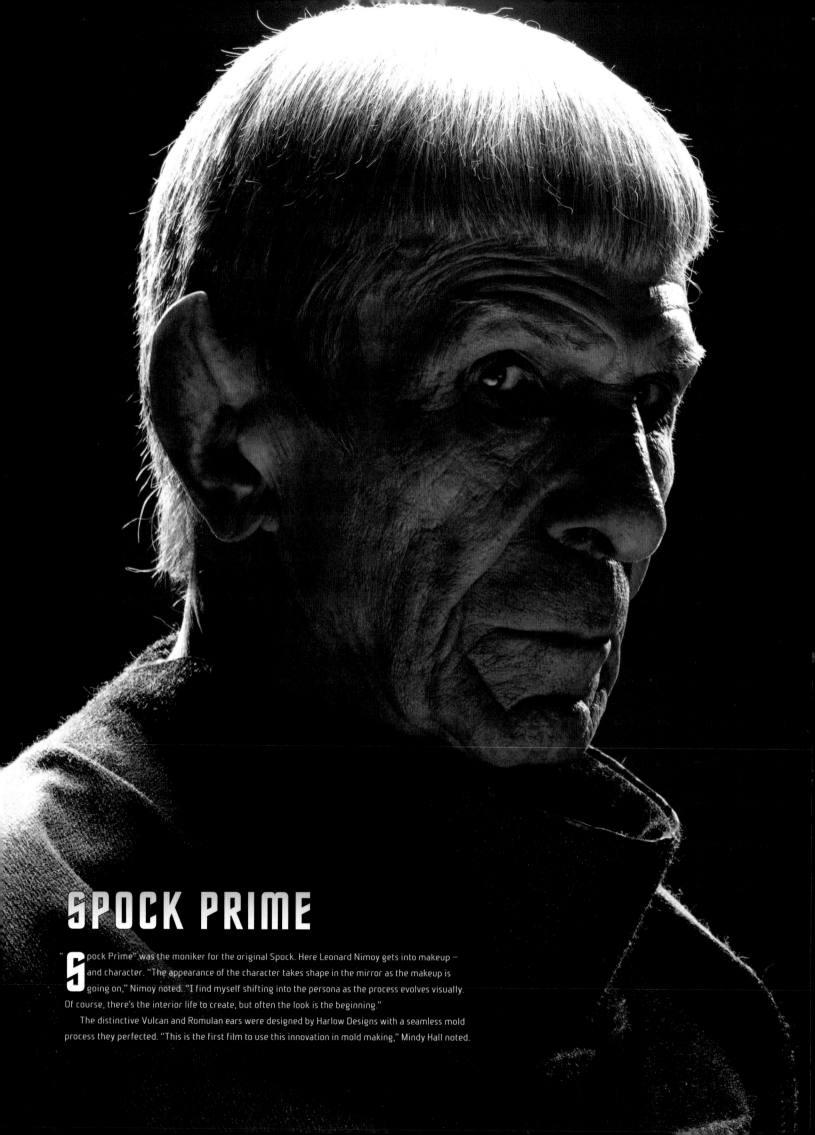

SPOCK PRIME

"Spock Prime" was the moniker for the original Spock. Here Leonard Nimoy gets into makeup – and character. "The appearance of the character takes shape in the mirror as the makeup is going on," Nimoy noted. "I find myself shifting into the persona as the process evolves visually. Of course, there's the interior life to create, but often the look is the beginning."

The distinctive Vulcan and Romulan ears were designed by Harlow Designs with a seamless mold process they perfected. "This is the first film to use this innovation in mold making," Mindy Hall noted.

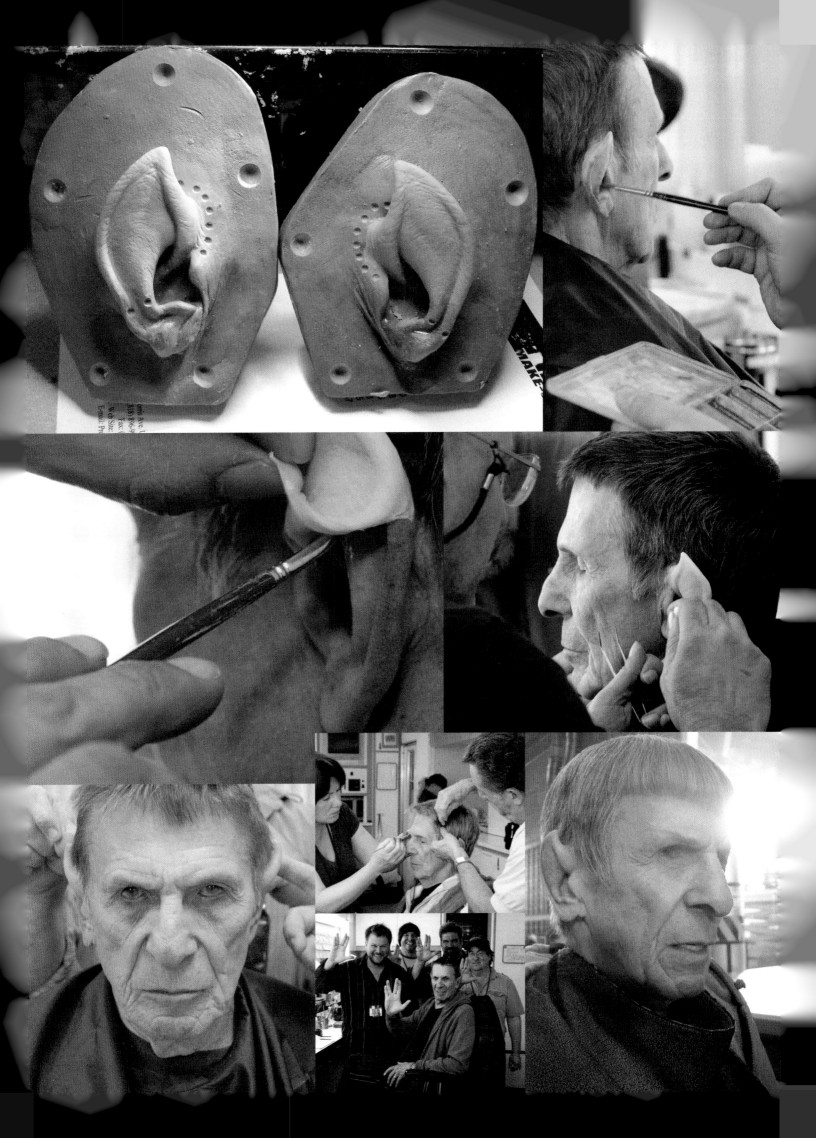

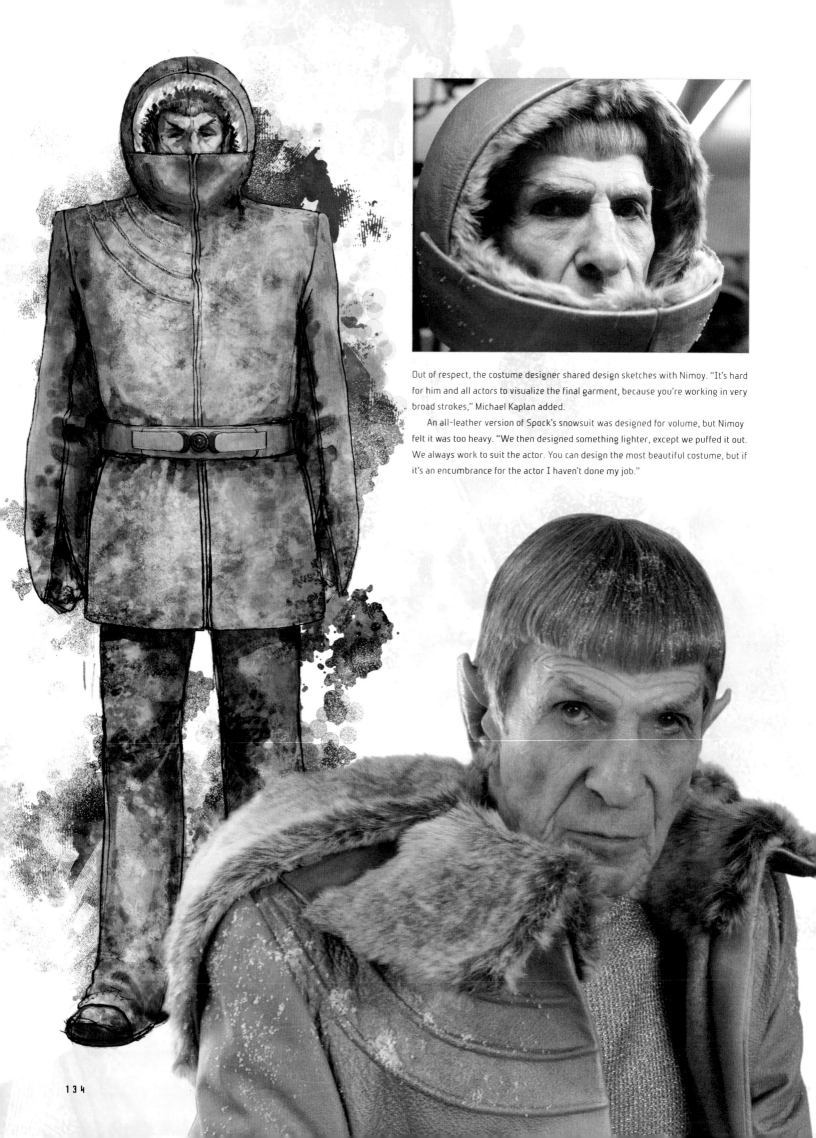

Out of respect, the costume designer shared design sketches with Nimoy. "It's hard for him and all actors to visualize the final garment, because you're working in very broad strokes," Michael Kaplan added.

An all-leather version of Spock's snowsuit was designed for volume, but Nimoy felt it was too heavy. "We then designed something lighter, except we puffed it out. We always work to suit the actor. You can design the most beautiful costume, but if it's an encumbrance for the actor I haven't done my job."

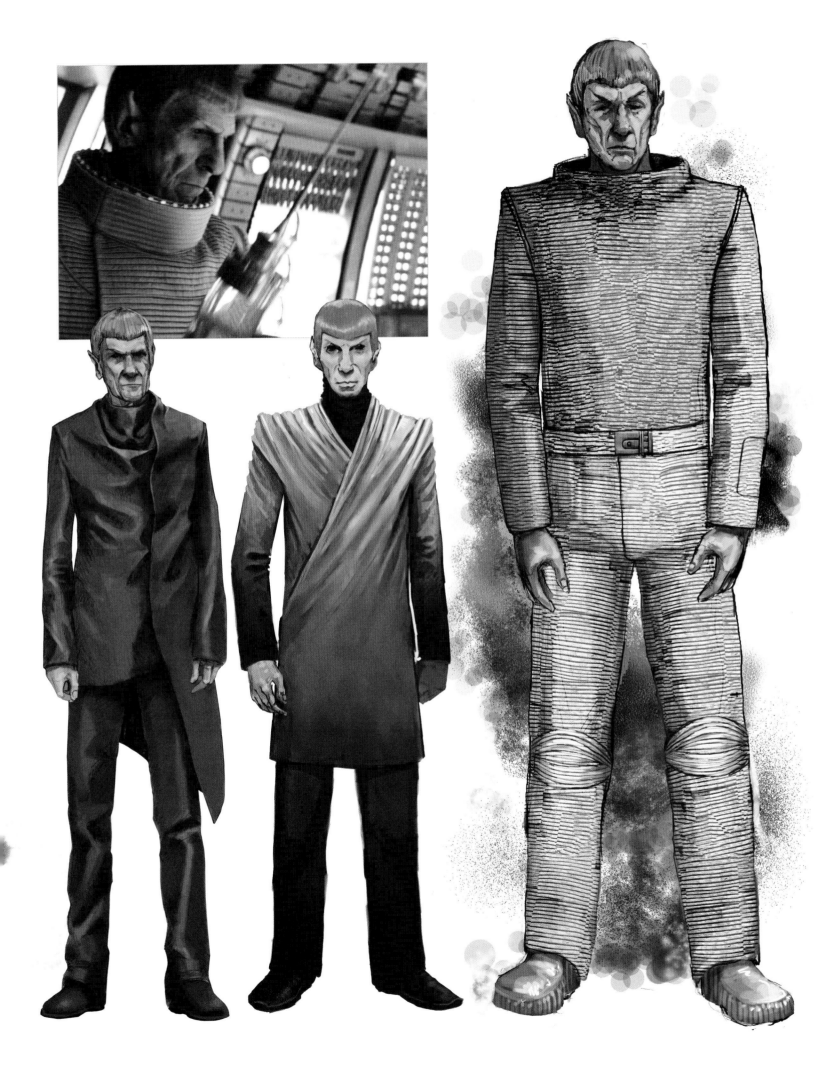

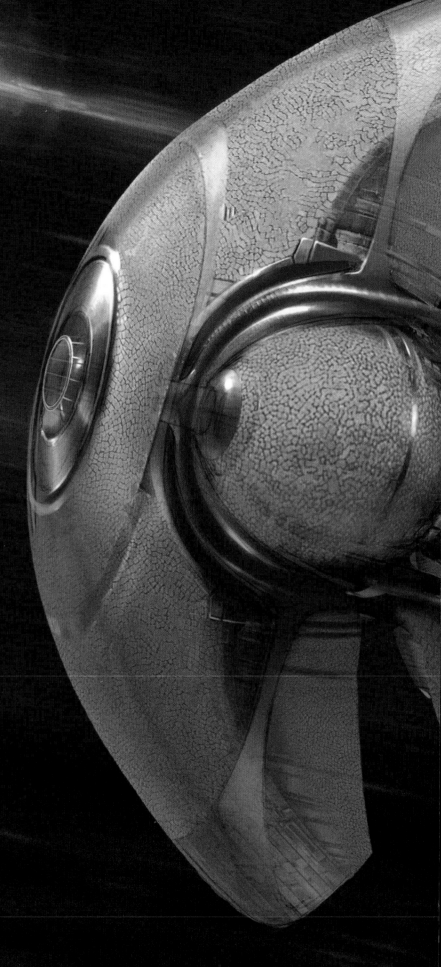

JELLYFISH SHIP

The Vulcan ship piloted by Spock (elder and younger) was described in the script as a "jellyfish." Church took cues from a jellyfish's shape and translucency, then imagined a cube of pure energy, something consistent with Vulcan science. "J.J. wanted the *opposite* of that. He said it had to have as much character as Leonard Nimoy had in his face, that he's going to be flying and doing heroic things in this ship. J.J. has a great instinct for playing against type, so that was a cool jumping off point." The final shape, developed from an original idea by comic book artist and illustrator Bryan Hitch, was based on a gyroscope, Chambliss added.

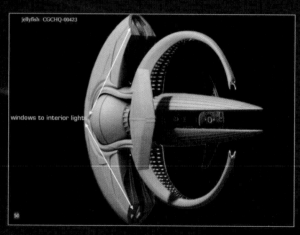

jellyfish CGCHQ-00423

windows to interior light

50

jellyfish CGCHQ-00423

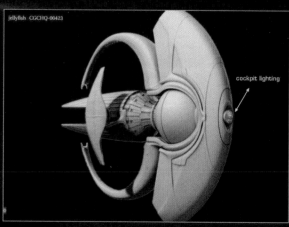

cockpit lighting

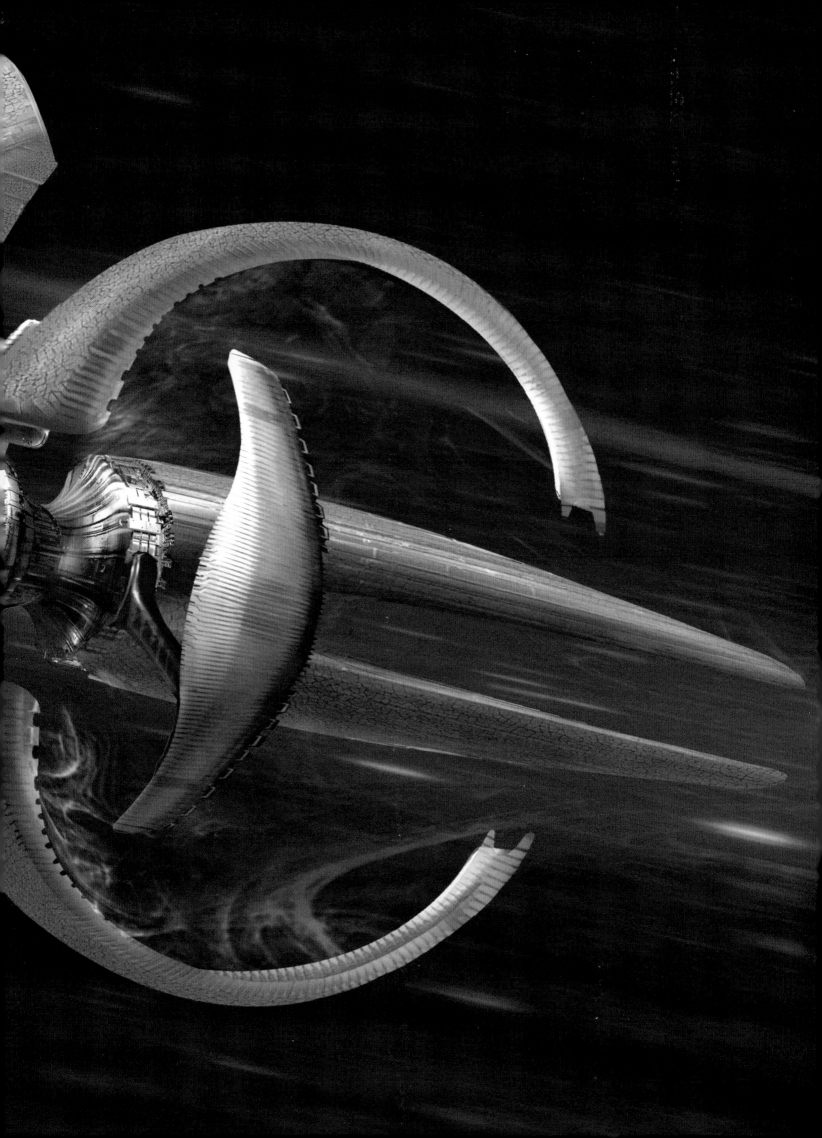

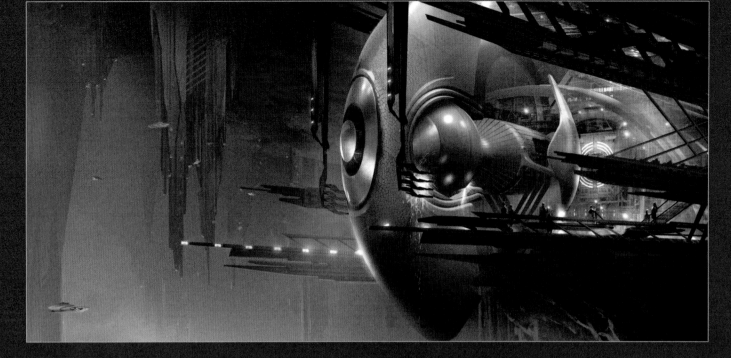

Conceptual designs for the outfitting of the fastest Vulcan ship, the "jellyfish," a scene from Spock's Vulcan mind meld sequence. "Scott did a wonderful job of building that ship, with its spinning gyroscopic quality," ILM's Guyett noted. "The Vulcan propulsion system burns 'green,' while I always felt Romulans just burned dirty fuel."

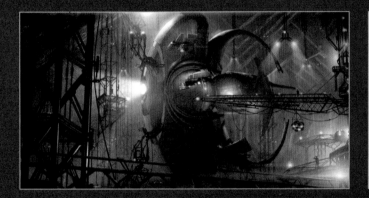

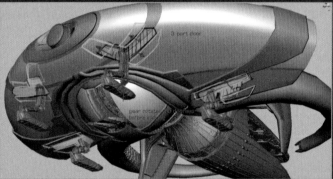

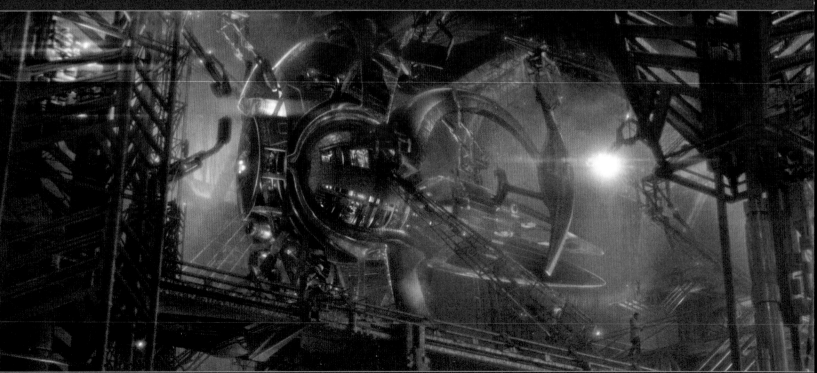

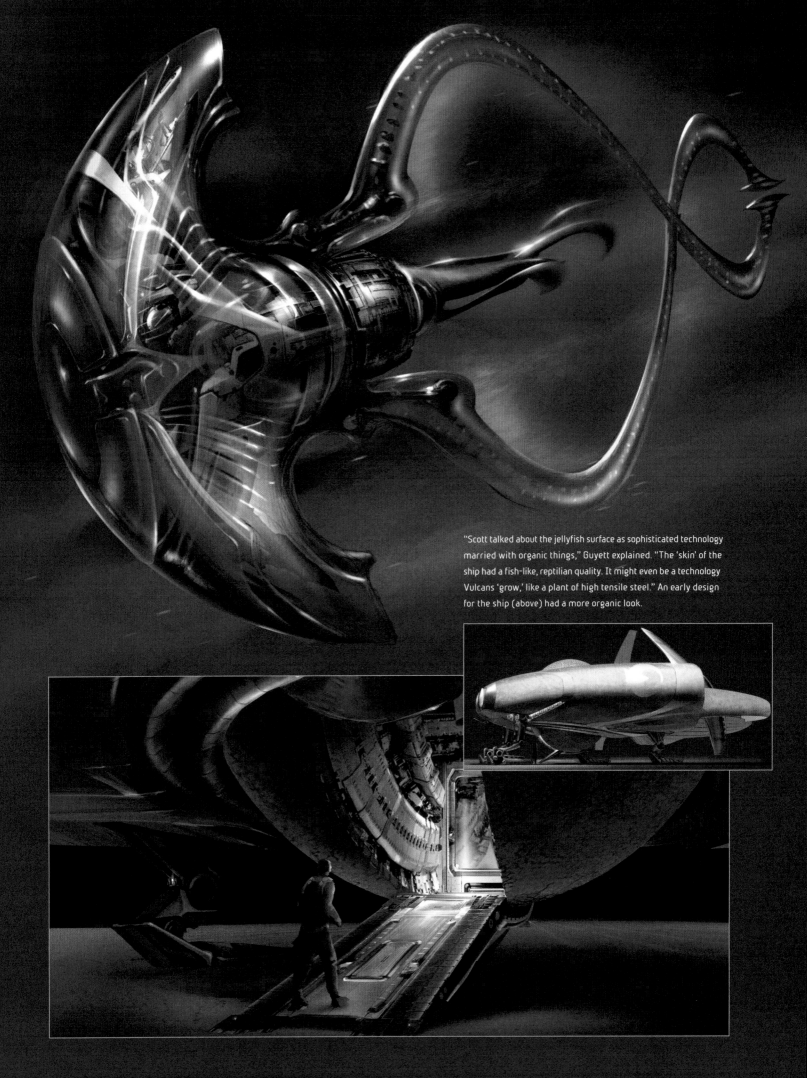

"Scott talked about the jellyfish surface as sophisticated technology married with organic things," Guyett explained. "The 'skin' of the ship had a fish-like, reptilian quality. It might even be a technology Vulcans 'grow,' like a plant of high tensile steel." An early design for the ship (above) had a more organic look.

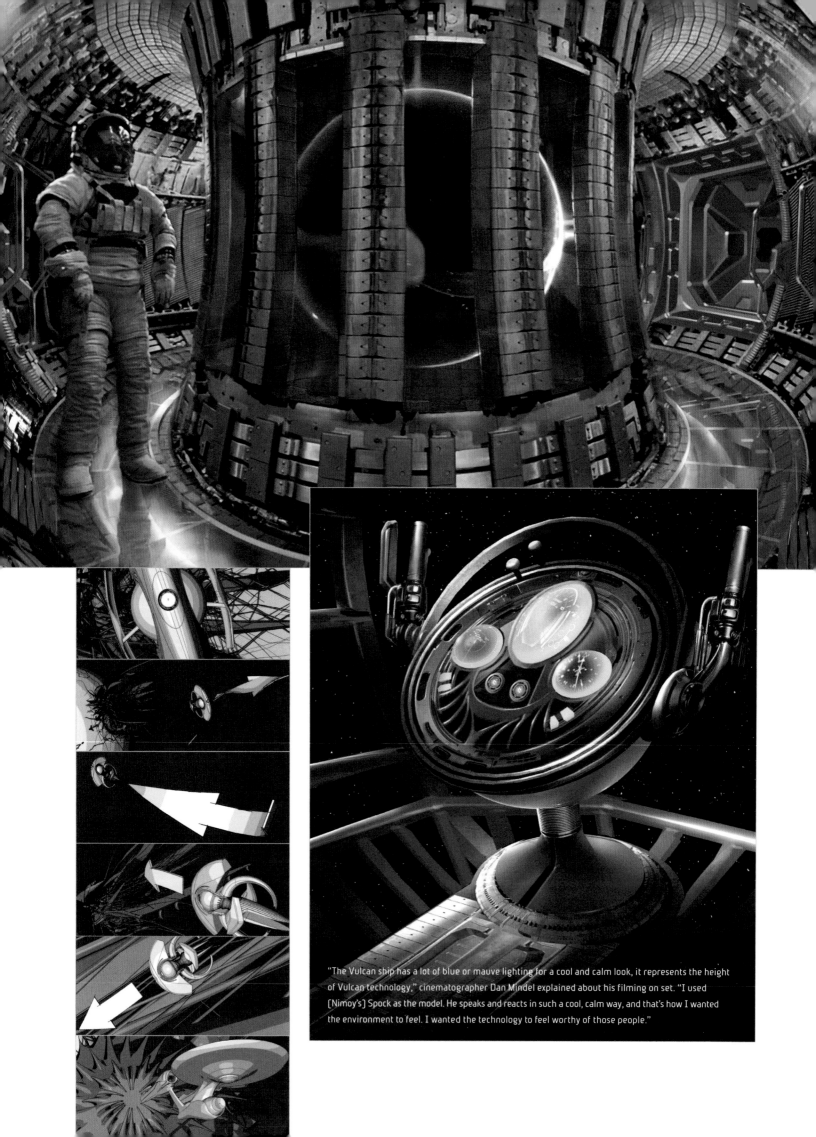

"The Vulcan ship has a lot of blue or mauve lighting for a cool and calm look, it represents the height of Vulcan technology," cinematographer Dan Mindel explained about his filming on set. "I used [Nimoy's] Spock as the model. He speaks and reacts in such a cool, calm way, and that's how I wanted the environment to feel. I wanted the technology to feel worthy of those people."

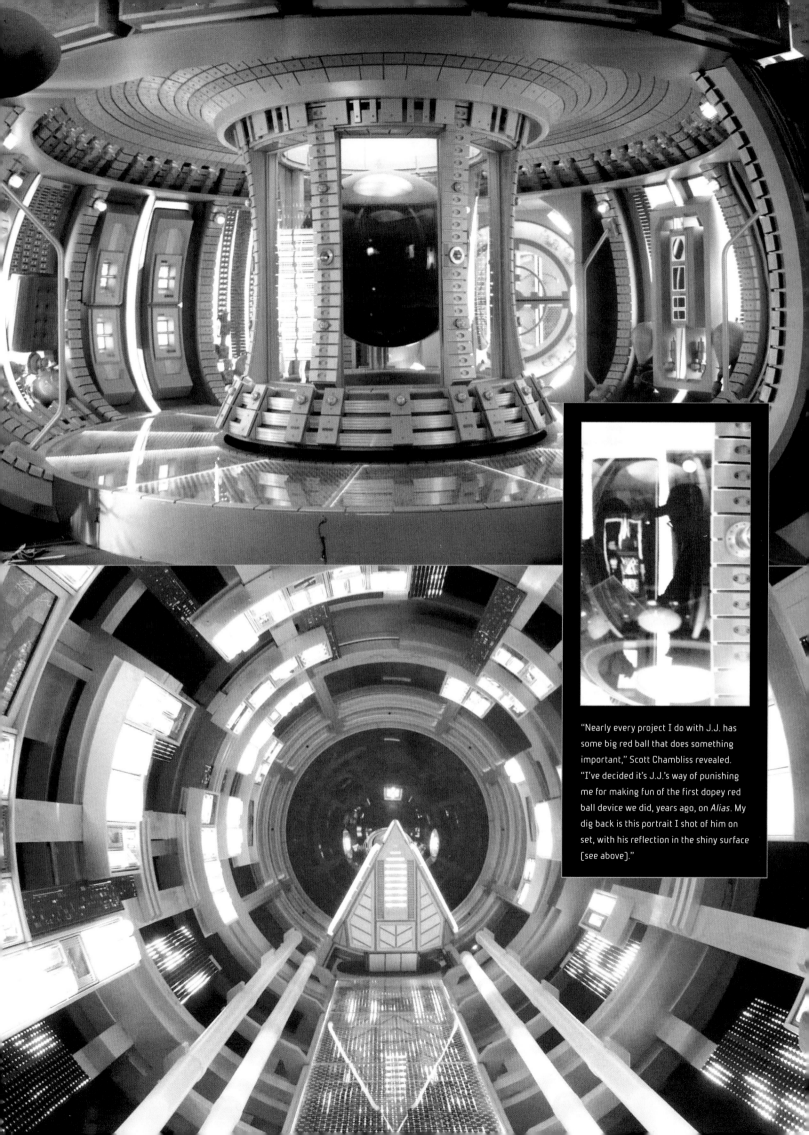

"Nearly every project I do with J.J. has some big red ball that does something important," Scott Chambliss revealed. "I've decided it's J.J.'s way of punishing me for making fun of the first dopey red ball device we did, years ago, on *Alias*. My dig back is this portrait I shot of him on set, with his reflection in the shiny surface [see above]."

ENTERPRISE VERSUS NARADA

"I loved the shots where we put the *Enterprise* and *Narada* side-by-side, seeing this dramatic scale," said Roger Guyett. "J.J. wanted to see things like torpedo racks coming down on the *Narada*, and we tried not to lose the overall design concept as we built in those details. We'd also talk with J.J. about a sequence and what he had in mind. When you construct a sequence, it helps the editing. For example, when the *Enterprise* moves in foreground like a wipe, we might cut to the interior. It helped the flow of the movie, panning from the CG model to the physical set."

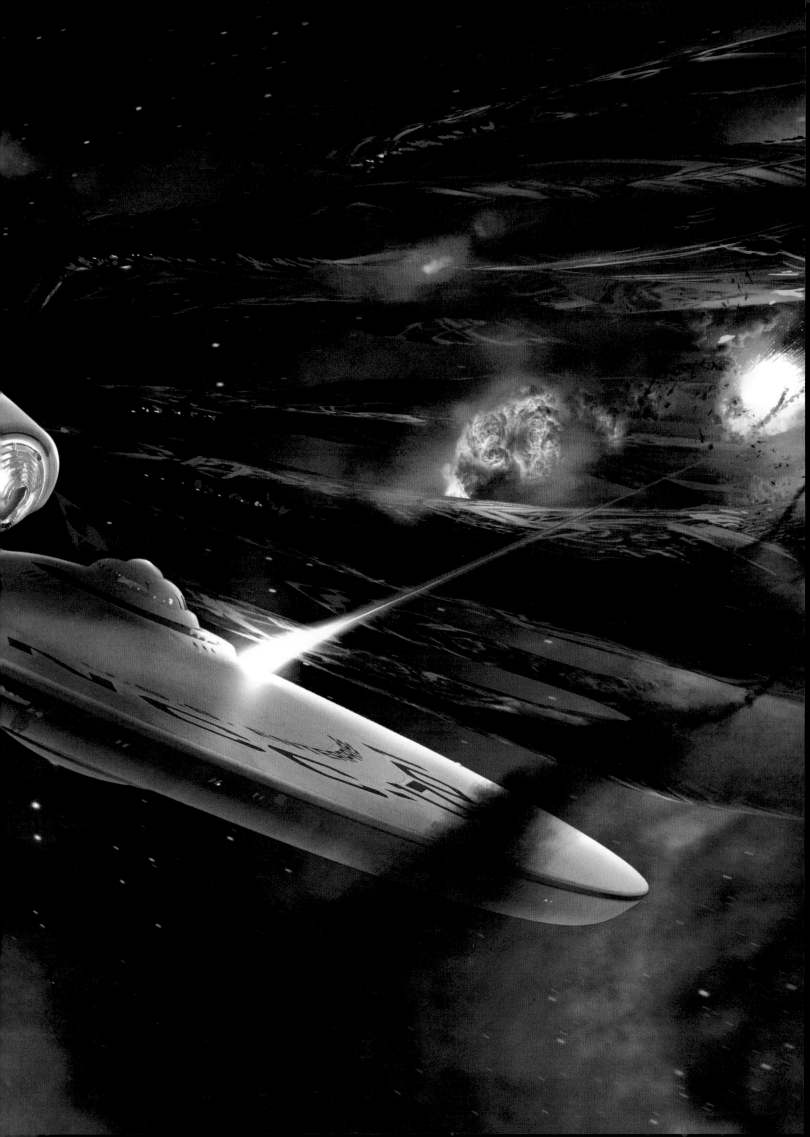

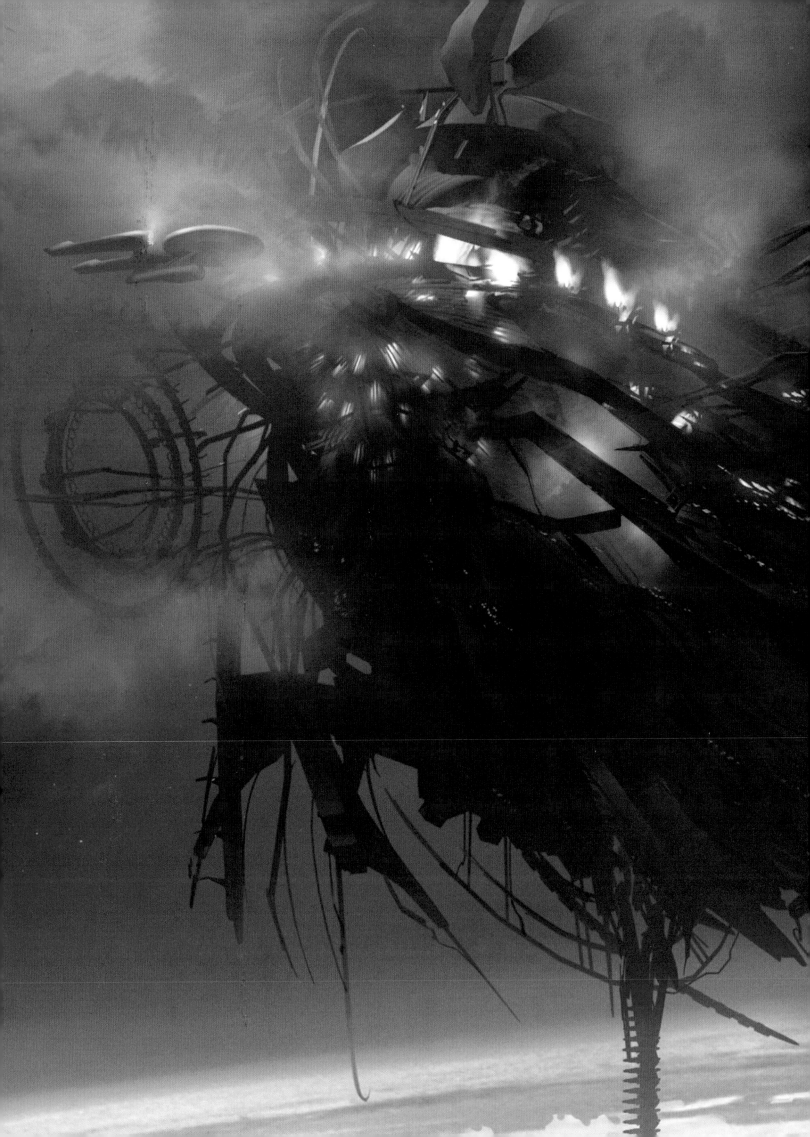

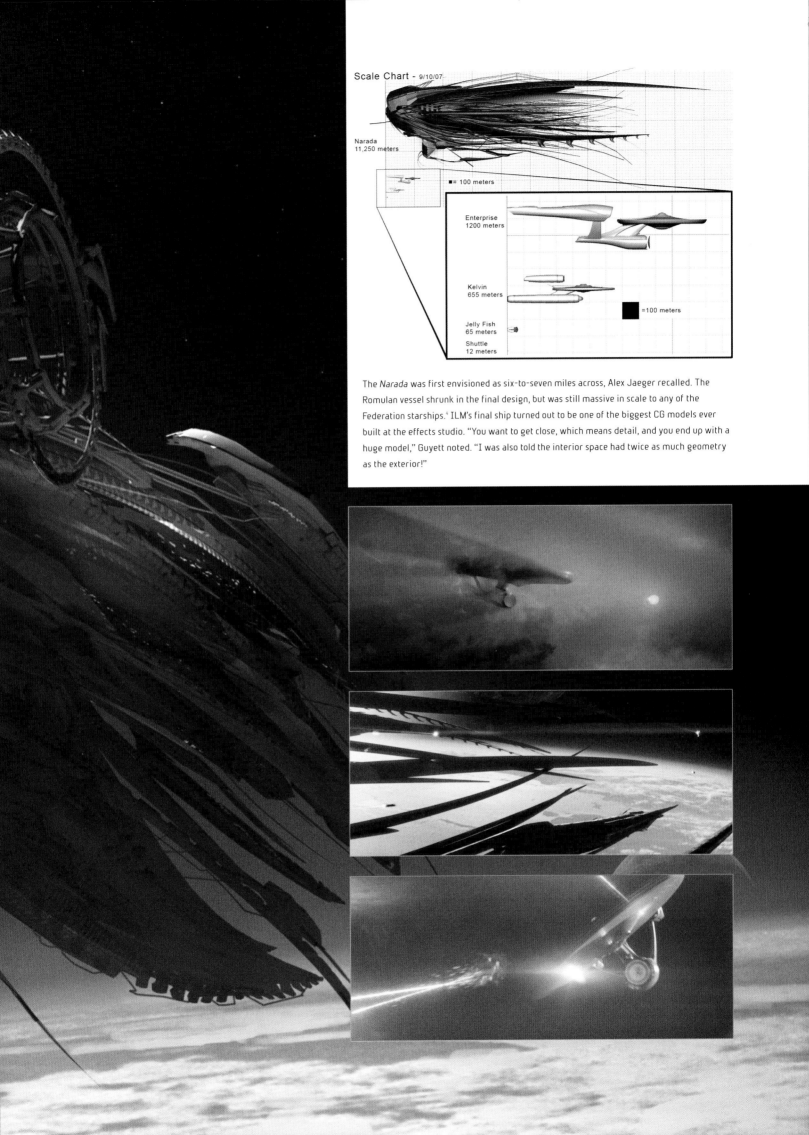

Scale Chart - 9/10/07

Narada
11,250 meters

■ = 100 meters

Enterprise
1200 meters

Kelvin
655 meters

Jelly Fish
65 meters

Shuttle
12 meters

■ =100 meters

The *Narada* was first envisioned as six-to-seven miles across, Alex Jaeger recalled. The Romulan vessel shrunk in the final design, but was still massive in scale to any of the Federation starships.[4] ILM's final ship turned out to be one of the biggest CG models ever built at the effects studio. "You want to get close, which means detail, and you end up with a huge model," Guyett noted. "I was also told the interior space had twice as much geometry as the exterior!"

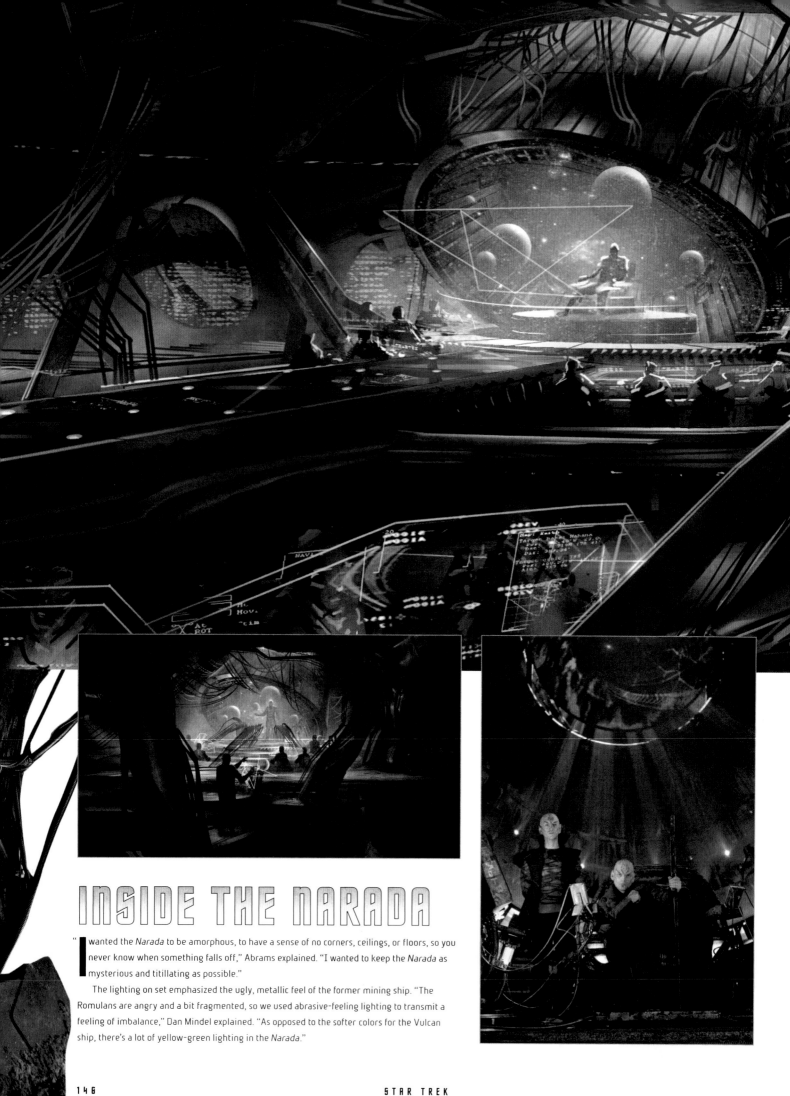

INSIDE THE NARADA

"I wanted the *Narada* to be amorphous, to have a sense of no corners, ceilings, or floors, so you never know when something falls off," Abrams explained. "I wanted to keep the *Narada* as mysterious and titillating as possible."

The lighting on set emphasized the ugly, metallic feel of the former mining ship. "The Romulans are angry and a bit fragmented, so we used abrasive-feeling lighting to transmit a feeling of imbalance," Dan Mindel explained. "As opposed to the softer colors for the Vulcan ship, there's a lot of yellow-green lighting in the *Narada*."

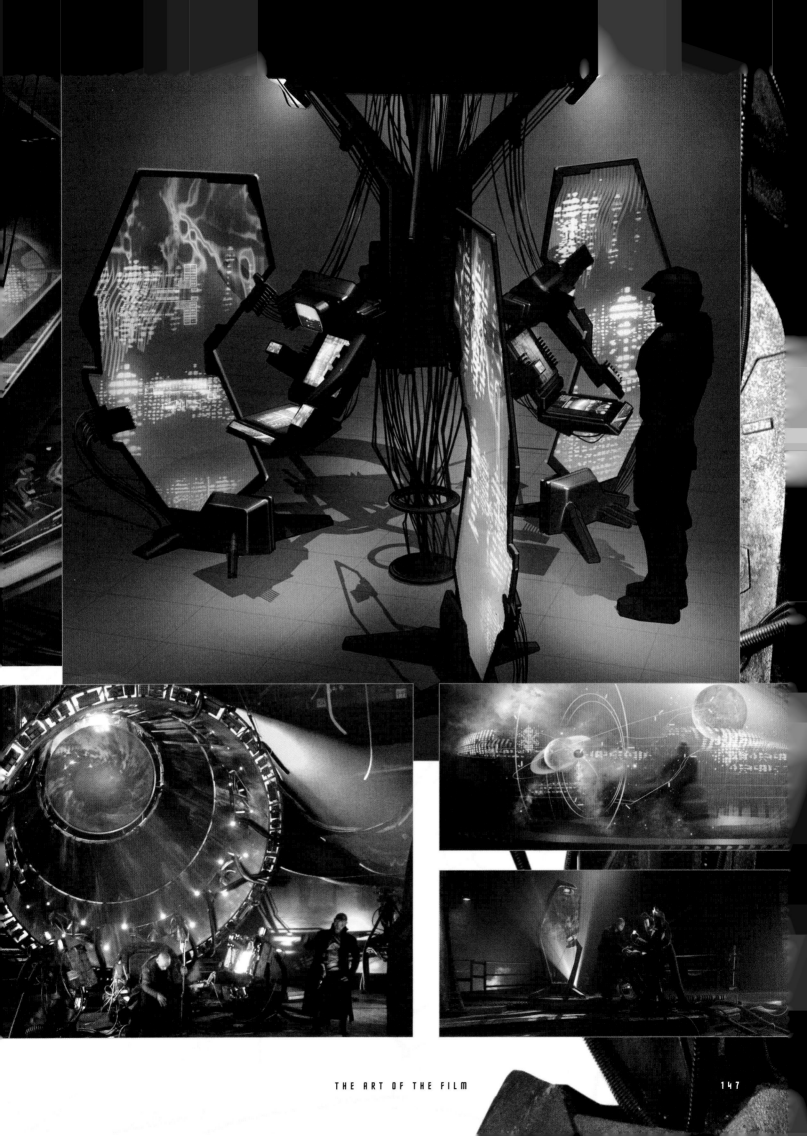

Inside the amorphous labyrinth is the powerful red matter device from the future, a device whose power Captain Nero uses for his own fanatical ends.

"To give some special energy to the third act and scenes of the jellyfish flying inside the *Narada*, we underlit the interior in classic horror movie style," notes ILM's Roger Guyett. "That idea came from a test that went wrong, but I actually liked the look. It was fun interjecting new ideas."

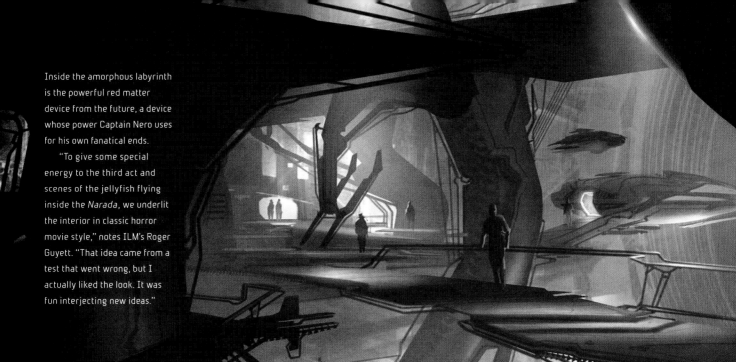

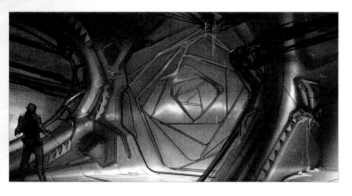

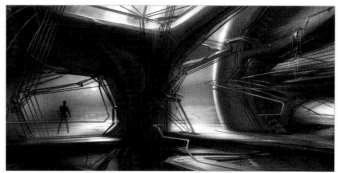

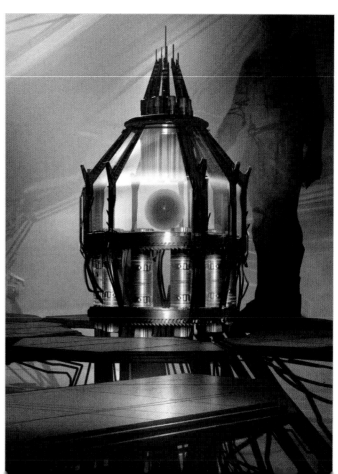

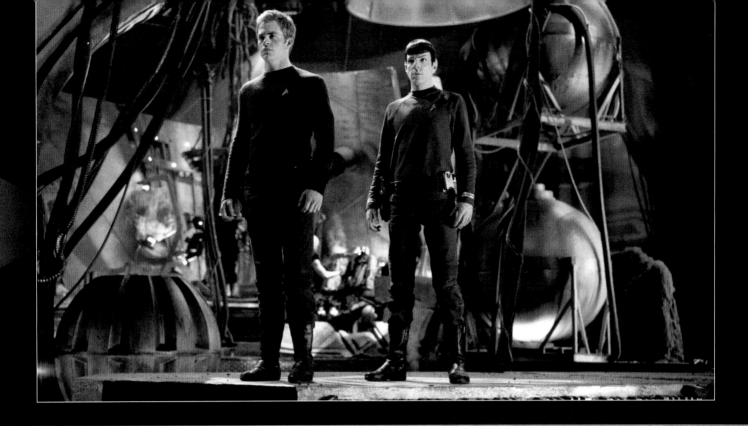

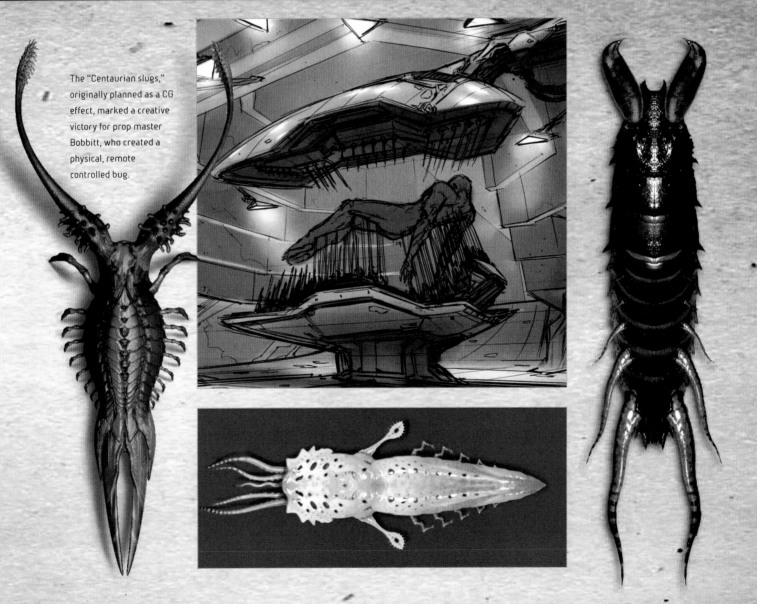

The "Centaurian slugs," originally planned as a CG effect, marked a creative victory for prop master Bobbitt, who created a physical, remote controlled bug.

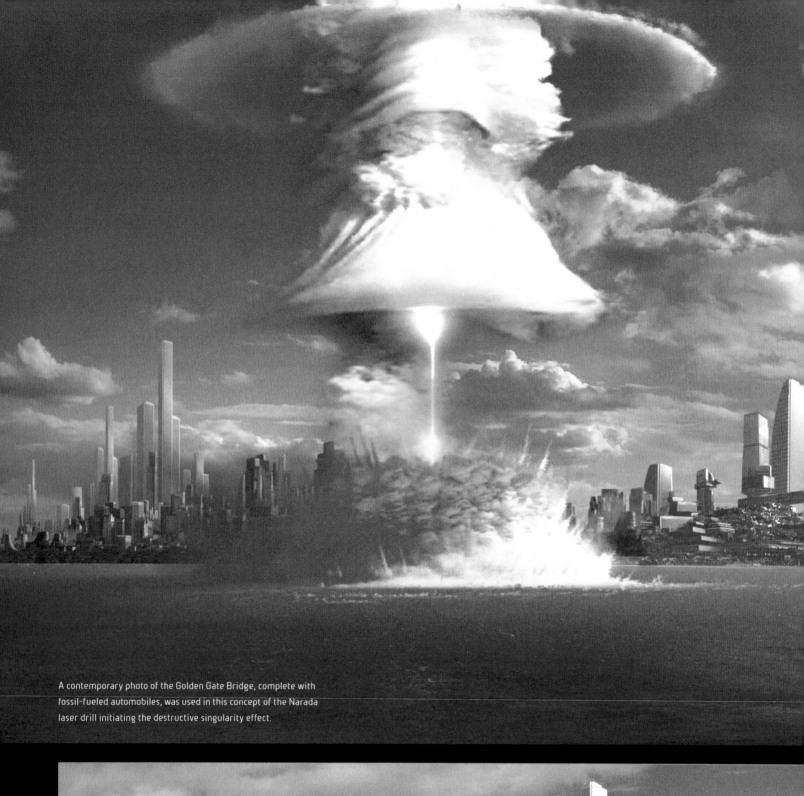

A contemporary photo of the Golden Gate Bridge, complete with fossil-fueled automobiles, was used in this concept of the Narada laser drill initiating the destructive singularity effect.

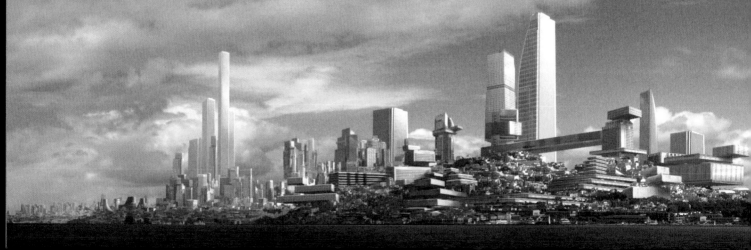

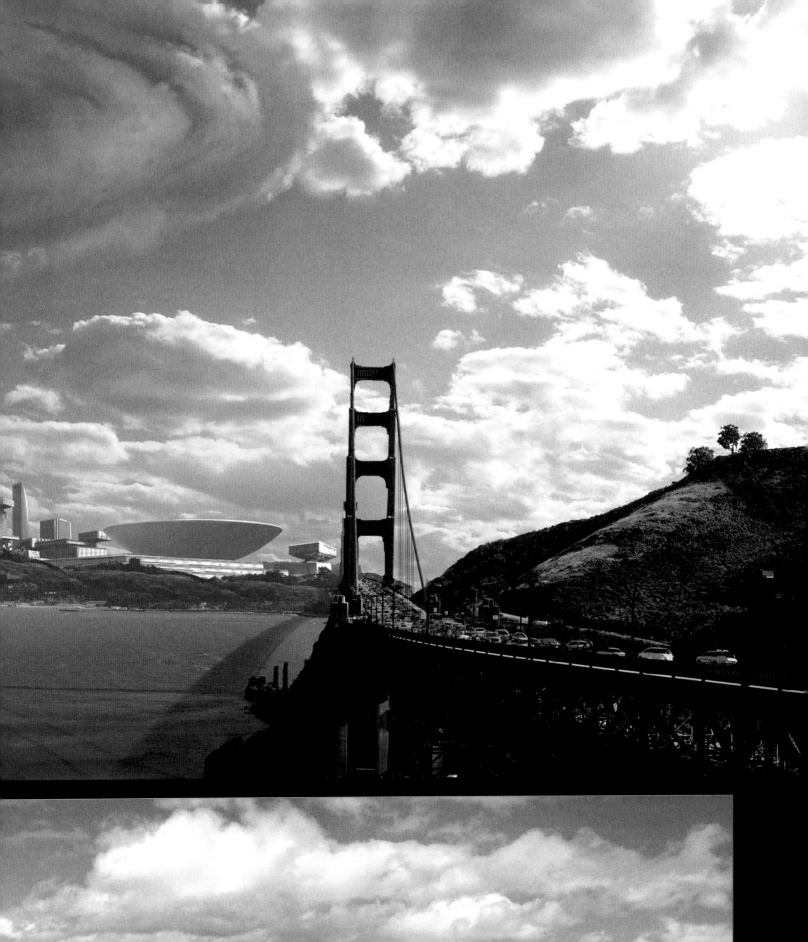
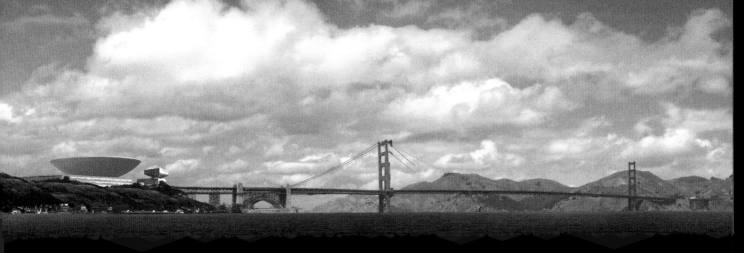

POSTER DESIGN

"Good art is good advertising," Paramount Pictures founder Adolph Zukor once said of movie posters. Film writer Dave Kehr has referred to them as "invitations to dream." The *Star Trek* poster campaign — early concepts for which are shown here — was in this grand tradition: advertisements for the coming attraction... and an invitation to dream.

 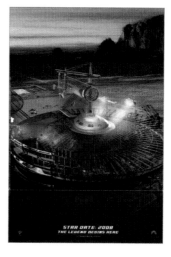

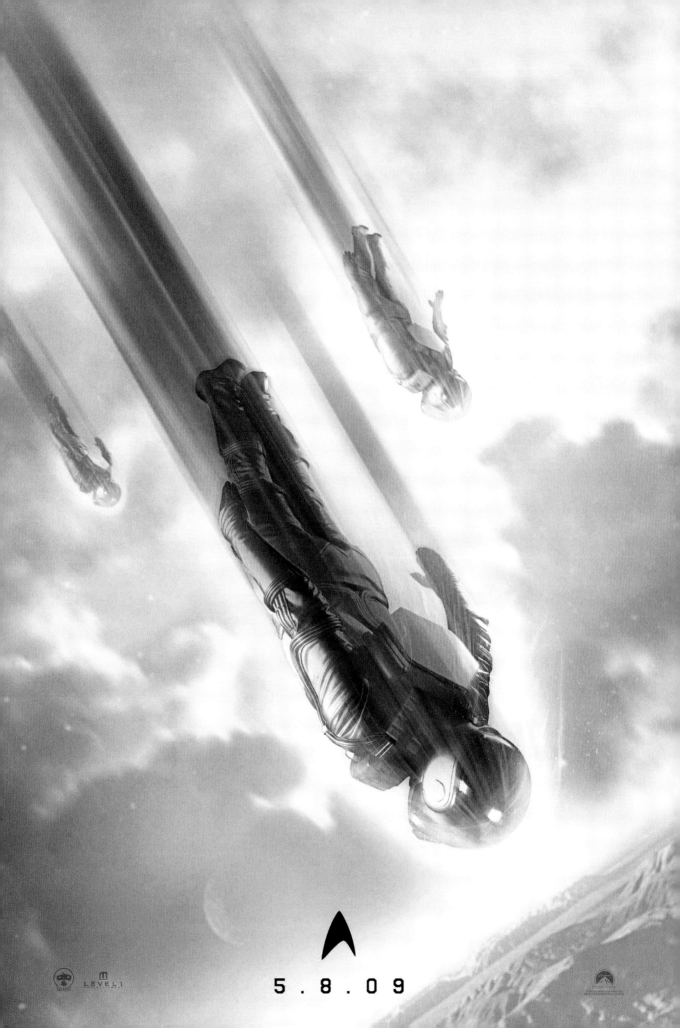

5.8.09

Top: A catalog produced by Kelvin Electronics, the company owned by J.J. Abrams' grandfather Harry Kelvin.

Above: Abrams' prized, unopened Mystery Box, as featured (with digitally added text) on the cover of *Wired* magazine.

THE MYSTERY BOX

J.J. Abrams recalls standing in the Paramount Pictures parking lot, stuck on how to conjure *Enterprise* space jumpers hurtling through space. "I then remember saying, 'Do you have any mirrors?'"

Six-foot sheets of mirrored plastic were laid flat and camera scaffolding built. The camera aimed down upon actors standing on the sheets in their space jump uniforms. Sky reflected, camera shake, wind effects – *voilà*! Space jumpers. It was funny, Abrams mused, that with all the technology at his disposal, he still looked to "low tech, old school ways" to create illusions. And, in this case, doing it with mirrors, the oldest magic trick in the book.

"I've always been a fan of magic, and I think my love of movies is completely connected," Abrams said. "Whether a coin vanish or a ship flying through space, it's creating a reality that doesn't exist, with the goal of making people believe it's real. That emotional connection to a trick that a magician has with his audience, and what the filmmaker has with his audience, is very similar.

"When I was a kid, it was always a highlight for me to be with my grandfather and go to the magic store to get a little bag of magic tricks I could perform for my sister and my parents. My grandfather wasn't a magician himself, he owned an electronics company. It was wonderful having him as a grandfather. He was an amazing support system for me, and indulged my curiosity in magic. His name was Harry Kelvin. I named the *Kelvin* after him."

An enduring talisman from those magical days is Abrams' "Mystery Box," bought at a magic store in New York City thirty years ago. It remains unopened. "I could open it, but – no more mystery!" Abrams declared. "Inside, I'm sure, are cheap little tricks. But, at the end of the day, there's no way that what is in that box is as interesting as what *could* be in that box!"

A photograph of the Mystery Box graces the May 2009 cover of the *Wired* magazine "Mystery Issue" which Abrams guest edited. The Mystery Box remains a creative metaphor for the producer/director. "Mystery invites exploration, but in a narrative the exploration is one of imagination," Abrams reflected. "When the storyteller withholds information, it engages the audience, they must fill in the blanks – the 'mystery box,' as it were. The audience personalizes the story with their own fears, sense of romance, excitement, and heartbreak."

Mystery, exploration, imagination – the stuff of *Star Trek*.

Abrams' *Star Trek*, originally scheduled for Christmas 2008, was held over for the following blockbuster summer season. One aspect of the release would have been science fiction to the original show's creators: Paramount transferred the film to NASA Mission Control in Houston, which uplinked it to the laptop computer of astronaut Michael Barratt at the International Space Station he shared with his crewmates, Russian cosmonaut Gennady Padalka and Koichi Wakata of Japan's Aerospace Exploration Agency. "I remember watching the original *Star Trek* series and, like many of my NASA coworkers, was inspired by the idea of people from all nations coming together to explore space," said Barratt.[5]

The original *Star Trek* series was cancelled weeks before *Apollo 11* reached the moon, but Abrams' *Star Trek* was still in theaters when the 40th anniversary of the

lunar landing was celebrated. On the eve of the anniversary, astronauts Neil Armstrong, Buzz Aldrin, and Michael Collins appeared at the Smithsonian Institution's National Air and Space Museum. In true Space Age spirit, they were looking to the future and proposing a mission to Mars, with Aldrin declaring the time had come "to boldly go again on a new mission of exploration." [6]

"If a ten-year old watching our movie is inspired to explore outer space, then we've more than done our job," executive producer Bryan Burk noted. "It was the optimism of *Star Trek* that really pushed J.J. to do this movie. The great hope is that once we learn to live together all the great adventures lie beyond."

The production itself emulated its time traveling storyline, with the 2009 film going back to a 1960s vision of the future. The synthesis, summed up in Abrams' first trailer slogan, "The Future Begins," reflected the optimism and adventure at the heart of both the original series and the new movie. "*Star Trek* was telling the kids, 'It's not all over, the challenges are not all gone, there is heroism,'" Gene Roddenberry, the late *Star Trek* creator, once reflected. "'It's really just the beginning for us, if we want to be brave about it.'" [7] ⋏

Space...

the Final Frontier.

These are the voyages of the Starship Enterprise.

Her ongoing mission: to explore strange new worlds,

to seek out new life forms and new civilizations,

to boldly go where no one has gone before.

STAR TREK: THE ART OF THE FILM

9781848566200

Published by Titan Books
A division of Titan Publishing Group Ltd
144 Southwark St, London SE1 0UP

First edition November 2009
10 9 8 7 6 5 4 3 2 1

Visit our websites:
www.titanbooks.com
www.startrek.com

Did you enjoy this book? We love to hear from our readers. Please
e-mail us at: readerfeedback@titanemail.com or write to Reader
Feedback at the above address. To receive advance information,
news, competitions, and exclusive Titan offers online, please
register as a member by clicking the "sign up" button on our
website: www.titanbooks.com

Acknowledgments

A big Starfleet salute to the talented filmmakers who contributed
their insights to this book:

J.J. Abrams, director; Damon Lindelof, producer; Bryan Burk,
executive producer; Roberto Orci, screenwriter; Scott Chambliss,
production designer; Ryan Church, conceptual artist; James Clyne,
conceptual artist; Dan Mindel, director of photography; Michael
Kaplan, costume design; Mindy Hall, makeup department head;
Neville Page, creature designer; Russell Bobbitt, property master;
Roger Guyett, visual effects supervisor/second unit director; Alex
Jaeger, ILM art director; David Dozoretz, senior previsualization
supervisor; Leonard Nimoy, actor; Chris Pine, actor; Zachary
Quinto, actor; Zoë Saldana, actor; Simon Pegg, actor.

This book was made possible thanks to the enthusiastic support
of J.J. Abrams, who wanted to document the making of Star Trek
and honor the talented artists who brought his vision to life. My
appreciation to Titan Books for asking me to join the party. The
stars of this endeavor are Titan editor Adam Newell and David
Baronoff at Bad Robot, who handled the considerable logistics of
gathering artwork, approving layouts, arranging contacts for the
author, and facing the innumerable tasks and challenges involved
in producing a book like this. You made it a pleasure, gentlemen.

Thanks also to Michelle Rejwan, J.J.'s assistant, Noreen
O'Toole, Damon Lindelof's assistant, Leigh Kittay and Adam
Gaines in Bryan Burk's office, Kim Cavyan, assistant to the
screenwriting team of Alex Kurtzman and Bob Orci, Bad Robot's
Peter Podgursky, for logistical help (and the Idaho connection),
and Greg Grusby, technical publicist at ILM. Nguyen Ngoc at
Paramount provided support, including facilitating feedback from
Trek cast members. And a special Vulcan salute to Scott
Chambliss, Roger Guyett, and Neville Page, who filled in a few
blanks. My appreciation, as always, to cinematic illusionist Bruce
Walters, who always snaps my author's photos.

On a personal note, my appreciation as always to my agent,
John Silbersack, whose devotion and efforts on behalf of his
clients are of Herculean proportions, and his wonderful assistant,
Emma Beavers. As always, love and hugs to my parents and
family for their love and support.

To all of you, Spock said it best: Live long and prosper!

– M.C.V.

Titan Books would like to add their huge thanks to David
Baronoff, and also thank Brandon Fayette at Bad Robot, John Van
Citters at CBS Consumer Products, and Risa Kessler from
Paramount Licensing for all their help.

ARTISTS CREDITS

Front endpaper: James Clyne
Pages 2-3: Ryan Church
Pages 6-7: Ryan Church
Pages 22-23: Main image by Ryan Church.
Pages 24-25: Main image by Ryan Church. Other images on p25
by Alex Jaeger.
Pages 26-27: Main image and top right by James Clyne. Chair
design by Dawn Brown. Ship control systems designed by
Gustavo Ferreyra.
Pages 28-29: Art by James Clyne, except p28 bottom by John
Eaves.
Pages 30-35: Art by James Clyne, except p32 strip of three
panels and p35 top and bottom by Alex Jaeger.
Page 40: Prop designs by Russell Bobbitt. Page 41: Costume
design by Michael Kaplan, sketches by Brian Valenzuela.
Page 42: Top: James Clyne. Bottom left: Costume design by
Michael Kaplan, sketch by Brian Valenzuela. Bottom right: Prop
designs by Russell Bobbitt.
Page 43: Center left: Costume design by Michael Kaplan, sketch
by Brian Valenzuela. Bottom: Aaron Haye.
Page 44: Top: James Clyne. Center right: Alex Jaeger. Car
image: Ryan Church.
Page 45: Cop design: Alex Jaeger. Hoverbike art: Clint Schultz.
Cop costume: Design by Michael Kaplan, sketch by Brian
Valenzuela.
Page 46: Costume designs by Michael Kaplan, sketches by Brian
Valenzuela.
Page 47: Art by Joel Harlow.
Pages 48-55: Art by Ryan Church, except p48 bottom: John
Eaves; p51 top: James Clyne; p52 bottom two images: Aaron
Haye; p55 bottom right: set design by Dawn Brown.
Page 56: John Eaves.
Page 57 top: Alex Jaeger
Page 58: John Eaves.
Page 59: Alex Jaeger.
Pages 60-61: Art by Ryan Church.
Pages 62-64: Costume design by Michael Kaplan, sketches by
Brian Valenzuela.
Pages 67-68: Neville Page.
Page 69: Costume design by Michael Kaplan, sketch by Brian
Valenzuela.
Page 70: Top left: Barney Burman/Proteus. Top right: Joel
Harlow. Bottom right: Neville Page.
Page 71: Neville Page
Page 72: Top: Art by Joel Harlow. Bottom: Art by Barney
Burman/Proteus.
Page 73: Bottom: Art by Joel Harlow.
Page 74: Top row from right: Barney Burman/Proteus, Neville
Page, Neville Page. Middle row: Barney Burman/Proteus,
Barney Burman/Proteus, Neville Page. Bottom row: Barney
Burman/Proteus, Neville Page, Barney Burman/Proteus.

Page 75: Top row from right: Barney Burman/Proteus, Neville
Page, Barney Burman/Proteus. Middle row: Barney
Burman/Proteus, Barney Burman/Proteus, Neville Page.
Bottom row: Barney Burman/Proteus, costume design by
Michael Kaplan, sketch by Brian Valenzuela, Barney
Burman/Proteus.
Pages 76-87: Art by James Clyne, except p82-83 top: art by Tony
Kieme, p86, costume designs by Michael Kaplan, sketches by
Brian Valenzuela.
Pages 88-101: Art by Ryan Church, except p90: Pencil sketches
by Tim Flattery, with notes by Scott Chambliss; p94-95 Nacelle
studies by Alex Jaeger; p96-97: all pencil sketches by John
Eaves; p99: color key sketch by Scott Chambliss.
Page 102: Top: Andrea Dopaso. Center left: Scott Chambliss.
Bottom left: Dawn Brown.
Page 103: Chair design by Dawn Brown. Ship control systems
designed by Gustavo Ferreyra.
Pages 104-107: Art by Ryan Church, except p104: bottom right
color key sketch by Scott Chambliss; p107: bottom: Alex Jaeger.
Pages 108-109: Prop designs by Russell Bobbitt, Paul Ozzimo
and Doug Brode.
Pages 110-117: Art by James Clyne, except p110: bottom: Tony
Kieme; p111: bottom: Tony Kieme; p112-113: center strip: Alex
Jaeger; p117: bottom: costume design by Michael Kaplan,
sketches by Brian Valenzuela.
Pages 118-119: Top color illustrations by James Clyne. Bottom
pencil sketch by John Eaves. Costume design by Michael Kaplan,
sketch by Brian Valenzuela.
Pages 120-121: Ryan Church.
Page 122: Neville Page.
Page 123: Storyboards by Richard Bennett. Sketch by Neville
Page.
Pages 124-127: Art by Neville Page (with Alex Alvarez and Sofia
Velacruz).
Pages 128-129: Main image by Ryan Church. Costume design by
Michael Kaplan, sketch by Brian Valenzuela.
Page 131: Top: Neville Page. Costume design by Michael Kaplan,
sketch by Brian Valenzuela.
Pages 134-135 Costume designs by Michael Kaplan, sketches by
Brian Valenzuela.
Pages 136-143: Art by Ryan Church (p136-137 based on concept
by Bryan Hitch), except p138: top: James Clyne, center right:
Warren Fu.
Pages 144-149: Art by James Clyne, except p149 Centaurian
slug designs by Neville Page.
Pages 150-151: Ryan Church.
Rear Endpaper: James Clyne.

Notes

1. Tom Russo, 'Fallen Star,' Entertainment Weekly, July 25, 2003. 36.
2. Eric Bana, Star Trek production notes, Paramount Pictures, 2009 (comments edited for continuity).
3. Paul Simpson, 'Leonard Nimoy is Spock Prime,' Star Trek Magazine, June 2009: 58.
4. The scale of the Enterprise changed during the design process too, with the 'official' length of the ship ultimately confirmed as 725.35 meters.
5. National Aeronautics and Space Administration (NASA) press release, 'NASA Astronaut to Watch New Star Trek Movie Among the Stars,' May 15, 2009 (supplied to author by Paramount Pictures).
6. 'Astronauts set their sights on Mars,' San Francisco Chronicle, July 20, 2009 (Associated Press release), p. A4.
7. 'The Creator: Gene Roddenberry,' TV Guide: Star Trek 35th Anniversary Tribute, 2002: 50 (Roddenberry quote from TV Guide, April 27, 1974).
Additional Sources: Karl Urban quote on p 16 from Paul Simpson, 'Karl Urban is Leonard McCoy' Star Trek Magazine, June 2009: 22. John Cho quote on p 19
and Anton Yelchin quote on p20 from Star Trek production notes, Paramount Pictures, 2009.